THE ART OF BLACK & WHITE PHOTOGRAPHY

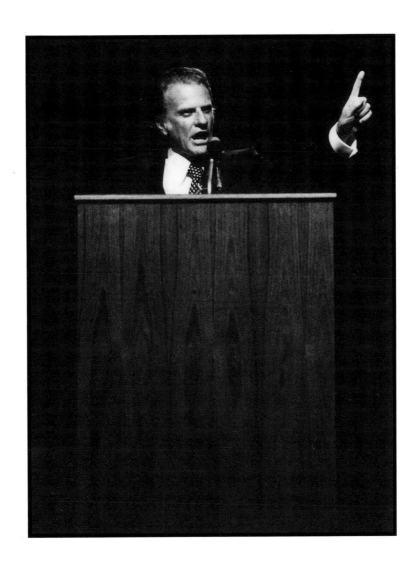

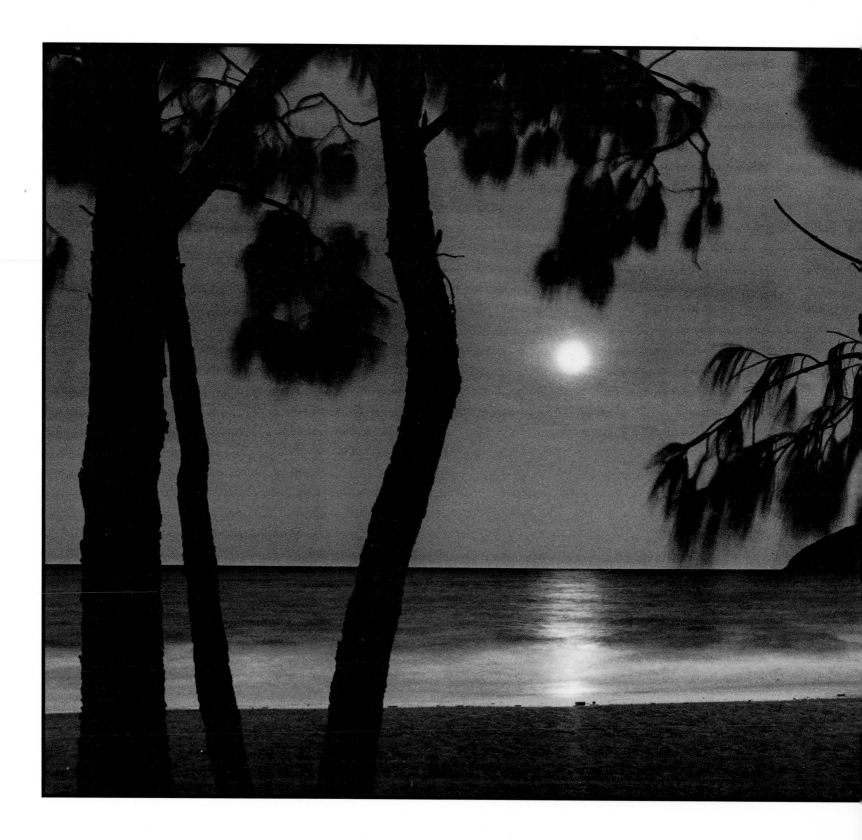

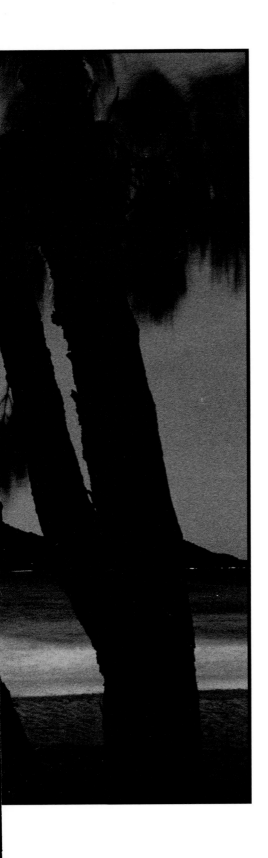

THE ART OF BLACK & WHITE PHOTOGRAPHY

JOHN GARRETT

MITCHELL BEAZLEY

THE ART OF BLACK AND WHITE PHOTOGRAPHY

Edited and designed by Mitchell Beazley,
an imprint of Octopus Publishing Group Ltd,
2-4 Heron Quays, London E14 4JP

Executive Editor **Judith More**
Editor and co-writer **Richard Dawes**
Art Editor **Simon Blacker**
Editorial Assistant **Jaspal Bhangra**
Production **Ted Timberlake**

This paperback edition published 1992, revised and reprinted 1995, 2001

A CIP catalogue record for this book is available from the British
Library

ISBN 1 85732 956 2

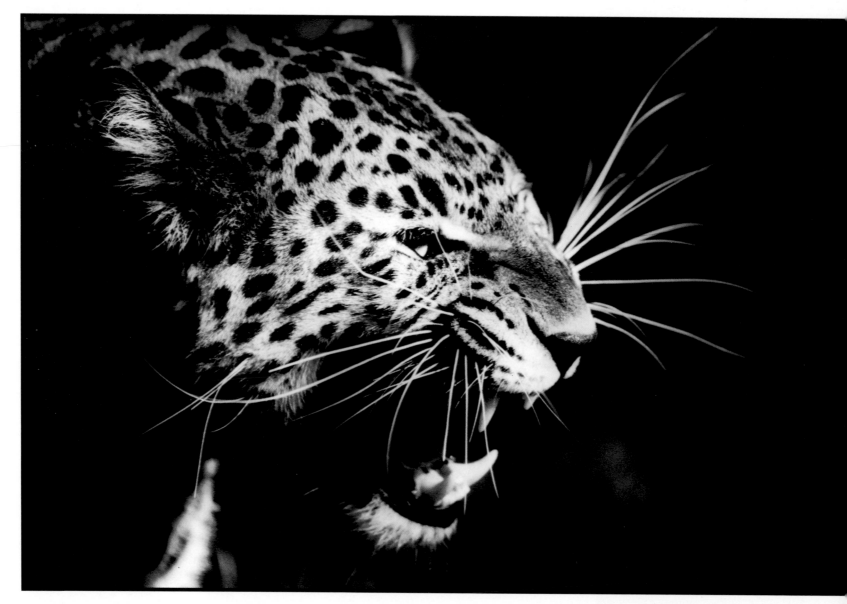

The publishers have made every effort to ensure that all
instructions given in this book are accurate and safe, but they
cannot accept liability for any resulting injury, damage or loss
to either person or property whether direct or consequential and
howsoever arising.
The authors and publishers will be grateful for any information
which will assist them in keeping future editions up to date.

Typeset in 11/14pt Bodoni Book and 9/10½pt Bodoni Italic by Servis Filmsetting Ltd,
Manchester, England
Reproduction by Scantrans Pte Ltd, Singapore
Printed and bound in Hong Kong
Produced by Toppan Printing Co. (HK) Ltd.

Contents

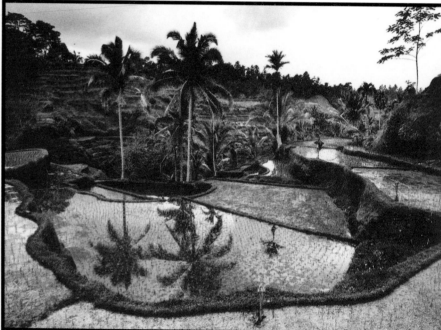

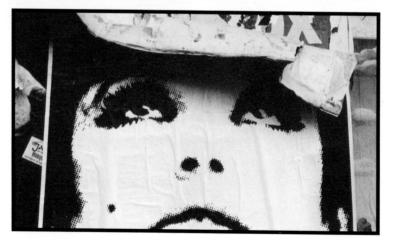

Introduction

My earliest inspiration as a young photographer was provided by the black and white photostories of *Life* magazine, the gritty, grainy reportage pictures of *Paris Match* and the elegant black and white portraits and fashion shots of *Harper's Bazaar* and *Vogue*. I am therefore all the more excited by the recent revival of the medium and its inspiration to photographers of all ages.

This book, stimulated by this reawakened interest, attempts to simplify the art of taking black and white pictures. It is not intended to provide a set of hard-and-fast rules, let alone fail-safe techniques. It looks at the way I take black and white pictures; at the whys and hows of my pictures. No serious photographer can claim to know everything, for black and white photography is a constant learning process. My work in black and white is not the same as it was when I started this book. The experience of shooting and writing material for it has stimulated me to reassess my attitude to both my own pictures and the medium itself. I trust that your reading of it will do the same for you.

Most professional photographers become rather specialized, as indeed I have in the fields of reportage and portraiture. Even so, I have always been interested in photographing almost anything, seeing the potential in most subjects. Many newcomers to photography ask, "What should I photograph?" My answer is a question: "What are you interested in? Your children, sport, nature, architecture?" Most of us take our best pictures when our photography is an extension of our lifestyle.

After some 25 years of taking black and white pictures I still get as much excitement from producing a final print as I did in the early days. In recent years I have shot many advertisements in colour and I enjoy the creative challenge, but I always return to black and white for my own pictures because I enjoy its complete cycle. You visualize the picture, shoot, develop and print what you saw. Rather, you print your interpretation of the subject, for shooting in black and white frees us from the obligation to faithfully record the world of colour, allowing us instead to make a picture of how we feel about what we see. I hope that this book will provide you with an eye for light and shade, shape, form and pattern and with the technical skill to realize your vision and emotional response.

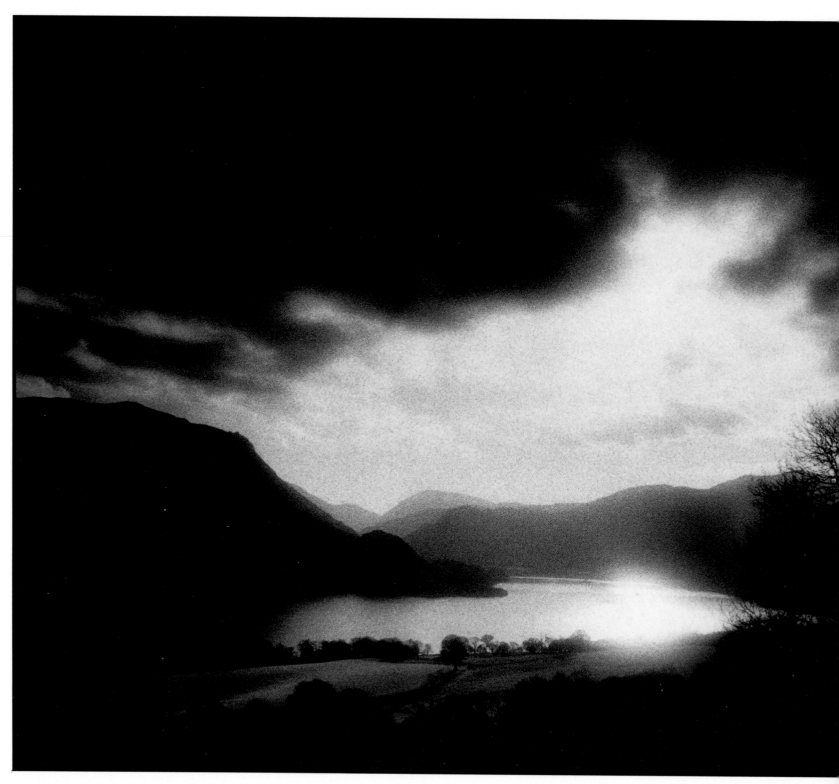

The World of Black & White

It is only by looking more closely at the world of colour all around us, which we take for granted most of the time, that we learn how to make good black and white pictures. An understanding of how black and white film depicts colours lies at the heart of successful photography in this medium. This first section of the book explains that relationship between colour and tone and introduces black and white photography as an alternative way of seeing reality, a medium with its own powerful means of expression.

Seeing in black & white

Black and white photography does not seek to depict reality with accuracy, or even to imitate it. Nor is it a substitute for colour. It is simply another way of interpreting the subject, another way of seeing. But how do we learn to see the world of colour in black and white – that is, as tones? This skill is central to getting the best from black and white photography. We must be able to judge whether, for example, an orange flower will stand out from the grass around it, or whether a pattern on a model's dress will make a strong composition in black and white or will prove distracting. Concentrate on the intensity of colours rather than their hue. A good way to do this is to use the camera to meter the relative values of colours in a familiar scene such as your garden. Then, by shooting the same scene in both black and white and colour, you will confirm the different intensities of the colours and the tonal relationships that exist between them in black and white. You can reinforce what you learn in this way by adjusting your TV from colour to black and white and back again at frequent intervals, noting what happens to particular colours when they are rendered as tones.

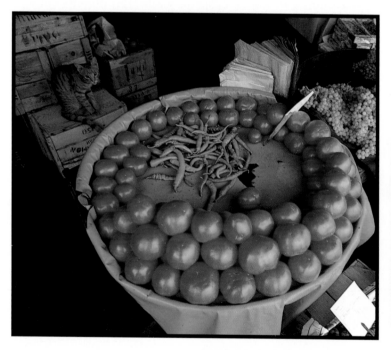

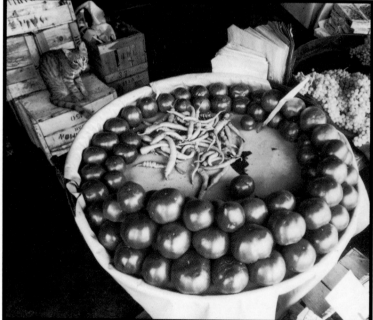

Weak black and white subject
Creative control in black and white photography demands first of all the ability to predict how colours will translate into tones, particularly how distinct from each other they will appear in the print. In the picture on the left above, the even lighting gives the red of the tomatoes and the green of the beans equal prominence, so that they stand out against one another. Their vibrancy makes them a natural subject for treatment in colour. But, although the colours are complementary, when translated into black and white, as shown in the picture on the right above, they are too close in tone to provide an interesting contrast.

Good black and white subject
Like the colour picture on the opposite page, the study of young Masai right is a good colour subject because of the limited number of colours and the strong contrast between them. But here the strong side light of late afternoon has produced large areas of deep shadow in the clothing. It is this shadow that provides a strong contrast with the background in the black and white version below. However, the relatively well-lit rust-coloured areas, such as the shoulder of the tallest figure, merge with the green background when reduced to tones.

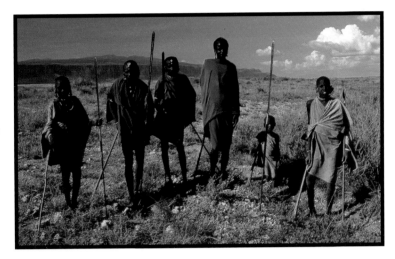

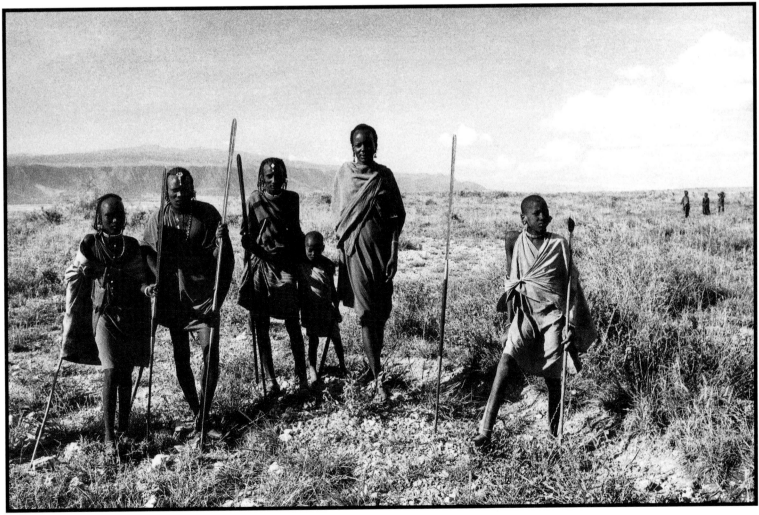

Filters

Filters make it possible to alter the tonal relationships in a picture by a small amount or dramatically, depending on their strength. Most filters are of glass or plastic and are fitted over the camera lens. To darken a subject colour, a filter complementary to that colour – that is, at or toward the other end of the spectrum – should be used. To lighten a subject colour, a filter is used that is as near to it in colour as possible. Consider a scene in which a red-brick house stands in a green field. The bricks can be made lighter and the grass darker in tone by using a red filter. While the opposite effect can be obtained with a green filter – darkening the bricks and lightening the grass – the effect is not as strong. For precise filtering effects it is best to select filters according to their number in the Kodak Wratten system.

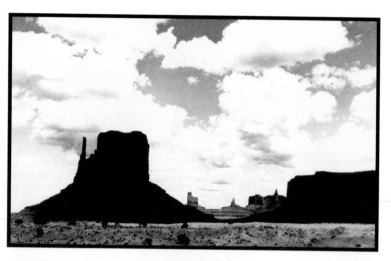

Improving the complexion

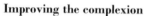

The most common use of an orange filter is to hold the tone of a blue sky and, by doing so, to emphasize the contrast between the sky and the whiteness of the clouds. However, a filter of this colour is also useful in portraiture, as it improves the complexion by lightening skin tones and concealing blemishes. The upper shot is unfiltered and displays a normal range of skin tones. In the lower shot an orange filter has lightened the skin and increased the contrast. A yellow filter produces similar effects to an orange filter, but they are not as pronounced.

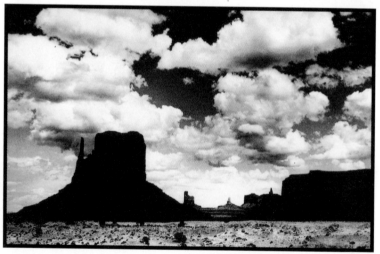

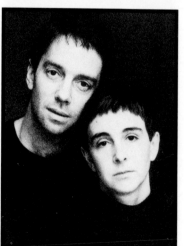

Increasing contrast in the sky
The scene in the two photographs above is a perfect subject for the use of a red filter. In the picture at the top, which was shot without a filter, the sky has comparatively little drama. In the lower picture, which was shot with a red filter, the sky has become much darker and more dramatic. The red filter has increased the contrast between the sky and the cloud, so that the clouds stand out more and assume greater importance in the composition. The sand in the foreground, because it is toward the red end of the spectrum in tone, has been made lighter by red filtration. This has further helped to focus attention on the sky's vastness.

Emphasizing the skin
For the picture on the left, a light blue filter was used. Since it is complementary to an orange filter (see opposite page), it has the opposite effect, strengthening skin tones and bringing out detail in the face. The use of a blue filter for this purpose is common in male portraiture.

USES OF FILTERS

The numbers of the filters referred to in the chart below are those of the widely used Kodak Wratten system. The exposure increase refers to the increase in stops required to compensate for the light-reducing effect of the filter. It is advisable to expose for the shadow areas. This is done to counteract the filter's tendency to increase contrast in the negative.

Subject	Effect	Suggested Filter	Exposure increase
Blue sky	Natural	No. 8 Yellow	1
	Darkened	No. 15 Deep Yellow No. 21 Orange Polarizing filter	$1\frac{1}{3}$ $2\frac{1}{3}$ $1\frac{1}{3}$
	Greatly darkened	No. 25 Red	3
	Almost black	No. 29 Deep Red	4
Marine scenes when sky is blue	Water dark	No. 15 Deep Yellow	$1\frac{1}{3}$
	Natural	None or No. 8 Yellow	1
	Increased contrast	No. 15 Deep Yellow No. 25 Red	$\frac{1}{3}$ 3
Distant landscapes	Increased haze effect	No. 47 Blue	$2\frac{2}{3}$
	Haze reduction	No. 15 Deep Yellow No. 21 Orange Polarizing filter	$1\frac{1}{3}$ 2 $1\frac{1}{3}$
	Greater haze reduction	No. 25 Red No. 29 Deep Red	3 4
Outdoor portraits against sky	Natural	No. 11 Yellowish-Green No. 8 Yellow Polarizing filter	2 1 $1\frac{1}{3}$

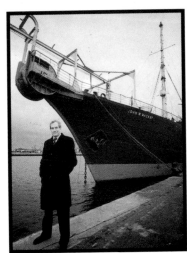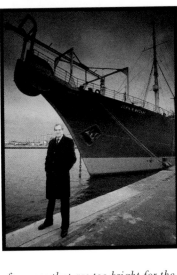

Using a graduated filter
A graduated filter has a clear bottom half and a coloured upper half, the colour's intensity increasing toward the top. This type of filter can be used in two ways with black and white film. It is used to reduce the tonal values of areas of a scene that are too bright for the film. Or it can be used to darken the sky when there is no blue for an orange or red filter to deepen. For the shot above left no filter was used. In the adjacent shot a graduated filter has lent drama to the sky.

Toning

You can give a print, film or negative a gentle colour by the process known as toning. The most popular colour used is sepia, which creates a warm, nostalgic mood. Make sure that the subject is suitable in character for this treatment. It is pointless to try to give a historical look to an image that could only be modern. Toning with selenium, which produces a cold, blue-black effect, is the method preferred for giving permanence to archival prints. Iron toning gives a deep blue effect, while nickel toning produces a magenta image. Metal-based toners of the type described above produce a single-colour effect. To tone a print in more than one colour – almost any colour is possible – you will need a colour-coupler or dye/toner kit.

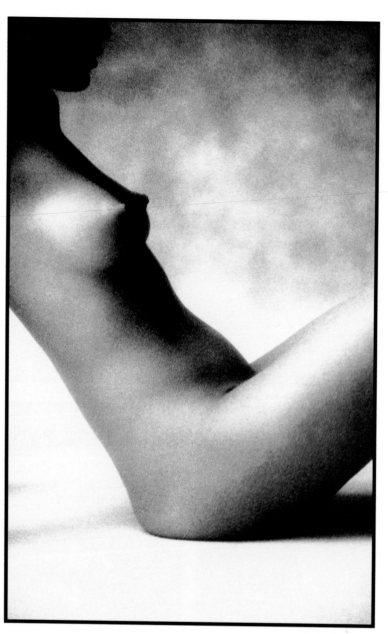

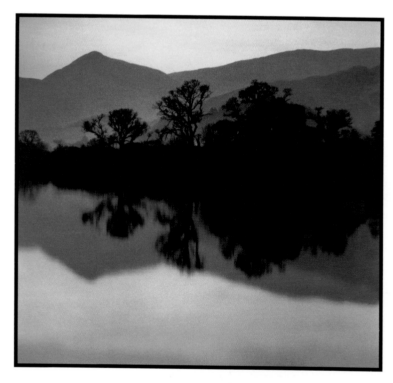

Selenium toning
The image above was given a strong blue tone by the use of selenium toner. The effect is immune to oxidation, the main cause of deterioration of a print.

Sepia toning
To produce a sepia-toned image you can use either of two methods. However, the traditional method, in which potassium ferrocyanide acts as a bleaching agent, creates an awful stench. As an alternative, I suggest the use of one of the convenient two-bath kits that are made by several manufacturers. For the picture above I used a kit made by Barfen.

Exposure & Light

Light is the essential ingredient in photography. Exposure is the way in which the photographer uses it. We have all witnessed a drab scene transformed into a beautiful subject for a picture by a sudden change of light. However, the amateur who waited for perfect light conditions would make no progress, while the professional photographer would go bust. Therefore, we must all learn to "read" the available light in order to make exposure decisions. To supplement this skill, it is also necessary to learn how to handle the artificial light provided by flash and studio lighting.

Exposure

The exposure received by a film is determined by two factors: the intensity of the light and the time for which the light reaches it. The first of these factors is controlled by the size of the aperture, the second by the shutter speed. The aperture is the adjustable opening in the lens through which light passes. The lens is calibrated according to an internationally agreed scale of values referred to as f numbers. The most common series of these numbers on lenses used with 35 mm cameras is f2, f2.8, f4, f5.6, f8, f11, f16, f22, although further values may be used at either end of this series. Each f number represents a fraction of the lens's focal length, so that f2 is half of the focal length, f16 one sixteenth of it. Therefore the greater the f number, the smaller the aperture and the less light passes through the lens onto the film. The relationship between the f numbers is such that at each consecutive number the amount of light passing through the lens is either halved or doubled. For example, adjusting the aperture from f2 to f2.8 cuts the amount of light by half, while changing it from f11 to f8 doubles it. The difference in exposure between one f number and the next is known as a stop. Changing from one aperture to a smaller one is referred to as stopping down. The opposite procedure is known as opening up.

An integral part of the camera, the shutter controls the duration of exposure in an action that is measured in fractions of a second. The shutter also allows the photographer to determine the precise moment at which the film is to be exposed. A reciprocal relationship exists between aperture and shutter, so that allowing a large amount of light to expose the film for a short time is equivalent to allowing a small amount of light to expose it for a long time.

The term "correct" exposure is misleading. Exposure is a creative decision made in response to the photographer's subjective requirements. For example, it may be determined by the desire to retain strong shadows, or to stress highlight areas at the expense of shadow detail. In black and white photography the process that starts with exposing a picture in such ways is completed in the darkroom.

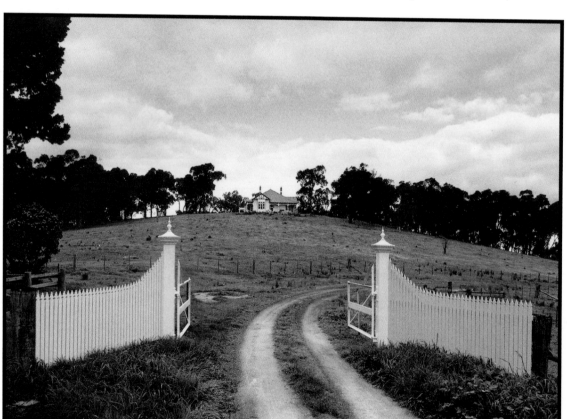

Exploiting depth of field

The term depth of field describes the area that is in sharp focus both in front of and behind the point focused on. The smaller the aperture used, the greater the depth of field. When a small aperture is selected on a lens with a short focal length, as for the picture on the left, depth of field is even greater. Here, an aperture of f16 on a 28 mm lens produced sharp focus from the nearest point in the scene to the farthest. In the photograph opposite depth of field has been kept to a minimum, rendering only the man and the gate sharp. For this shot, a 500 mm lens was used at its maximum aperture of f5.6.

In black and white photography, controlling depth of field has the further benefit of determining the relationship of tones. In the landscape shown here, the sharp focus makes the white fence and gateposts stand out against the dark field while in the picture opposite shallow depth of field provides a suitably blurred background that throws the subject into prominence.

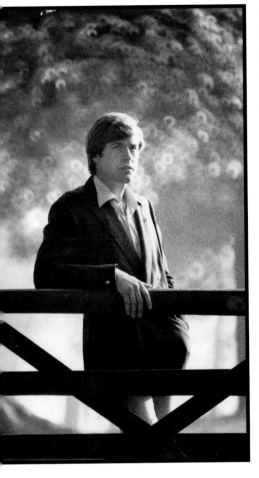

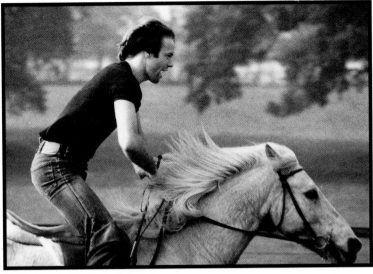

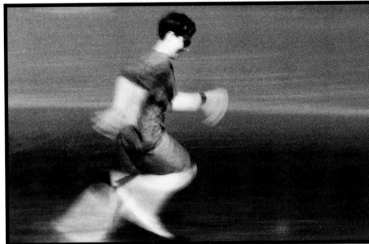

Varying shutter speed

The shutter speed can be used to "freeze" a moving subject, or to convey the sense of movement. In each case this has an effect on the tonal structure of the photograph. The picture on the left was exposed at 1/500 sec., fast enough to render both horse and rider sharp. The shutter speed made it necessary to use a wide aperture. This in turn, by providing a very shallow depth of field, made the subject stand out from the background, which has been rendered, by contrast, as indistinct tones.

For the picture of the woman running, a slow shutter speed of 1/8 sec. was selected in order to produce a blurred effect. Naturally, the limbs are the least distinct part of the body, but the tones comprising the whole figure merge into those of the background, emphasizing speed.

Factors affecting depth of field

The diagram on the right shows how three factors affect depth of field. These are aperture, the distance between the camera and the subject and the focal length of the lens. As the size of the aperture decreases, depth of field increases. As the subject distance increases, depth of field increases. As focal length decreases, depth of field increases.

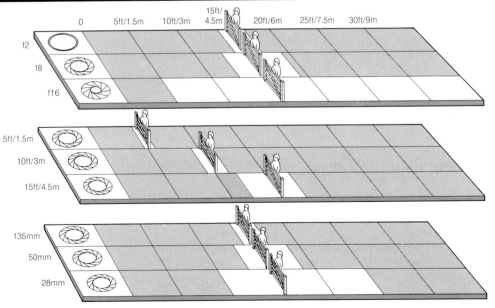

Metering

When confronted by the mass of promotional and technical information used to sell cameras, it is easy to assume that the latest model will solve all exposure problems, instantly turning the user into a skilled photographer. But no camera is in itself creative since it does not know what it is being pointed at nor what the potential or drawbacks of that subject are. Modern cameras have built-in light-metering systems. The simplest take a reading and allow you to set both aperture and shutter speed. Others set one or other of these, requiring you to select the other. Sophisticated cameras set both. The meters in cameras in both the 35 mm and the medium format (6 × 6 cm /$2\frac{1}{4}$ × $2\frac{1}{4}$ in) are designed to give good results in average lighting conditions. To achieve this, the meter is balanced to "average" the light values produced by the extremes of highlight and shadow in any scene. It gives a reading equivalent to that obtained by pointing the camera at a card with an 18 per cent gray tint, the middle tone reproducible by black and white film.

However, when lighting conditions are not average, the meter is likely to be misled and cause inaccurate exposure. It is possible to override the meter's automatic function. But because the meter is incapable of making judgments, the decision to override it is the photographer's alone. Being able to recognize potentially proble-matic lighting conditions is a large part of the creativity of all photography. The photographs on this and the opposite page are examples of such situations. This ability is particularly important in black and white because when faulty exposure produces an inadequate negative it is not possible to make a print that reflects the original intentions of the photographer.

TTL METERING

Modern 35 mm SLR cameras have TTL ("through the lens") light metering. Most use the center-weighted system, above right. This reads the light values across the whole picture area, but with a bias toward the central portion and, to counter the strong effect of the sky, toward the lower half of this portion. A few models use the spot-metering system, taking a reading from a central circular area marked on the viewfinder screen, right.

Compensating for a light background

When a strong light, either direct or, as here, reflected, is coming from behind the subject, the camera meter bases its reading on it. Here, the face would have been underexposed if I had not compensated. To do this, take a light reading from your vertical hand. The meter will take a reading based on the light value of skin and will suggest a suitable exposure. Take the shot with the meter's memory locked or repeat the exposure given by reading from your hand.

Compensating for high contrast

For the picture opposite I used a red filter to darken the sky. This also lightened the wall, which was of a similar hue to the filter. The contrast between the wall and the shadow areas of the picture was now increased. The contrast range was such that the film could record the highlights at which the meter was directed, but no shadow detail. To retain this detail I provided extra exposure of 2/3 stop. With an orange filter, 1/3 stop extra would have been adequate; with a dark red filter, a stop would have been required.

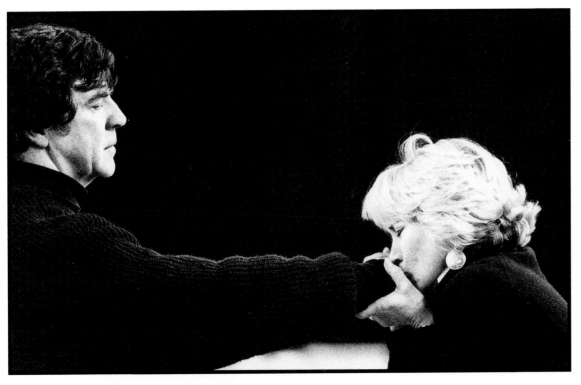

Compensating for a dark background

For the shot on the left, the camera meter tried to read subject detail in the shadows. The exposure that it recommended was too great for the lighter faces. Exposure for the faces was based on a reflected light reading (see below).

USING A HAND-HELD METER

For accurate light metering it is advisable to use a hand-held meter. Most models can be used to read both incident light – light falling on the subject – and light reflected from it. To take an incident light reading, point the meter at the camera from a position in front of or just to the side of the subject. A reflected light reading is generally more accurate. If you are shooting outdoors, use your hand to shade the meter from the sky. Point the meter at the subject from the direction of the camera (usually from about 3 ft/1 m for portraits). A few cameras take a precise reading from a narrow area of the scene. Their hand-held counterpart is the spot meter.

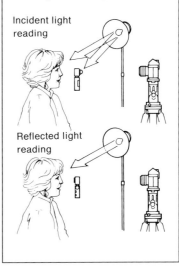

Incident light reading

Reflected light reading

Visualization

Black and white photography entails a departure from reality. But while the medium translates the subject into something quite different, this does nothing to diminish its expressive power and great versatility. The challenge is to interpret the subject as tones only and then select the film, filtration and exposure that enable you to produce a print that captures your original vision. This circular process can be called visualization.

If you are to get the most out of this interpretative freedom, you must first be able to see the tonal information the subject contains. The tonal value of any subject at any given moment is determined by the light falling on it, or, rather, reflected from it. Imagine that you are sitting at a black desk that is reflecting a strong light from a window facing you. The wall to the side of the window is white, but is in shadow. In reality, the desk is lighter in tone than the wall.

Never assume that what is black must be darker than what is white. You must carefully assess the true tonal values of subject elements every time you visualize a picture.

To check your reading of subject tones, shoot, give normal development, print the image straight and then compare the tones in the print with how you saw them. In this way you will learn how to match exposure to the demands of the subject. This in turn will enable you to produce negatives that allow you to make prints containing all the tonal information you saw in the subject.

Analyzing tonal range
The scale that is central to the Zone System devised by Ansel Adams (see p. 22) is used here to illustrate the breadth of tonal range achievable with average exposure in average light conditions. The traditional notion of a successful black and white image is one that has the range of tones seen here, which extend in zones from solid black through gray to pure white. The tonal density decreases by half from each zone to the next as the scale is descended and doubles as the scale is ascended. For example, Zone III is half as dense in tone as Zone II, while Zone V is twice as dense as Zone VI. The difference between each successive zone is equal to one stop of exposure.

To produce a complete range of tones in average light conditions, you should expose for the mid-tone (Zone V). For this picture, exposure was based on Kodak's Gray Card. This reflects 18 percent of the light that falls on it and is equivalent to the mid-tone reproducible by black and white film of any kind. In scenes where green grass, red brick or a tarmac surface is near the camera, exposure for the mid-tone can be based on any of these, since each is roughly equivalent to the mid-tone. Apart from Zone V, two other zones are particularly important in Adams's scale. Zone II is the first zone in which printable shadow detail is apparent, while Zone VIII is the lightest zone in which highlight detail is discernible.

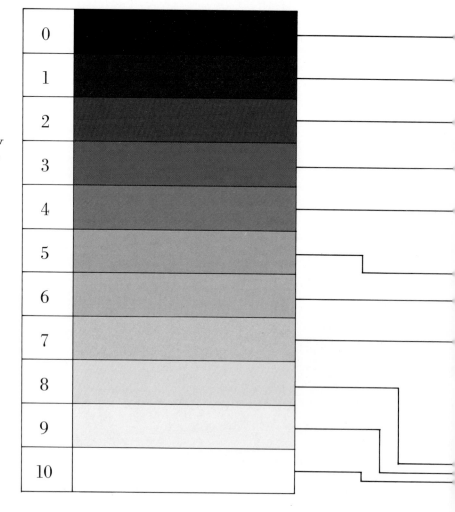

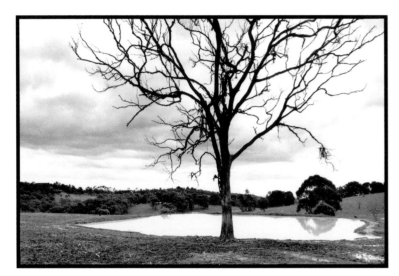

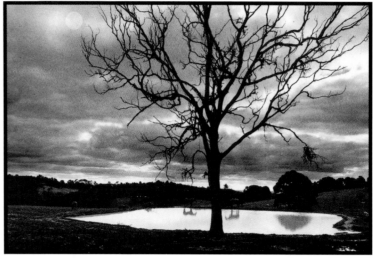

Reinterpreting a scene

The two photographs above illustrate different ways of interpreting a scene. In the example on the left I wanted to capture exactly what I saw. By exposing for the mid-tone represented by the grass I provided enough exposure to hold the shadow detail. However, to retain detail in the clouds I needed to burn-in the sky. As I was about to leave, two horses ambled up to the pond, where their reflections made an attractive addition. By exposing for the sky, which needed 2½ stops less exposure than I gave for the first shot, I could capture their bright reflections. But since this would have caused all the darker areas to go black, I decided to add a stop to the reading taken from the sky in order to retain some detail in those areas. Although it was morning, the high contrast in the water suggested moonlight. Therefore, when making the print I added a moon by placing a coin on the paper for one-third of the exposure provided for the sky.

Composing in tones

Success in composing a black and white picture depends on the ability to foresee how the tones will work together. It is often necessary to alter the impact of a tone. The simplest way is to change the relative significance of the shape that carries that tone by changing the camera position or the focal length of the lens. Varying depth of field and shutter speed will also change the impact of a block of tone. Other changes in tonal relationships can be achieved by using filters, by developing the image to increase or reduce the contrast between tones, by localized exposure control during printing or by changing the grade of printing paper.

Tonal organization

I composed this picture before the boat, which I had spotted when it was a good distance away, appeared in the viewfinder. I was ready to shoot at the precise moment the dark sail framed the house and sliced through the light tones of the clouds. In the meantime I had fitted a red filter to darken the sky and make the clouds stand out against it. On first seeing the scene I had decided to shoot from a low angle, making the sky the upper two-thirds of the picture. Most photographs benefit from a simple organization of tones, but, as this example shows, this requires planning, particularly when the subject is moving.

THE ZONE SYSTEM

The American photographer Ansel Adams developed his Zone System in the 1940s as a logical system of exposure and development control.

The system is based on a scale of eleven zones, Zone 0 being solid black and Zone X pure white (see p. 20). Zone V marks the middle of the tonal range produced by black and white film. Zones IV to 0 are progressively darker, while Zones VI to X are progressively lighter. To record the tones of the subject accurately in average lighting conditions, you must decide which area you will designate as the mid-tone, Zone V, and take the exposure reading from this area. This will give an average or "correct" exposure. The tones in the scene that are either side of Zone V will be reproduced in the same relationship to one another as they are in the scale. Normal development is then given.

A more advanced application of the Zone System lies not in achieving "correct" exposure but in allowing you to interpret a subject by emphasizing tonal detail at the dark end of the scale at the expense of the light end, or vice versa. This is achieved by assigning to Zone V a subject tone that is either darker or lighter than the true mid-tone (which with average exposure belongs in that zone). In this way the tonal values of the whole image are shifted up or down the scale, while retaining their original relationship to one another. For example, if you assign to Zone V a tone which would normally be in Zone IV, then you gain more shadow detail, but sacrifice detail in the highlight areas by losing Zone X from the scale. By assigning to Zone V a tone that would normally be in Zone VI you will achieve the opposite effect. Zone 0 will disappear from the scale, shadow detail being sacrificed in order to gain an increase in highlight detail. When a transposition of tonal values in either direction takes place, you must compensate during development. Thus, in the first example you must reduce development time by the equivalent of one stop because a one-stop exposure shift has occurred. In the second example development must be increased by one stop.

The above description of the Zone System is necessarily highly condensed. For a full account of Adams's system, see his book *The Negative*.

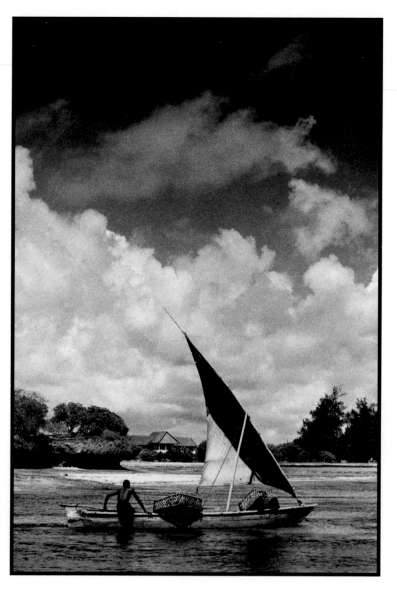

Lack of tonal contrast

I framed the picture below from a standing position, so that the water and sky are more balanced in area than in the picture on the opposite page. But the tonal organization is less interesting. The tones in the sail have become confused with those of the background foliage, while the large areas of the sky and the water are too similar in tone to create a dynamic composition.

Tonal manipulation in the darkroom

For my third version of the scene below I reorganized the tones of my second shot at the printing stage. I chose a paper with higher contrast (Grade 3 instead of Grade 2) and printed darker. I burned-in the sky to make it more dramatic and to emphasize the clouds. The resulting print has more tonal impact than the second picture, although I still prefer the way the tones work together in the first version. While darkroom manipulation can improve the relationship between tones, it is more satisfying to plan the overall tonal composition of the picture before you release the shutter.

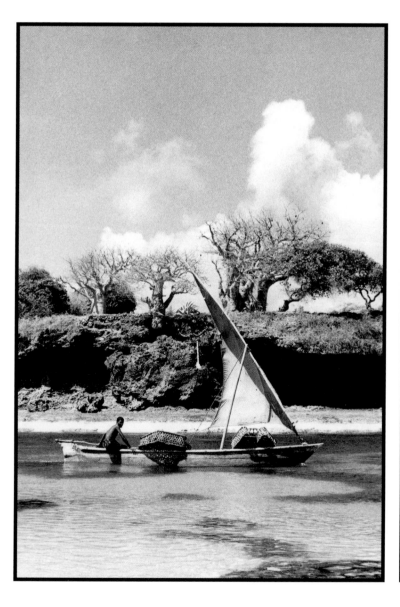

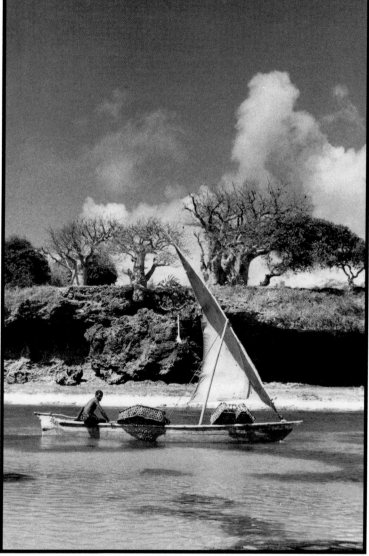

Available light

For the adventurous black and white photographer there is no such thing as bad light, only light that is less promising. Beginners often think of the subject in isolation, without considering the nature of the light that is actually available at the time. They are therefore disappointed to find a landscape, say, lit very differently from the way they had imagined. Particularly in temperate climates, it is not usually possible to predict lighting conditions with any certainty. The answer is to develop a repertoire of techniques that enables you to make the best of whatever light there is. This requires an understanding of the effects of the weather and the time of day on light.

The photographs below and on the following pages illustrate the main categories of available light and show their widely differing effects on subjects ranging from people to landscapes. Possessing this knowledge is of little use if you are not ready to take advantage of a wide range of often fast-changing lighting conditions. Above all, always carry with you films with a wide range of speeds, as well as a good selection of filters.

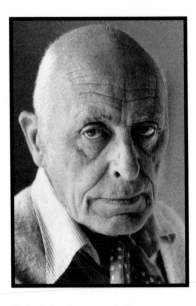

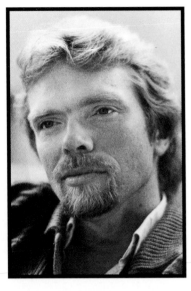

Side light from a window
Light from a window to the side of the subject makes for expressive portraits, as in this study of the American architect Robert Page. It depicts skin texture clearly and yet creates a sense of mystery by leaving part of the face in shadow.

Window light from both sides
This study of the airline and entertainment magnate Richard Branson benefits from light diffused through two windows, one each side of the sitter. Balanced lighting of this kind gives a frank, open look to a portrait.

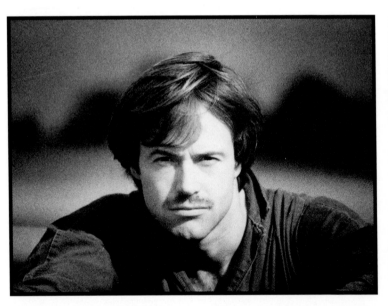

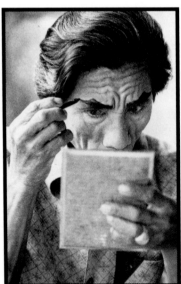

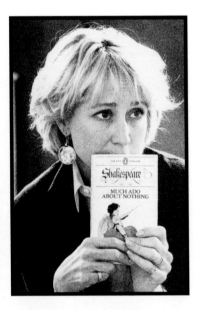

Using the sky as a reflector
The main benefit of shooting early in the morning before the sun climbs high is that the sun acts like a spotlight. When the sky is clear and the sun is strong its light is reflected from a clear sky and from the ground, illuminating details in the
shadow areas, as in this portrait of the actor Peter Finley. This kind of effect could have been obtained by substituting a key light for the sun and large reflectors for the sky and the earth.

Indirect light
This Balinese dancer was making up in the shade of a tree to escape the harsh light of midday. The light reflected from nearby buildings and sky light filtered through the branches onto his face have together produced a very flattering result.

Backlight from a window
The actress Felicity Kendall was lit by window light from behind. Already diffused by the glass, this light was softened still further by being directed back onto her face with a white reflector, creating a sympathetic halo effect.

Backlight outdoors

In the picture on the left outdoor backlight was reflected onto the subject's face with a white T-shirt. Exposure must be taken from the face in strong backlight, otherwise underexposure will occur. If your camera has a backlight compensation control, use this instead. With backlit portraits it is a good idea to position the subject in front of a dark background to emphasize the halo effect around the hair. Here, the subject was in front of dark trees.

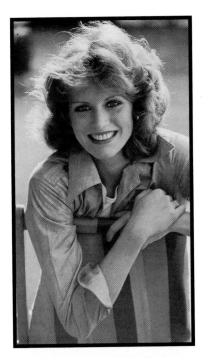

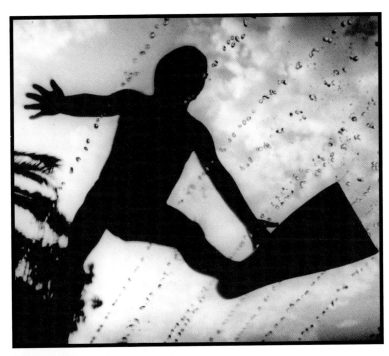

Lighting to produce a silhouette

The most effective silhouettes are those that are seen against a brightly lit background. Framing the unlit shape against the sky, as in the picture above, or against snow, sand or a white wall produces the best results.

Firelight

The light from a domestic open fire or a bonfire creates a striking, high-contrast effect. It is easy to lose the atmosphere of a shot like that on the left, which was taken at a children's fireworks party, by assuming that because there is apparently little light, flash must be used. Here, ISO 400 film was all that was needed.

Using available light

This selection of photographs illustrates a wide variety of common available light conditions.

1 *This shot was taken on a dark, wet winter's day when most of us leave the camera at home. Kodak Recording Film 2475 rated at ISO 1600 gave a grainy effect that was in keeping with the rain.*

2 *Storm light produces dramatic, high-contrast effects. Be prepared to act quickly as it may last only a few minutes.*

3 *Late afternoon sunlight produces large areas of strong shadow punctuated by small highlight areas.*

4 *At midday, with the sun directly overhead, you must decide whether to expose for the highlights and produce dense, hard-edged shadows, or for the shadows and lose all highlight detail. Avoid this light for portraiture.*

5 *In fog, subject tones become more subtle the further they are from the camera, as in the background here. The man stands out because he is nearer the camera and dressed in black.*

6 *The last rays of the sun are fading and the light of the moon is already apparent. The light is low but sufficient to hold detail in landscapes and cityscapes.*

7 *Overcast light reduces contrast, providing ideal conditions for descriptive, reportage-style photography. Exposure presents no problems and a complete tonal range can be captured.*

8 *Early morning light, before the dust of the day has risen into the atmosphere, gives sharp, hard-edged results.*

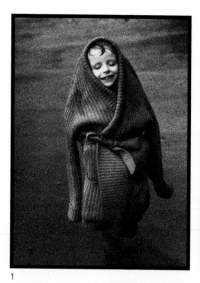

1

3

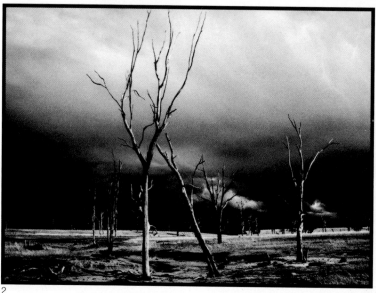

2

4

5

6

7

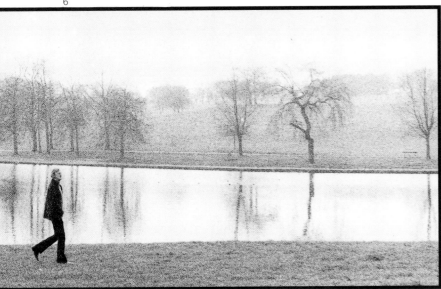

8

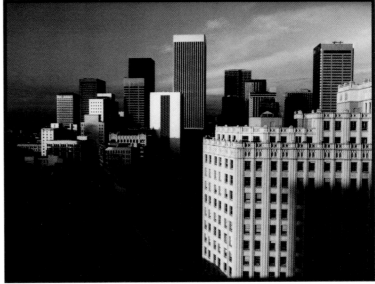

Flash

Professional photographers need to get acceptable results quickly and often rely on flash units, used on or off-camera, or studio flash lighting (see p. 30). But the amateur should explore the capabilities of fast films and fast lenses before assuming that flash is required. Flash provides adequate but flat light, often at the expense of atmosphere and subtlety.

Simple modern flash units measure the light reflected from the subject and provide the right amount of light to illuminate it. All you need to do is set the aperture (the choice is indicated by the flash), set the shutter to the flash synchronization speed and set the film speed on the flash. Most camera manufacturers also make "dedicated" flash equipment for exclusive use with their cameras and some makers produce "dedicated" units for use with various models. They work with the camera's TTL metering system to determine the amount of light required and are even easier to use than standard flash.

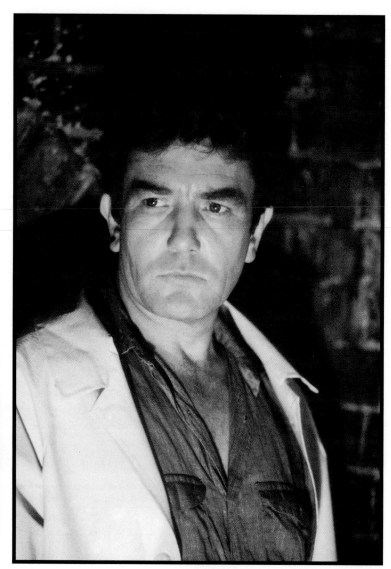

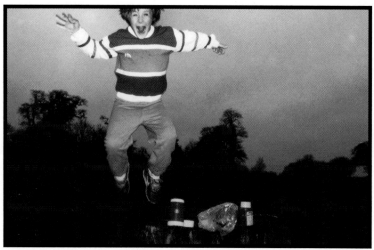

Freezing movement with flash
For the picture above I used "dedicated" flash to produce the effect of a figure frozen against a dark background. The flash synchronization speed of 1/250 second was fast enough to freeze the jump. The flash indicated that an aperture of f8 was needed. But I set the camera to f16 so that the sky would be more dramatic, by appearing much darker, than it would have been if it had been "correctly" exposed.

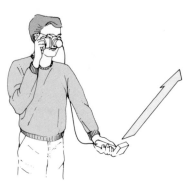

Lighting from below with flash
The shot above of Albert Finney was part of a picture story that covered the making of a film in which he starred. I held the flash at waist height and directed it up at the actor's face (see diagram, left). This simulated the atmospheric uplighting effect produced by the lighting used by the cameraman in the film. The flash automatically based its duration on the camera's TTL metering of the subject.

Using fill-in flash

In the shot on the right the backlight was strong, but the face was in shadow. I had no space to use a reflector to bounce light onto the face, so I diffused the light from the flash with tracing paper to keep its fill-in effect soft. The meter reading of the backlight gave me 1/125 second at f8, so I set both camera and flash at f8. If I had wanted the background to be darker, I could have used a smaller aperture.

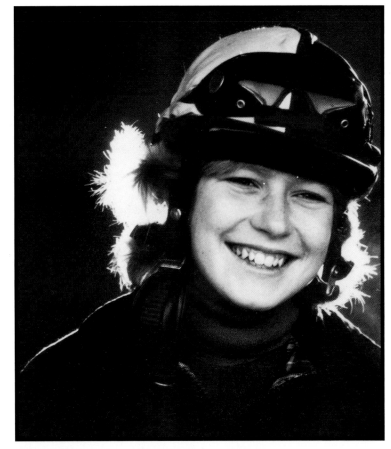

Capturing detail with flash

Flash is the sharpest light source there is, and in the picture below it has revealed almost every hair in the cat's jet-black fur. This result was achieved simply by allowing the dedicated flash to meter the subject. The aperture setting used was f16.

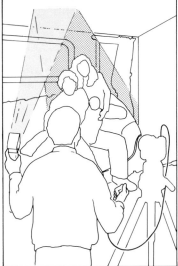

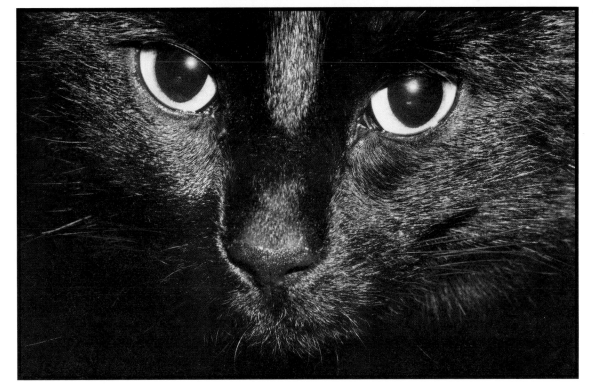

Bouncing light

For the picture of the family group, top, I bounced a flash off the cream-coloured ceiling (see diagram above). A dark surface, however, will absorb light, preventing enough reaching the subject. Bounced light provides sympathetic illumination that is softer than direct flash light. I used it here for this reason and because the baby was moving fast so that the shutter speed I would have needed for the available light (1/60 second) would have been too slow to "freeze" her. Flash made it possible to get a sharp image with a shutter speed of 1/250 second.

29

Studio lighting

There are two basic types of lighting for studio use: tungsten lights, which provide continuous illumination, and electronic flash. Both can be used to provide spot or flood light and supplementary equipment is available to modify their effect. Tungsten lights create considerable heat but have two main advantages over electronic flash. First, they allow you to see exactly how the subject will be lit when you shoot. (Electronic flash lights incorporate a modelling lamp to indicate the effect of the flash but this is not as reliable as a means of prediction.) Secondly, since it is not linked to the camera's automatic exposure functions, tungsten light continues throughout the exposure, however long this is. With electronic flash it may be necessary to repeat the illumination in a rapid series in order to provide enough light.

Some studio lighting set-ups are intended to create special effects – dramatic or glamorous, for example – but most good studio lighting results from accurate imitation of natural light. The diagram below and the photographs on these pages illustrate the most common techniques of studio lighting.

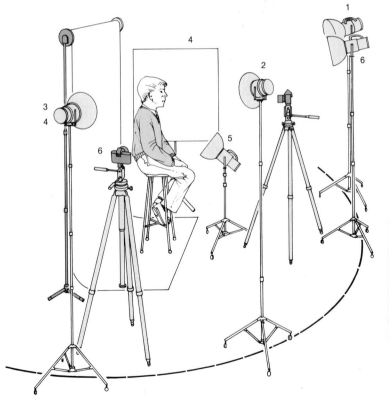

1 Frontal top light
With the light 3 ft (1 m) above the camera the cheek bones are well lit.

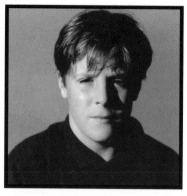

2 Three-quarter top light
An air of mystery occurs with the light at 45° to camera and subject.

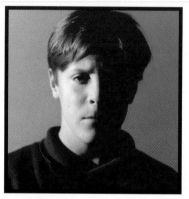

3 Side light
A light falling on the face from the side makes it look long and narrow.

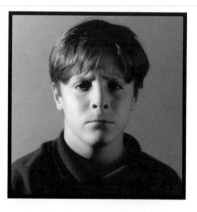

4 Side light and reflector
Using a reflector and raising the chin have broadened the face.

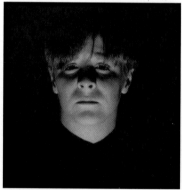

5 Lighting from below
A light at waist height makes the face eerie and almost rectangular.

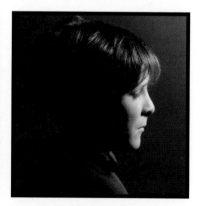

6 Frontal top light with profile
The use of the first set-up above also defines a profile effectively.

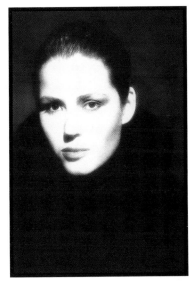
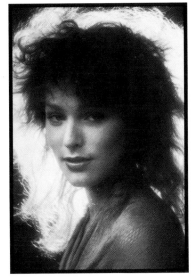
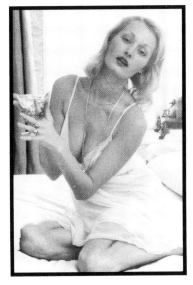
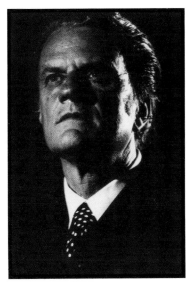

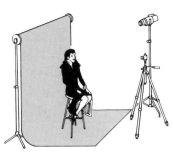
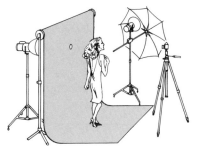
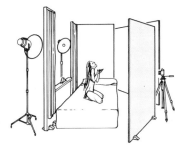

Flattering portrait lighting

A single spotlight to the right of the camera and above the head provides attractive modelling of the cheek bones. This set-up, used since the earliest days of movie photography, is referred to as "Hollywood lighting." However, the spotlight would have been too harsh without the use of a No. 1 Softar filter on the lens. To create a striking tonal contrast that makes the face stand out I used a black coat and a black background. A softer, less dramatic effect could have been produced by using the same lighting but clothes and background with lighter tones. Whether it is dark or light, clothing in such lighting looks better if it is of one tone only, with no pattern.

Backlighting for glamour

This set-up is particularly effective with long, lustrous hair. Frontal light is bounced onto the face from an umbrella attached to a studio flash light. (An equally good alternative is to diffuse a flood light by placing tracing or tissue paper about 2 ft (0.6 m) in front of it.) I cut a 4 in (10 cm) hole in the dark background and placed a light centrally behind it to backlight the hair. The balance between the strengths of the backlight and the front light is a matter of personal taste, but make sure that the backlight is covered by the head to prevent its light flaring into the lens. A soft-focus filter or stocking over the lens will soften the effect.

Shadowless lighting

For this location shot studio lights were set up on the balcony outside the bedroom and diffused through the French windows onto large polystyrene reflector boards surrounding the bed. These bounced extremely soft light onto the model, producing a high-key, almost shadowless effect. Bounced light is also very effective for creating softly lit portraits of babies.

"Heroic" lighting

This kind of lighting is often used for portraits of politicians and other leaders as it gives them the look of men of vision. Frontal top light from a spotlight is complemented by backlight from a second spot. The latter gives the hair a lustrous look and emphasizes the jutting jawline. Both lights are set up to produce "three-quarters" lighting. The low camera angle is an important factor as it reinforces the impression of a man whose idealism sets him above the crowd. Take the meter reading with only the front light on. The light from the other spot will mislead the meter, leading to underexposure of the face.

31

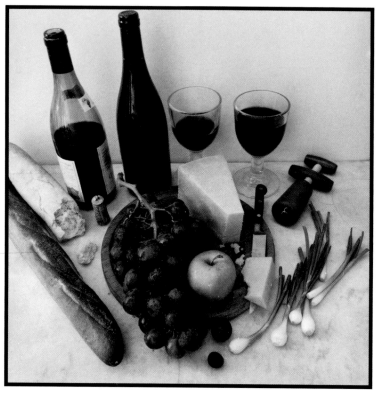

Using available light indoors

The still-life on the left was shot in my conservatory, which is glazed on one side and has a glass roof and white walls. The day was overcast, so that the already diffused light from the sky bounced off the light walls to illuminate the subject gently, with very soft shadows. I needed no artificial light, but even when studio lights are to hand it pays to experiment with diffused available light for its softness.

Simulating daylight

For the shot on the left I used the same location as for the shot above it. However, I took the picture in the evening when the pale sun had set. I positioned a reflector in front of the windows and another to approximate light from the glass roof. I bounced a flood light off each reflector. The shadows were too strong, so I used large reflectors to direct light back into them.

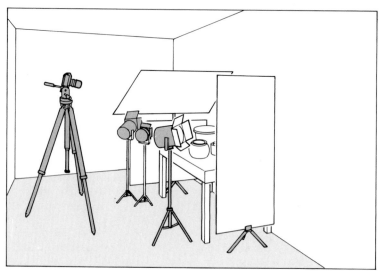

Film & Formats

The essential factor in choosing black and white film is its speed, or sensitivity to light. This governs the amount of grain visible in the print and, to a lesser extent, the contrast. Since both these characteristics vary widely, it is possible to find a film to match any subject or style. The interpretative potential of black and white film is further increased by the fact that it can be used successfully at speeds other than those recommended by the manufacturer as long as development is varied accordingly.

The choice of format is inevitably linked to the choice of film because the camera format is that of the film it is designed to use. Since changing format nearly always means changing cameras, an understanding of the advantages and drawbacks of the various formats is advisable.

Choosing film

The sensitivity of film to light is indicated by its ISO rating, or speed. The lower the ISO rating, the slower the film and the less sensitive it is. Black and white films can be divided into four groups: slow (ISO 25-50), medium (ISO 100-200), fast (ISO 400) and ultra-fast (ISO 1000-6400). In general, the slower a film the sharper its resolution of subject detail, the finer its grain structure and the higher its contrast. In my experience manufacturers' film speed ratings are generally optimistic in these respects, and therefore I always rate ISO 50 films at ISO 32, ISO 125 films at ISO 80 and ISO 400 films at ISO 300.

Many professional photographers favour one or two film and developer combinations, preferring to know exactly what to expect when they shoot and develop. However, I would advise the less experienced photographer to explore the full range of black and white films and developers rather than be influenced by the preferences of others.

Slow films
With their very fine grain and excellent resolution these films are ideal for architecture (see above) and still life, or any subject where high image quality is essential. Results with 35 mm slow film can be as good as those with medium-format cameras. Slow films produce high contrast and have less exposure latitude than medium or fast films so accurate exposure is critical. They are completely unsuitable for "pushing;" that is, using at a faster speed than that recommended by the manufacturer and then giving longer development to compensate.

Medium films
A little grainier than slow films, these films still show very good resolution and smooth tones, as in the picture above, which was shot on medium format and cropped slightly. Medium-speed films are useful for a wide range of subjects, provided that very high image quality is not required. I do not use this group much in the 35 mm format as I find them too much of a compromise. If the subject warrants it, I choose slow films for their higher resolution or, for reportage in particular, fast films because of their usefulness in low light.

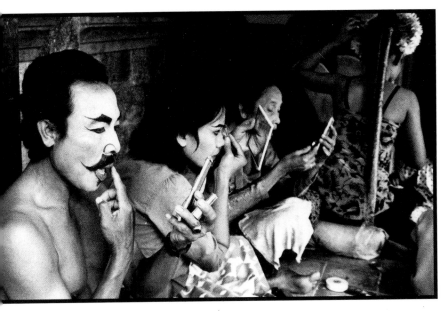

Fast and ultra-fast films

ISO 400 films show a softer tonal gradation than slower films which makes them ideal for high-contrast subjects, such as the Balinese dancers, left. These films have a wide exposure latitude: two stops under- or overexposure is printable. These qualities, combined with their sensitivity, make fast films ideal for reportage. Many photographers use fast films with medium-format and even large-format cameras as graininess is not a problem when enlargement is less great. Ultra-fast films are designed to be used at variable speeds and developed accordingly. Kodak's TMX 3200, for example, can be used at ISO 6400 and still reveal shadow detail.

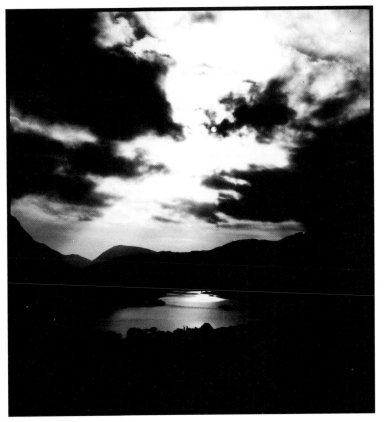

Film	Speed (ISO)	Comments
Agfapan APX 25	25	Outstanding high resolution and ultra-fine grain. Best with Agfa developers.
Ilford Pan F Plus	50	Excellent high resolution and ultra-fine grain. Best results with Ilford Perceptol developer.
Agfapan APX 100	100	High quality, high resolution, fine grain.
Ilford 100 Delta	100	Exceptionally sharp and free from grain, and allows good-quality results over the range ISO 50-200.
Kodak TMX-100	100	High resolution and very fine grain. Best results with Kodak T-Max developer.
Ilford FP4 Plus	125	High resolution and fine grain. Ideal for general use.
Kodak Plus-X	125	Good quality, high resolution, fine grain. Ideal for general use.
Agfapan AP400	400	High resolution for fast film. Fine grain. Suitable for "pushing."
Ilford 400 Delta	400	Extremely fine grain and very high sharpness. Can be used at any speed within the optimum range ISO 200-1600.
Fuji Neopan 400	400	Good for general fast use. Suitable for "pushing."
Ilford HP5 Plus	400	Excellent quality. Suitable for "pushing."
Ilford XP2 400	400	Dye-image. Can be rated from ISO 50 to 1000 depending on development time in C41 process (not ordinary developers).
Kodak TMX-400	400	Fine grain for fast film. Good for general fast use. Best results with Kodak T-Max developer.
Kodak Tri-X	400	Good for general fast use. Sharp grain structure. Suitable for "pushing."
Fuji Neopan 1600	1600	Very fast-quality film. Can be rated at ISO 400 or 800 for finer grain
Kodak Recording Film 2575	4000	Best rated at ISO 1600 when grainy effect required. Otherwise, use Kodak TMX-3200.
Kodak TMX-3200	3200	High resolution despite very high speed. Crisp grain. Best results with Kodak T-Max developer.

Infrared film

This film is sensitive to light wavelengths at the near-infrared end of the spectrum and produces unusual, often striking, images. Green grass or foliage and faces become pure white, while blue skies turn almost black. The landscape above was shot on Kodak High-Speed Infrared film. A No. 25 filter was used to absorb all but the infrared wavelengths, intensifying the film's effect. The sky appears far more contrasty than it would have done on normal panchromatic (sensitive to all colours) black and white film. Although it was a misty day, the film has recorded mountains barely visible to the eye. Infrared film must be loaded and unloaded in darkness and transported in its container as it can become fogged.

35

Formats

Most amateurs use only one camera, usually the highly versatile and convenient 35 mm. Many professionals, too, do much of their work with this format, not least because the sharpness of the lenses and the high image quality of black and white films makes it possible to produce large prints that are very sharp and grain-free.

Medium-format cameras are mostly of the 6 × 6 cm ($2\frac{1}{4}$ × $2\frac{1}{4}$ in) type, but 6 x 7 cm ($2\frac{1}{4}$ × $2\frac{1}{2}$ in) and 6 x 4.5 cm ($2\frac{1}{4}$ × $1\frac{3}{4}$ in) cameras are also available. Their larger negative size allows them to capture greater shadow detail and render tones more smoothly than 35 mm cameras. Larger formats give high image quality but are not as commonly used because they are less convenient.

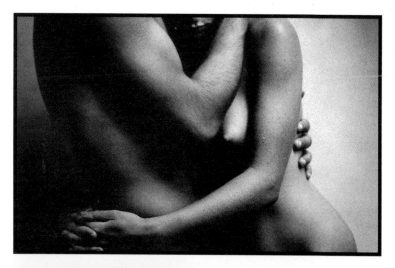

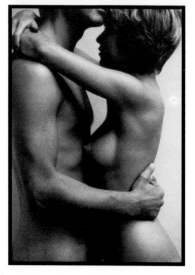

Compositional variety
Because of its rectangular 3:2 proportions the 35 mm frame provides widely differing compositional possibilities. A vertical format was ideal for the pose on the left, but a casual switch to the horizontal format for the shot above prompted me to close in on the figures and spread them to make use of the width of the frame. You will often find that a composition that works well one way is even stronger when the camera is turned around. Because of the versatility of the format, its convenience and the wide range of lenses available, I shot more than three-quarters of the photographs in this book on 35 mm.

Excellent image quality
The larger image above was shot on a 5 × 4 in (12.5 × 10 cm) camera. These, like 10 × 8 in (25 × 20 cm) models, produce excellent images because the degree of enlargement is less than with smaller formats. Their rendering of tones and of minute detail is superb. They also allow frontal adjustments to correct horizontal and vertical perspective

distortion. The sheet film used in these cameras allows each frame to receive individual attention in the darkroom. The main drawback of the format is its weight. The medium-format inset above exploits the 6 × 6 cm ($2\frac{1}{4}$ × $2\frac{1}{4}$ in) frame to the full. Using the square format to enclose rectangles, circles, triangles is a compositional challenge.

Composition

The true power of a successful picture lies in the combination of a strong subject and a strong composition – what you choose to leave out can be just as important as what you include. Until well into the twentieth century composition in photography was dominated by the compositional principles of painting; that is, by the way that the unaided eye sees the subject. But with the introduction of wide-angle lenses, with their extreme perspective, and telephoto lenses, with their ability to compress subject planes, photography began to create its own rules of composition (discussed on the following pages), even reversing earlier trends by in its turn influencing painters. Deployment of shapes is only one of the skills of composing a successful picture in black and white. Effective composition requires first of all the ability to see the subject as tones. Once you can do this you will be able to arrange the tones within the picture so that they relate expressively to one another.

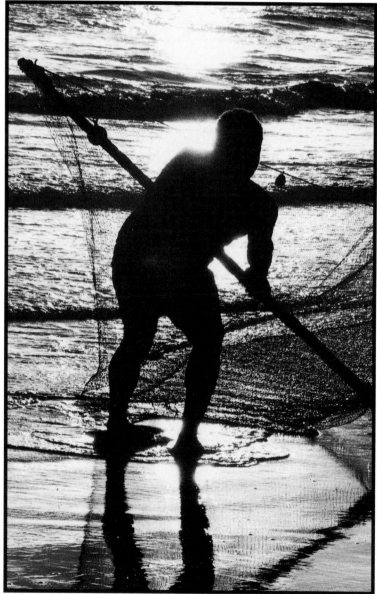

Exploiting tonal distribution

Many pictures that appear spontaneous in reality often require careful planning. Street scenes are a good example of this – I was attracted to this one by its extreme tonal range, which I enhanced by using a red filter. But although the tonal contrast made a good composition, the picture still needed a focus of interest. I had noticed the occasional passerby going home from work, so, with the camera set up on a tripod, I captured this man as he reached the end of the curved shadow area. His presence greatly strengthened the composition in terms of tonal distribution and provided the missing focal point.
Nikon F3, 24 mm, Kodak TMX 100, 1/125 sec., f8. Red filter.
PROCESSING: Kodak T-Max.
PRINTING: Grade $2\frac{1}{2}$ (Multigrade); 14 secs., f8; wall burned-in 5 secs.

Planning a composition

To provide a contrast with the strong diagonal of the net's handle, I waited until the waves formed evenly spaced horizontal bands before shooting.
Nikon FE, 80-200 mm zoom at 180 mm, Ilford HP5, 1/500 sec., f16.
PROCESSING: Ilford Microphen.
PRINTING: Grade 3; 8 secs., f8; water highlights burned-in 20-60 secs.

Highlighting the subject

To draw attention to this surfer in Hawaii I used a very long lens and positioned him in the top right corner of the frame, following the Rule of Thirds (see box, right). This composition gives the figure greater visual impact than if it had been centrally framed. Another reason for not always composing the picture with the subject in the center of the frame is that it can limit your scope, when using black and white film, to achieve an interesting tonal relationship in the picture. In this shot the relatively restricted area of white foam highlights the subject and contrasts effectively with the darkness of the sea and sky. Also, because it leads the eye out of the picture, it reinforces our sense of the surfer's headlong plunge.

Nikon F2, 1000 mm (mirror lens), Ilford HP5, 1/1000 sec., f11.
PROCESSING: Kodak D-76.
PRINTING: Grade 3½ (Multigrade); 10 secs., f8; bottom third burned-in 15 secs.

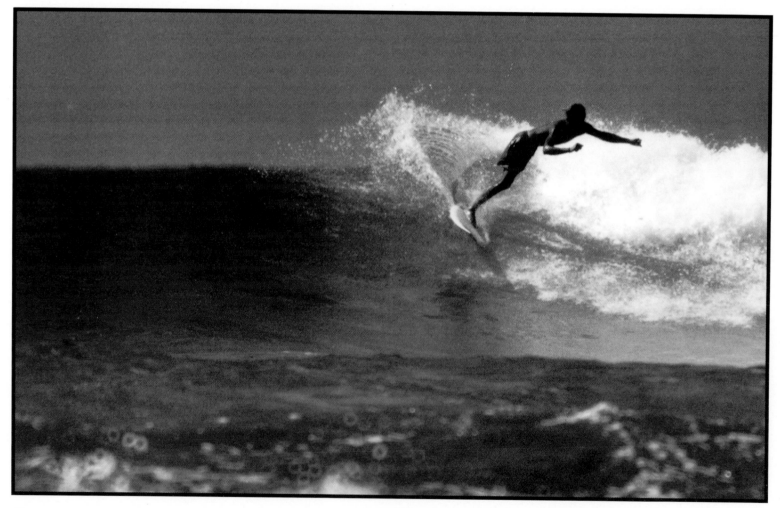

Rule of Thirds

Visualize the frame divided into thirds vertically and horizontally, as in the diagram on the opposite page. Each of the four points at which vertical and horizontal lines intersect is a strong position for the main subject. In a scene with more than one focus of interest, the Rule of Thirds is still a reliable guide to composition, since the subject elements can be centered on any of the four points.

Telling a story

When the aim of the picture is to encapsulate a story there is no point in placing the subject in a particular part of the frame unless the remaining area works narratively and compositionally. Placing the diminutive Soviet gymnast Olga Korbut in the bottom third of the picture, with the great parallel bars looming above her, was a logical and expressive way of conveying the mood of the event. I shot many pictures of her routine, but this one seemed to convey what it must be like to face the challenge of the bars as a world-class gymnast. Restricting her to the lower portion of the frame emphasized her smallness and apparent vulnerability, and seemed the best composition to stress her drawn-in stance.

I had no doubts about shooting in black and white, since the colours in the crowd and the gymnast's red leotard would have distracted the eye from the real subject of the picture – the tension and concentration in her face and body. Nikon F2, 180 mm, Ilford HP5, 1/60 sec., f2.8.
PROCESSING: Ilford Microphen, pushed 1 stop.
PRINTING: Grade 3½ (Multigrade); 8 secs., f8; face shaded 2 secs., background burned-in 4-12 secs.

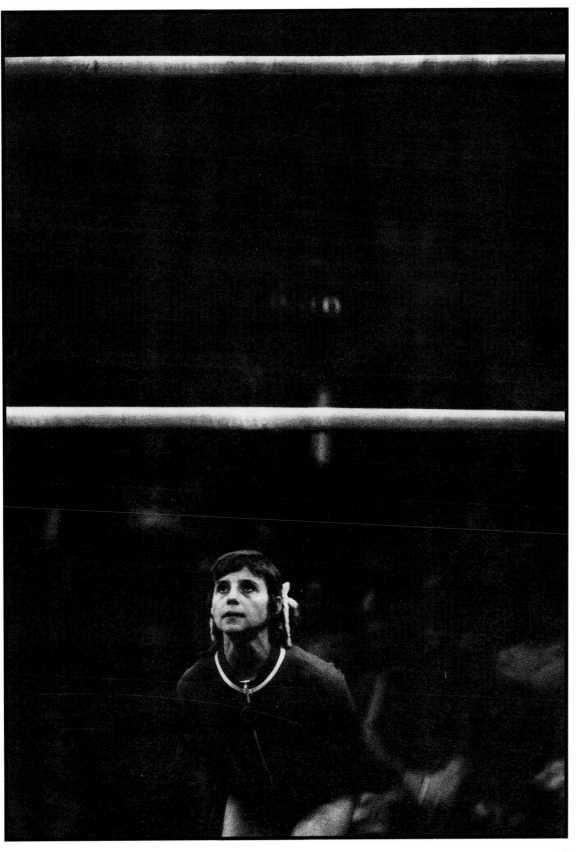

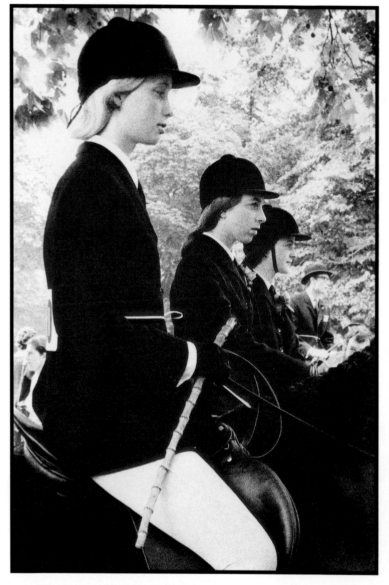

Experimenting with perspective

Early painting and drawing reveal no grasp of perspective. But, once mastered, the skill played an important role in art for several hundred years. Only in this century has conventional perspective ceased to be regarded as sacrosanct. The photographer can experiment in this area very easily, for simply changing lenses (or using a zoom lens) brings about an instant change in perspective. The longer the focal length, the more foreshortened the perspective. In the picture below a 400 mm telephoto lens has dramatically reduced the distance between the "toreador" and his adversary – in reality about 50 yards (45 m).

This trick was used for the purpose of creating a picture story and refutes the notion that the camera never lies.
Nikon FE2, 400 mm, Ilford HP5, 1/250 sec., f11.
PROCESSING: Ilford Microphen.
PRINTING: Grade 3 (Multigrade); 12 secs., f8; cow shaded 3 secs.

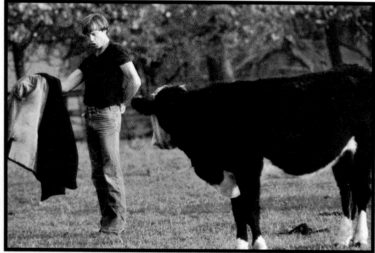

Composing with normal perspective

A standard or "normal" lens – 50 mm for a 35 mm camera (80 mm for a $2\frac{1}{4} \times 2\frac{1}{4}$ in/6 × 6 cm camera) – gives roughly the same perspective as the unaided eye. For this shot of horsewomen in London's Hyde Park I wanted to convey the repetition of receding forms without distorting the perspective, so I used a standard lens. Shooting in black and white allowed me to concentrate on the shape of the figures and their relationship to each another, rather than give a detailed description that included colour.
Nikon F, 50 mm, Ilford HP4, 1/125 sec., f11.
PROCESSING: Kodak D-76.
PRINTING: Grade 2; 15 secs., f8; faces burned-in 4-8 secs.

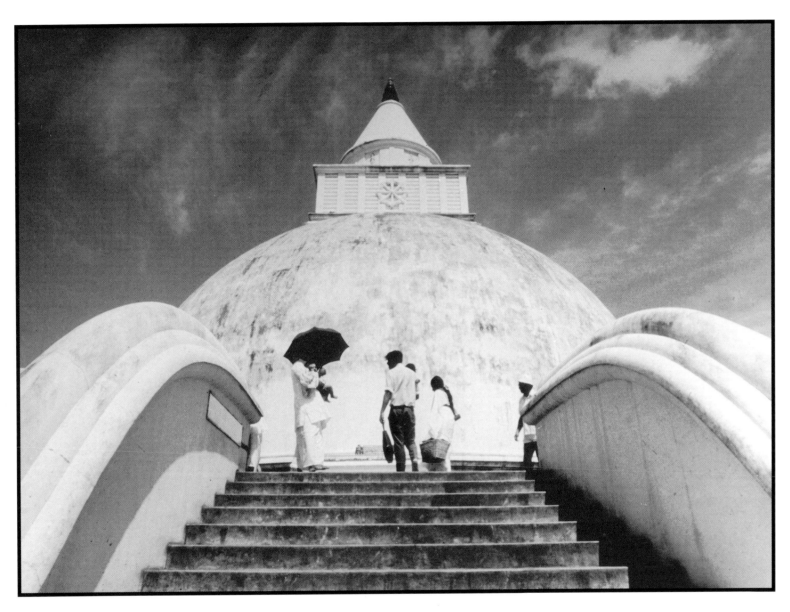

Exaggerating perspective

To create a composition that emphasized what I felt to be the spirit of the place, I photographed this Buddhist temple in Sri Lanka using a 24 mm wide-angle lens. This exaggerated the sweeping curves of the imposing entrance and reproduced the temple proportionately smaller than it appeared to the naked eye. Wide-angle lenses separate the subject planes, creating a sense of space and amplitude, and so are particularly useful for impressionistic or flattering pictures of buildings.
Nikon FE, 24 mm, Ilford FP5, 1/125 sec., f11.
PROCESSING: Kodak D-76.
PRINTING: Grade 2 (Multigrade); 12 secs., f8, both edges of entrance burned-in 4 secs.

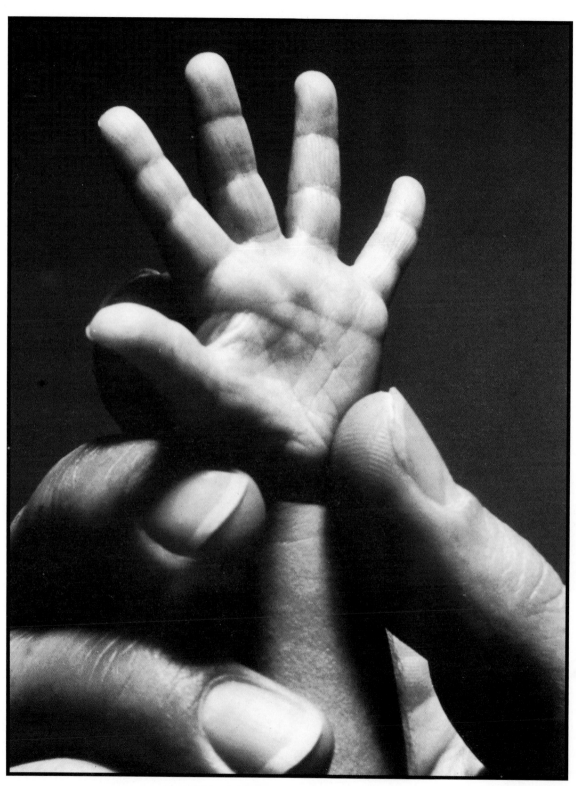

Scale as subject

We can marvel at the smallness of a baby's hand, but words can never convey it as graphically as a photograph. I shot in colour and black and white. The latter had far more presence. To freeze movement and to allow enough depth of field I used flash, bouncing it off an umbrella above the subject.

Dare to keep your composition more simple than seems prudent – it will usually pay off.
Nikon FE, 80-200 mm zoom at 120 mm, Ilford HP5, 1/125 sec., f16.
PROCESSING: Ilford Microphen.
PRINTING: Grade 2 (Multigrade); 14 secs., f8; palm shaded 4 secs., fingernails burned-in 3-7 secs.

Using an indicator of scale

OPPOSITE: *Paradoxically, because of its relative insignificance, the white dot on the road that winds through Monument Valley, in the USA, is a powerful compositional device. We all know the size of a truck, and can therefore comprehend the vastness of the scene. Shot without a familiar indicator of scale – a person, a house, a cow or horse – landscapes often have less impact, not allowing us to grasp so readily what it would feel like to be there. Where the sheer scale is the motivation for the photograph, colour becomes an optional element. Here, the dramatic shapes and the tonal contrast were best rendered in black and white.*
Nikon F2, 24 mm, Ilford HP5, 1/500 sec., f5.6. Red filter.
PROCESSING: Ilford Microphen.
PRINTING: Grade 2½ (Multigrade); 16 secs., f8; truck burned-in 8 secs., right side of sky burned-in 4 secs.

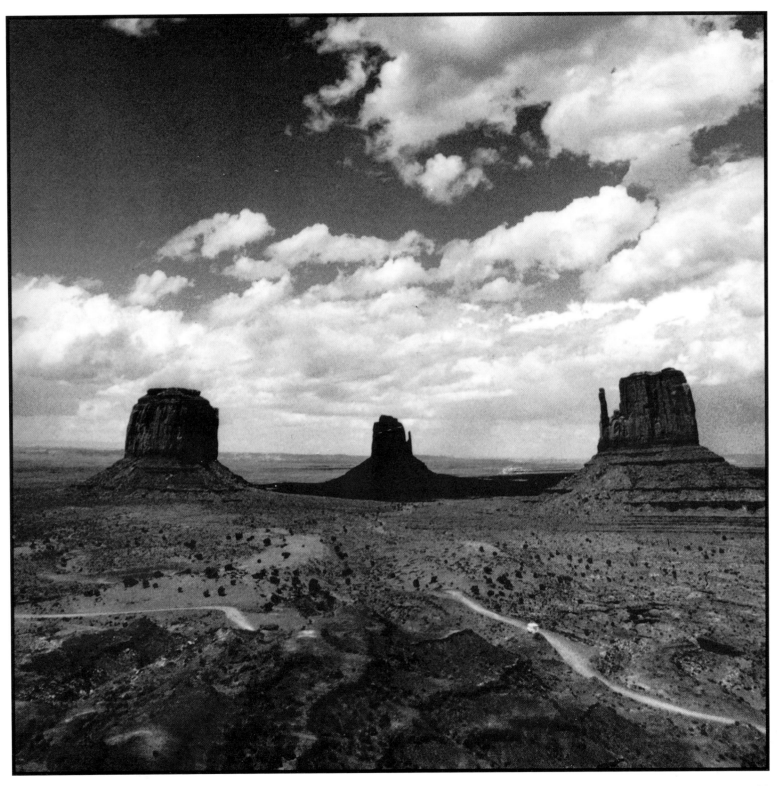

Tonal economy

One of the greatest strengths of using black and white film is that you can create a powerful image with a limited range of tones. To illustrate this, I made this print from a colour transparency of monks bathing at sunset in a Sri Lankan lake. In the original I had chosen to depict their expressive shapes by rendering them as silhouettes. I exposed for the highlights in the water so that the rest of the scene was underexposed. In the print, with no colour at all, the silhouettes had even greater immediacy.

However, both in black and white and colour tonal economy demands a strong composition. When silhouettes are seen against a light ground both the shapes themselves and the relationship created by the spaces between them are important compositionally. Therefore, when I took the original picture I waited for a pleasing configuration before releasing the shutter. The bathers form a gentle "V."
Nikon F2, 35-105 mm zoom at 35 mm, Ilford FP4 interneg from Kodak Ektachrome-X original, 1/125 sec., f8.
PRINTING: Grade 4 (Multigrade); 8 secs., f8; sky burned-in 6 secs.

Printing to minimize tonal range

OPPOSITE TOP: *The negative of this stark scene, in which a Kenyan man contemplates a tree, offered no sky tone. It thus provided a good opportunity to make a highly graphic image by printing for a minimal tonal range. Results of this kind are very much a darkroom creation. To produce a suitable negative you must learn to predict, when you make the original exposure, how the tones will work in the print.*
Nikon F2, 80-200 mm zoom at 100 mm, Ilford HP5, 1/500 sec., f11.
PROCESSING: Kodak D-76.
PRINTING: Grade 4 (Multigrade); 25 secs., f11; right side of light ground shaded 6-12 secs., sky shaded 8 secs.

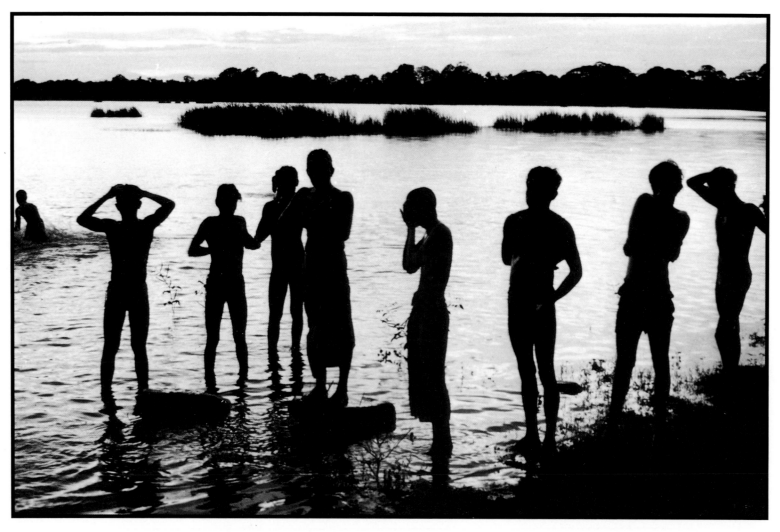

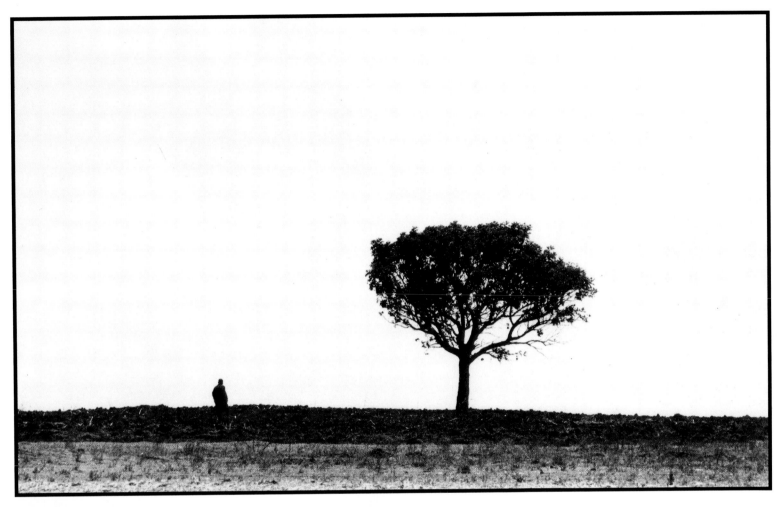

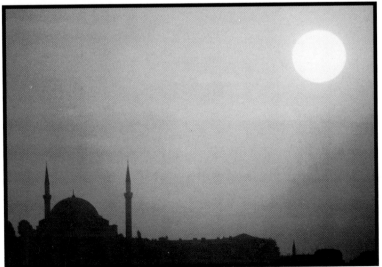

Composing with light

For this photograph of a sunset over Istanbul I used a 500 mm lens to dramatically increase the size of the sun relative to the mosque. Its immense radiance, illuminating the minarets, provides a simple but strong subject that is perfectly suited to depiction in black and white.
Nikon F2, 500 mm, Ilford HP5, 1/1000 sec., f8.
PROCESSING: Kodak D-76.
PRINTING: Grade $2\frac{1}{2}$ (Multigrade); 6 secs., f8; sun burned-in 15 secs.

Using a high camera angle
This view of the arrest of an anti-apartheid demonstrator at Twickenham rugby stadium, London, resulted from my dissatisfaction with the lack of impact provided by a ground-level camera position. I went up into the stand, where the high angle allowed me to dramatize the scene by composing it as a triangle (of police) pointing toward the main subject (the arrested man). This change of viewpoint sharpened my perception of the scene so that not only was the composition strengthened, but the shot reflected the mood more accurately by depicting the demonstrator as small and helplessly outnumbered.
Nikon F2, 105 mm, Ilford HP5, 1/250 sec., f8.
PROCESSING: Ilford Microphen.
PRINTING: Grade 3½ (Multigrade); 15 secs., f8; black shadows in police burned-in 3-15 secs.; print flashed during development for background details.

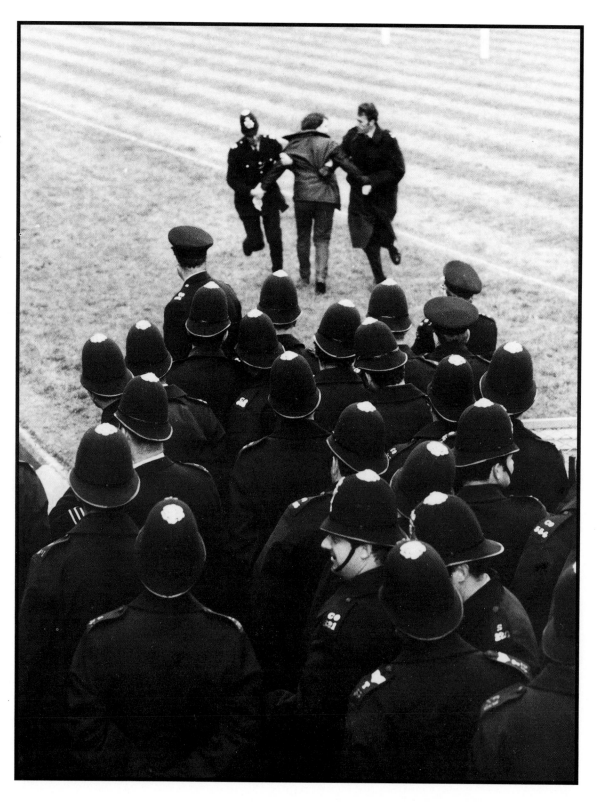

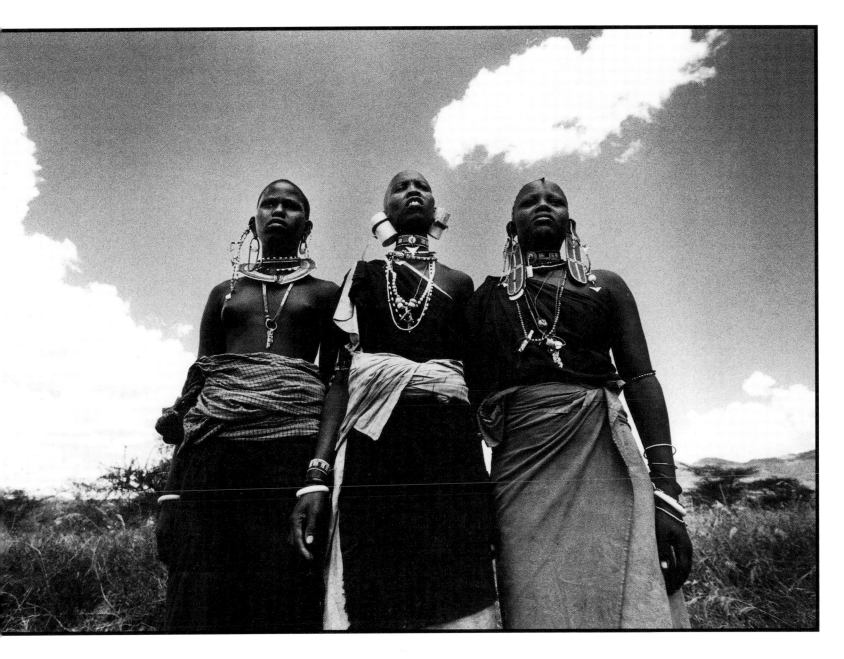

Using a low camera angle

I adopted a low position for this picture of Masai women of the Serengeti Plain in Tanzania as it seemed the most effective way to describe their dignity and self-possession. Because I did not know them personally, it was more appropriate to depict the women's common characteristics rather than try to capture their individuality. The camera angle helped me in this aim by creating an imposing, sculptural group that for me symbolized Masai womanhood. The subject nearly always gains power and impact when it is pictured from a low angle.

Nikon F2, 24 mm, Ilford HP5, 1/250 sec., f11. Orange filter.
PROCESSING: Ilford Microphen.
PRINTING: Grade 3½ (Multigrade); 12 secs., f8; figures shaded 4 secs., sky burned-in 6-10 secs.

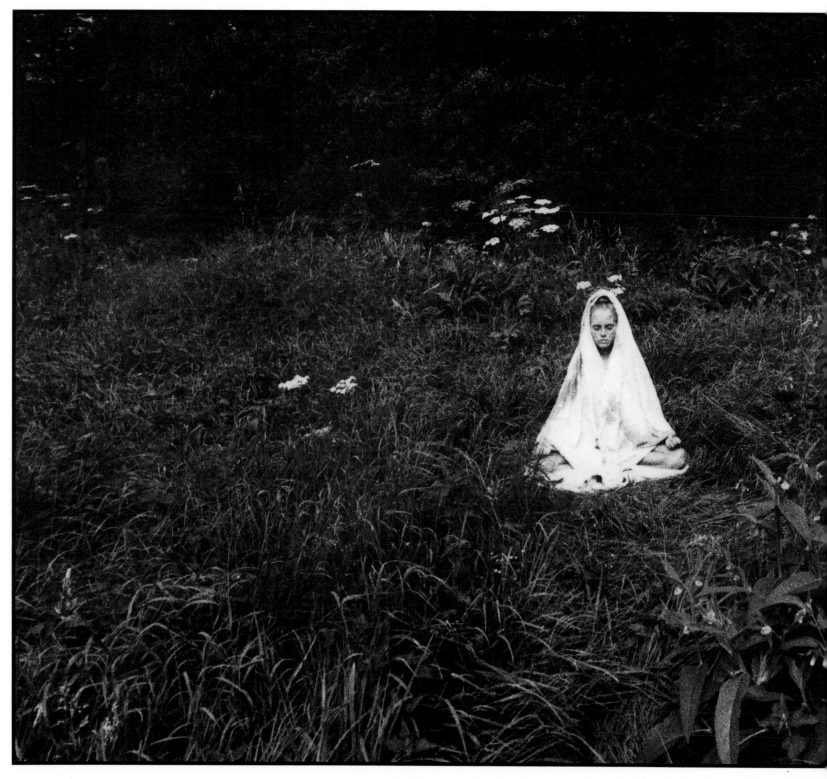

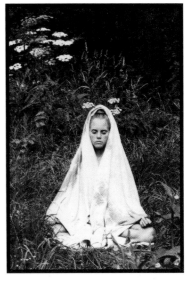

Varying the framing

These two studies of a young woman meditating show how you can improve the composition by changing lenses and thus varying the framing. In the small picture, above, taken with a 180 mm lens, the composition places the meditator firmly on the ground. For the version on the left I switched to a 28 mm lens, so that she was framed as a small, light, triangular shape seemingly floating in a dark rectangle. A red filter emphasized the contrast between the light figure and the dark surroundings. The composition, with cropping, was much more sympathetic to the feeling of the situation than my first attempt.

SMALL PICTURE: Nikon FE, 180 mm, Ilford HP5, 1/250 sec., f8.
PROCESSING: Ilford Microphen.
PRINTING: Grade 3 (Multigrade); 12 secs., f8.
LARGE PICTURE: Nikon FE, 28 mm, Ilford HP5, 1/60 sec., f8. Red filter.
PROCESSING: Ilford Microphen.
PRINTING: Grade $2\frac{1}{2}$ (Multigrade); 8 secs., f8; figure burned-in 5 secs.

Composing with triangles

Painters have long found the triangle a potent and pleasing compositional device. In photography, too, it is used to strengthen the composition. In this picture, taken at a London Underground station, the perspective lines of the walls converge dramatically, forming triangles that draw the eye into the picture. The symmetrical and tonally contrasting arrangement of the dark triangle of the stairs framed by the strong triangles of the walls, gives a monumental dimension to an everyday scene. The arch softens the scene by introducing a different shape, but does not lessen the impact of the triangles.

Nikon FE2, 50 mm, Kodak TMX 100, 1/60 sec., f8.
PROCESSING: Kodak T-Max.
PRINTING: Grade 2½ (Multigrade); 15 secs., f8; steps shaded 5 secs., right side burned-in 4 secs.

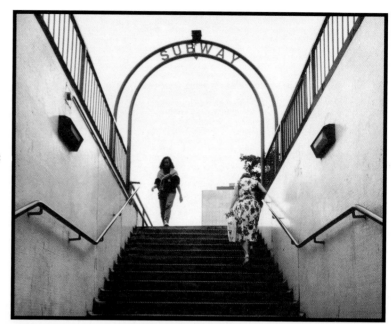

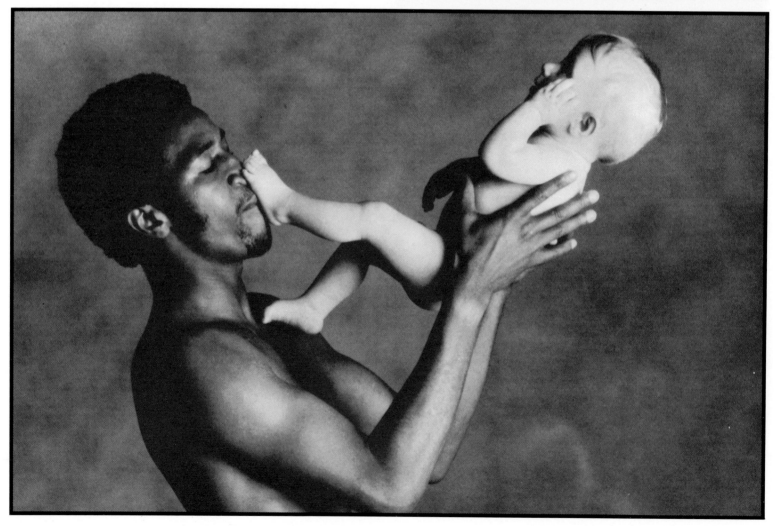

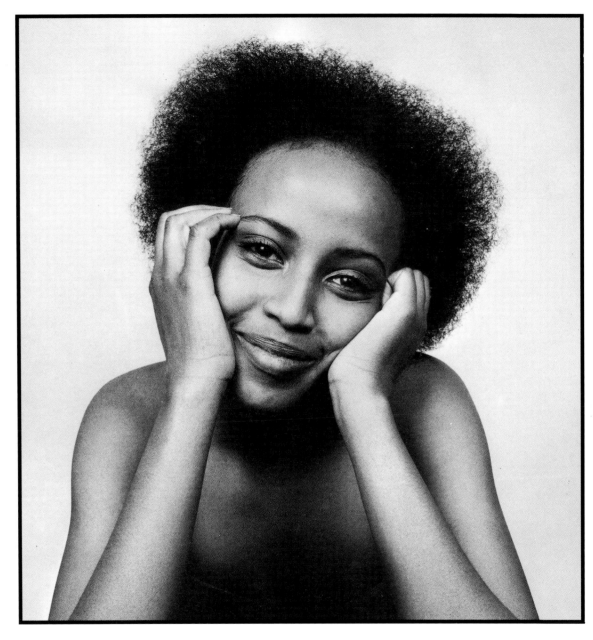

Complementary triangles

This portait of Selina does not rely for its effect solely on her beauty. The composition is given strength by the simple device of a large outline triangle (the head and body) with a smaller, inverted triangle (the head framed by the hands) inside it. The square format of the $2\frac{1}{4} \times 2\frac{1}{4}$ in (6 x 6 cm) camera was exactly what I wanted for this composition. The exploration of complementary shapes needed no colour. Studio flash provided the lighting.

It may seem like a rather mechanical approach, but if you analyze your subject, whether it is a person or anything else, as shapes, you will then be able to arrange these so as to strengthen the composition. If I had included more of Selina's body, the balance between the triangles would have been lost.

Hasselblad, 80 mm, Ilford FP4, 1/250 sec., f11.
PROCESSING: Ilford Microphen.
PRINTING: Grade 3 (Multigrade); 15 secs., f8. Print flashed during development.

Using triangles for unity

OPPOSITE BOTTOM: *The inverted triangles suggested by the man's arms and the baby within them echo one another and their relationship underlines the picture's emotive message of support and dependence. Triangles form the heart of the composition and hold it together, leaving no unconnected or distracting elements. Black and white was the obvious choice for this picture because the strong tonal differences serve to play one triangle off against the other and remind us of the human component. Studio flash was used to light the shot and the background was sprayed with pressurized paint to give a mottled effect.*

Nikon F3, 80-200 mm zoom at 120 mm, Ilford HP5, 1/60 sec., f8.
PROCESSING: Kodak D-76.
PRINTING: Grade $2\frac{1}{2}$ (Multigrade); 8 secs., f8; baby burned-in 6-20 secs.

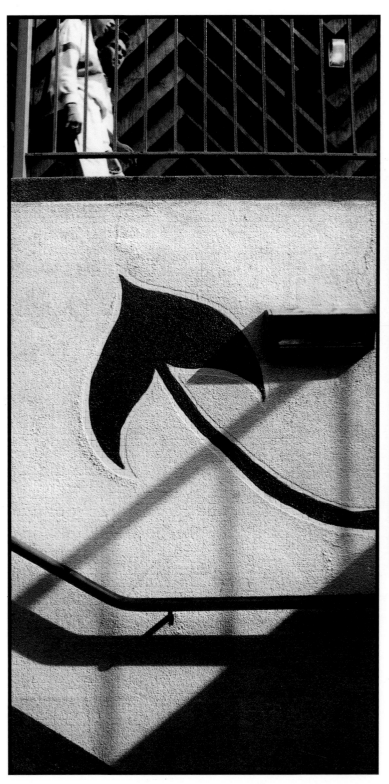

Pattern and contrast

At a London Underground station I was struck by the contrast between a tight vertical and diagonal pattern and the softer, organic lines of the stylized exit sign below it. To depict the repeated shape that forms a pattern or, as in the shot on the left, to also contrast it with adjacent shapes, an effective approach is to reduce the scene to black and white. The composition will be all the stronger without the unnecessary component of colour.
Nikon F301, 28 mm, Kodak TMX 400, 1/250sec., f8.
PROCESSING: Kodak T-Max.
PRINTING: Grade 2½ (Multigrade); 12 secs., f8.

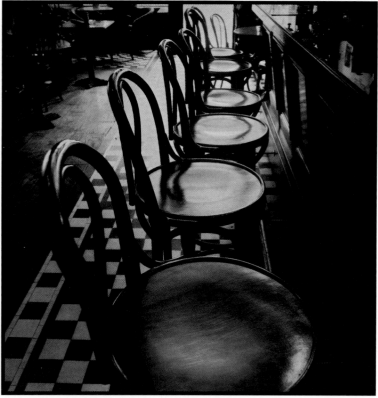

Geometrical patterns

Patterns, both natural and manmade, occur everywhere and by looking carefully you will spot their compositional possibilities. In a café near my home I noticed this random scattering of circles on a formal ground – a picture made for black and white. Repetition, the essence of pattern, always compels the eye, but this composition gains additional strength from the use of a camera angle that stresses perspective. The square picture format reinforces the interplay of circles and squares.
Hasselblad, 50 mm, Kodak TMX 100, 1 sec. (with tripod), f16.
PROCESSING: Kodak T-Max.
PRINTING: Grade 2½ (Multigrade); 8 secs., f5.6; progressive burning-in (from second chair back) of 3-20 secs.

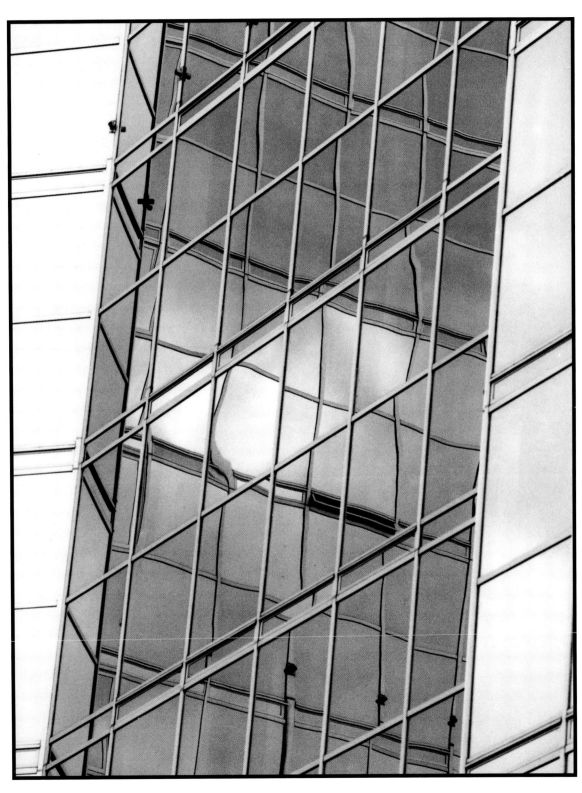

Manipulating pattern

An important part of the photographer's skill lies in isolating an interesting pattern from a welter of visual information and then composing the picture to best depict it. But a further exercise is to modify a pattern imaginatively. For this picture I selected a promising section of an office building by zooming in and out from a fixed position with an 80-200 mm lens. I then tilted the camera to make the strong verticals run diagonally. I included the distorted reflections of the window frames for the relief they introduce to the otherwise uniform design.

There was nothing to be gained by shooting in colour – the regular shapes formed by the intersecting lines are the subject.

Nikon FE2, 80-200 mm zoom at 180 mm, Kodak TMX 100, 1/250 sec., f5.6.
PROCESSING: Kodak T-Max.
PRINTING: Grade $3\frac{1}{2}$ (Multigrade); 15 secs., f8.

Broadening the picture

I could have photographed these Kenyan children from a closer viewpoint, without including much background, for they made a touching little group. But often you can make a picture of people of any age more telling by suggesting something of their daily life. So I reframed the shot to include the blackboard. Apart from enabling me to tell the story of their "Number-Work," or arithmetic lesson (they had just learned that 2 + 2 = 4), this juxtaposition produced a more interesting composition. Together, the two elements, one vertical and one horizontal, emphasize the smallness of the children and perhaps remind us of the power that the blackboard possesses when we are young.

Nikon F, 28 mm, Ilford HP4, 1/60 sec., f4.
PROCESSING: Ilford Microphen.
PRINTING: Grade 3; 8 secs., f8; left side burned-in 20 secs., right side burned-in 10 secs.

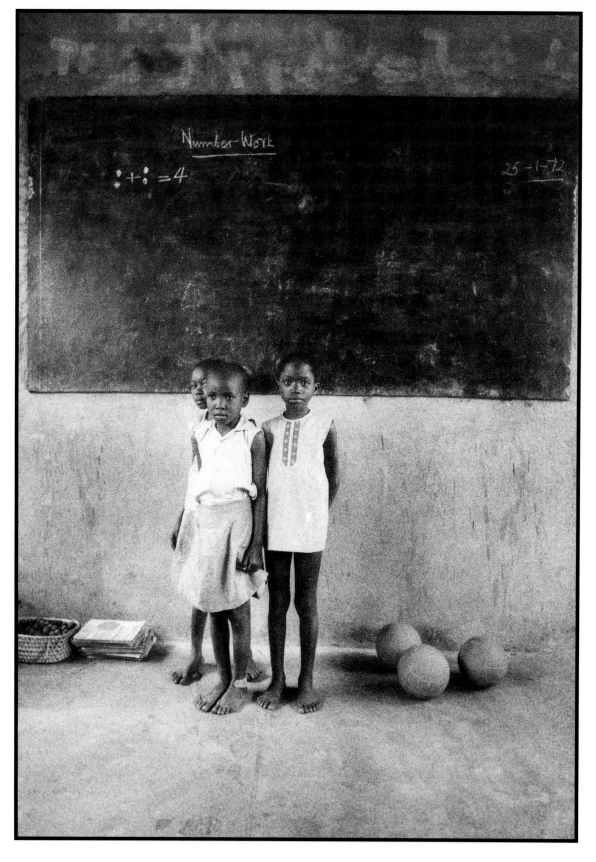

Combining picture elements

Lost in her own thoughts, the girl sat in the café beneath the huge image of the clown, unaware of his mocking smile. Separately, the girl and the clown were not worthy of a picture. Juxtaposed, the two very different moods produced an expressive composition. When a subject catches your eye but seems to lack something, widening your view with a different lens or changing position can reveal a stronger composition. Here, it is the contrast in mood between the elements that provides a picture.

Nikon F2, 105 mm, Ilford HP5, 1/30 sec., f5.6.
PROCESSING: Ilford Microphen, pushed 1 stop.
PRINTING: Grade 1½ (Multigrade); 13 secs., f8; highlights burned-in 3-12 secs.

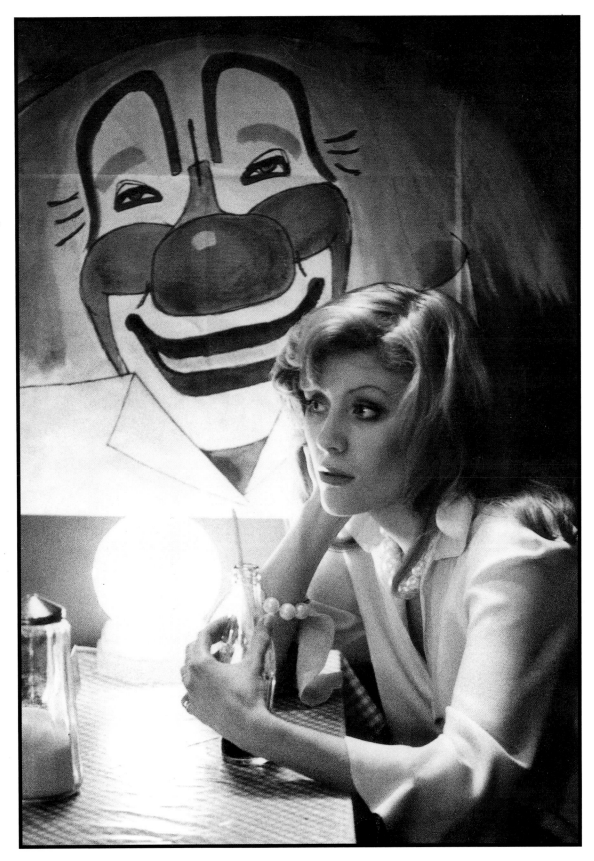

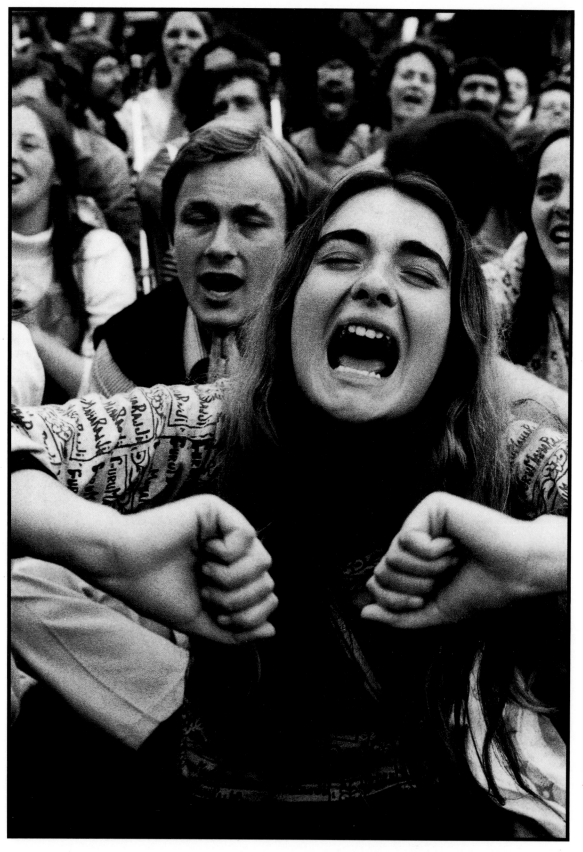

Symbolizing tension

I don't know what emotion this girl was experiencing in the presence of the Guru Maharaji Jai, but it looked like an attempt to break out. I used a wide-angle lens at close range. By emphasizing the perspective, this viewpoint draws the eye both to the girl's contorted face and to the extreme tension in her outstretched arms and clenched fists. I cropped in close on her hands so that she seems to be bursting out of the frame itself. The composition echoes the scene's emotional content. Nikon FE, 24 mm, Ilford HP5, 1/60 sec., f5.6.
PROCESSING: Ilford Microphen.
PRINTING: Grade 3 (Multigrade); 12 secs., f8; hands burned-in 5 secs.

Using space to create tension

OPPOSITE BOTTOM: *Many compositions derive their strength from the careful depiction of the space that exists between elements of the picture. Here, it is not so much the combative stance of the dogs, their dark shapes against a lighter background, or the fact that their owners are only half revealed, that produces a mood of bristling tension. More important is the diagonal space between the dogs, defined by the strong line of the paving stones and leading the eye from one animal to the other.* Nikon FE, 35-105 mm zoom at 40 mm, Ilford HP5, 1/250 sec., f8.
PROCESSING: Ilford Microphen.
PRINTING: Grade 2; 14 secs., f8.

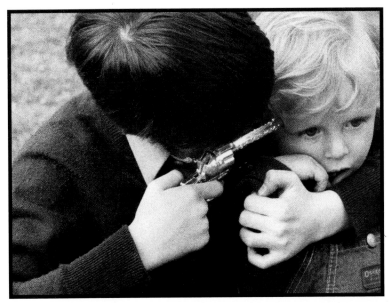

Dramatic cropping

I originally photographed this "stick-up" as a vertical picture, but the art director of the German magazine Stern *gave it far more drama by cropping it as a horizontal. In this way the younger boy's face was pushed to, and held in by, the edge of the frame, so that there seemed to be no escape. His plight is also emphasized by the tonal structure of the composition, since his light face is imprisoned by large areas of dark tone.*

This sort of scene calls for a quick reaction, but if there is time take several frames so that you can compose the picture in a variety of ways, then select the one that conveys tension most effectively. Of course, like me, you may discover that the final print itself can be improved by judicious cropping.
Nikon FE, 105 mm, Ilford HP5, 1/125 sec., f8.
PROCESSING: Ilford Microphen.
PRINTING: Grade 3; 8 secs., f8; hands and gun burned-in 6-14 secs.

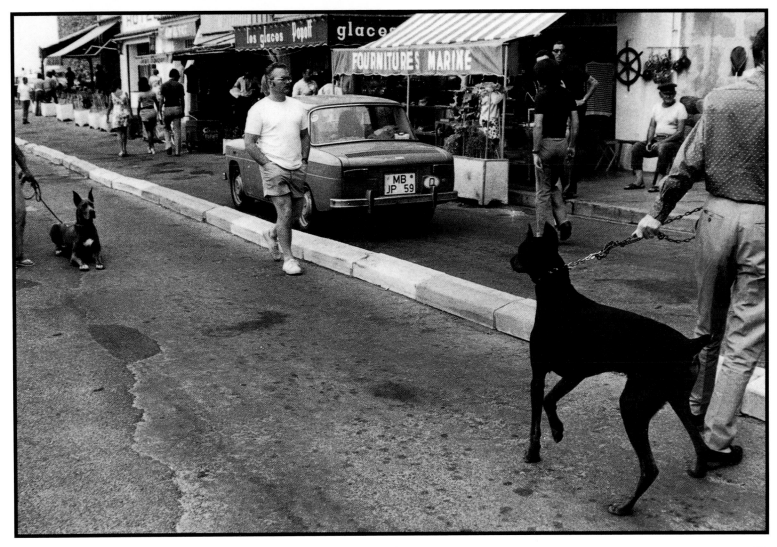

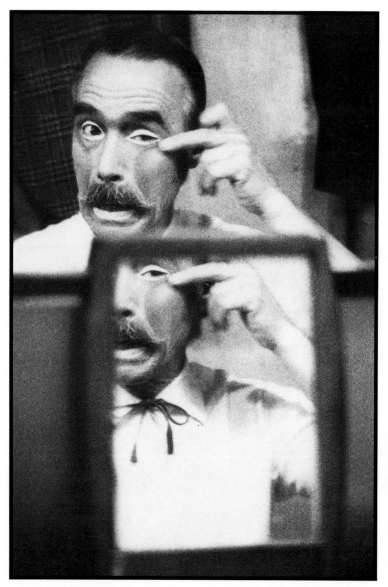

Incorporating a mirror image

I have always been drawn to scenes which contain an echo or reflection of the main subject. Here the eye goes from the circus clown to the image in the mirror, and back again, having gained a different view of the whole picture. For me, the reflection is more interesting than the real face because, cut in half, it relies on suggestion for effect and because it is framed more boldly. Visual play of this kind needs no more than tones to make its point; the effect would have been less immediate in colour.
Nikon FE, 50 mm, Ilford HP5, 1/30 sec., f8.
PROCESSING: Ilford Microphen.
PRINTING: Grade 2; 15 secs., f11; mirror image burned-in 12 secs., hand and background light burned-in 7 secs.

Frame inside a frame

When I took this picture I did not notice that the top, darker half of the man was framed by the shutters. But later, when struggling to print the subtle tonal separation, I realized that the composition was stronger than I had thought. Composing in black and white is a challenge because of the film's ability to heighten the tonal contrast that the naked eye misses.
Nikon F2, 35-105 mm zoom at 85 mm, Ilford HP5, 1/500 sec., f11.
PROCESSING: Ilford Microphen.
PRINTING: Grade 2 (Multigrade); 15 secs., f8; face shaded 5 secs., shirt shaded 4 secs. Print flashed during development.

Two images – one idea

These two old men were sitting near to one another in a town square in Greece, obviously preferring company of sorts to sitting alone at home. But they were isolated by their memories. The dominant pole and its shadow provided a strong compositional device, dividing the picture into two self-contained portraits. At the same time it seemed, like the men themselves, to disprove the idea that "No man is an island."

Apart from conveying the extreme tonal range in the most simple and direct way, black and white film seemed to be ideally suited to capture the reflective mood.
Nikon FE, 35-105 mm zoom at 90 mm, Ilford HP5, 1/500 sec., f11.
PROCESSING: Ilford Microphen.
PRINTING: Grade 3 (Multigrade); 10 secs., f8. Print flashed during development.

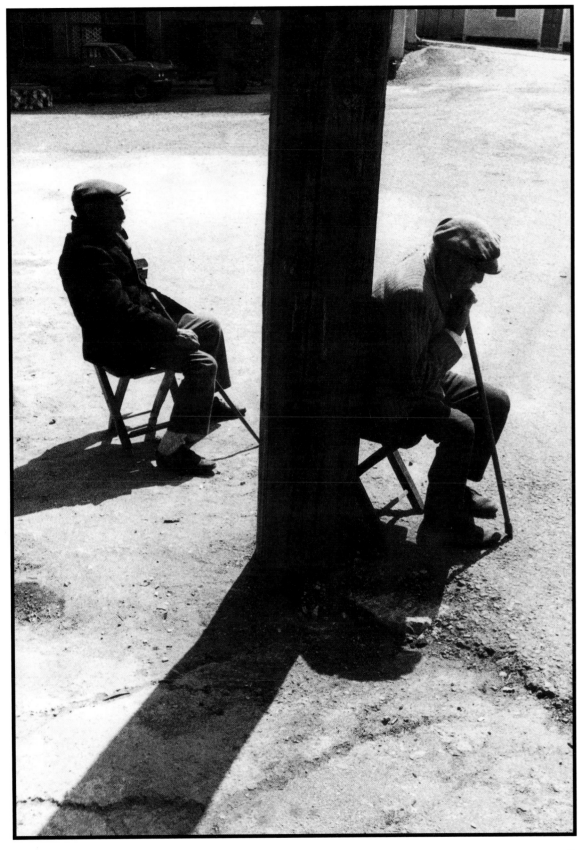

Composing a sequence

This picture story, showing the actors Felicity Kendall and Alan Bates sharing a joke, was shot during a pause in their rehearsal of Shakespeare's Much Ado about Nothing. *Still photography is in most cases about concentrating meaning in a single image, but there are times when a sequence works better. To make the story flow, it is best to retain the same basic composition in each frame. In this way the attention focuses on the changes of detail as the narrative unfolds – in this case, on the couple's facial expressions. Using the same composition, however, means that the first shot should be well-planned, otherwise its shortcomings will be reinforced by repetition. For me, an essential part of the composition of these pictures was the expanse of Bates's light-toned raincoat, which contrasts strongly with the dark clothes.*
Nikon FE2, 105 mm, Kodak TMX 3200, 1/125 sec., f5.6.
PROCESSING: Kodak T-Max.
PRINTING: Grade 2 (Multigrade); 8 secs., f8; coat and chairs burned-in 15 secs.

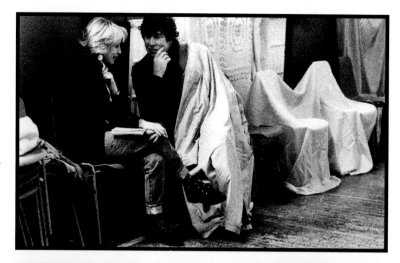

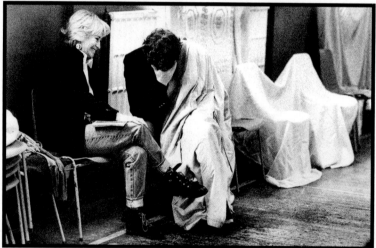

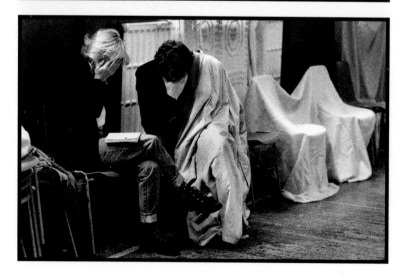

The Classic Themes

No photographer can hope to give equal attention to the whole range of subjects covered in the following pages, although enthusiastic amateurs will want at some time or other to explore most of these classic themes. In doing so they will learn skills that allow them to tackle a particular subject with confidence. These themes are not closed compartments – most techniques and approaches covered in one theme can be easily adapted to create a successful result with a subject that fits into another.

Portraits

If portraiture were simply a matter of creating an accurate record of the sitter, then the black and white photographer would be at a major disadvantage. But, far from colour being indispensable, a black and white portrait can have more power and authority than its colour counterpart, as I found when photographing the Masai warriors on p. 70. Often, we take colour portraits for granted as a straightforward likeness. By contrast, black and white photography's reduction to tones makes us pay attention to the contours of a face revealed by the play of light and shade.

The most successful portraits are those that do more than provide a likeness, capturing the subject's personality. Even the portrait of a stranger can have an emotive charge, simply because we glimpse the subject's character – or the photographer's view of it. The great American photographer Richard Avedon said of his stark, powerful portraits of the rich and famous, "They are pictures of me, of the way I feel about the people I photograph." Whether we endorse Avedon's philosophy or not, his statement hints at the influence a portraitist has on both medium and subject.

To make a good portrait you must be relaxed and confident enough of your technique to be able to give something of yourself. In what for most sitters is a daunting situation, the first task is to put the subject at ease, for the outcome of a portrait session depends as much on the atmosphere the photographer creates as on the lighting set-up. Technical considerations cannot be overlooked, but lighting and other arrangements should be prepared before the session and adjusted without disrupting it.

All portraiture except for the most informal requires the cooperation of the sitter, but it is the quality of the photographer's direction that is more important. Work out what you want to capture, preferably before the session, and do not be afraid to ask for it. Your confidence will draw out the nervous subject and allow you to make detailed observations about the sparkle in the eye, the expressive gesture, and so on.

Never think that black and white portraiture, with its apparent simplification compared with colour, is an easy option. The challenge is to use the gradations of light both to capture your subject's appearance and to reveal his or her inner self.

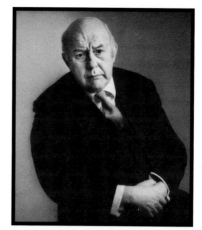

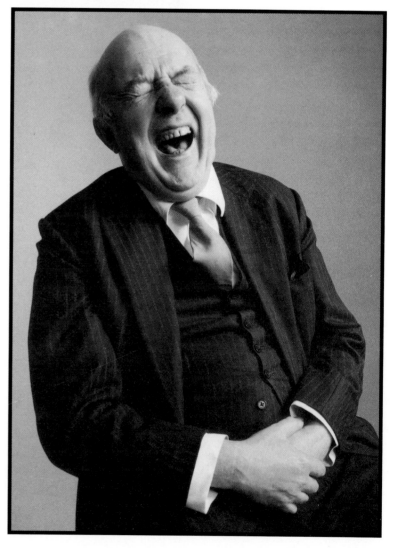

Lighting contrast
Two moods of the late Sir John Betjeman. For both shots I bounced studio flash off an umbrella and used a polystyrene board behind him to reduce the light reflected from the background onto his left side. Hasselblad, 65 mm, Ilford FP4, 1/250 sec., f8.
PROCESSING: Ilford ID-11.
PRINTING: Grade 3; 15 secs., f8; shadow side shaded 3 secs.

Interpreting personality

A portrait of the Australian painter Wes Walters. To capture the intensity of this man, I framed tight, showing nothing but the face. An ultra-sharp 105 mm macro lens picked up all the details in the skin revealed by cross-lighting from a large window. The result suggests a map of the path travelled through life by the sitter. If you intend to work as close as this, do not use a lens shorter than 80 mm, otherwise you will distort the face. Focal lengths between 105 mm and 200 mm are best for this sort of portraiture.

For me, this picture is an example of what photography can do much better than painting, and what black and white photography can do better than colour. Black and white creates an immediacy and authority, particularly with faces, that often surpasses that of colour. It also allows the photographer great freedom of interpretation. This is perhaps most true of the printing stage, when the density and tonal contrast that you produce in the print determine to a large extent how the the subject's personality is perceived by the viewer.

Nikon F2, 105 mm (macro), Ilford FP4, 1/60 sec., f5.6.
PROCESSING: Ilford Microphen.
PRINTING: Grade 3; 12 secs., f8; shadow area shaded 3 secs.

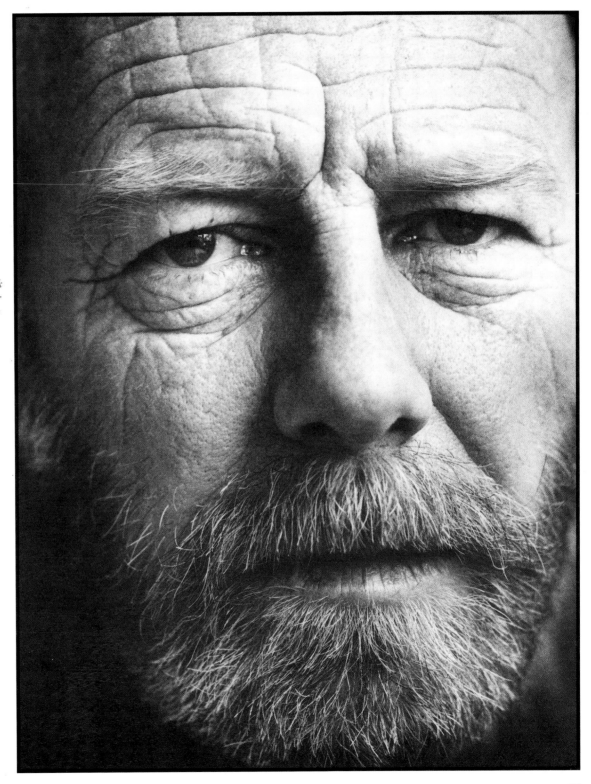

Emphasizing the face

The subject needed no adornment, and she was confident enough of her own beauty to allow me to use a single light source. A large umbrella covered with diffusing material was positioned at 30 degrees to the camera and threw light from a flash head onto the model's face, creating a classic V-shape of light around her right eye.

The hair and clothes form a simple dark frame that emphasizes the face. When you include hands in a portrait, it is best to show them in profile since their relative mass and lightness of tone can draw attention away from the face.
Hasselblad, 150 mm, Ilford FP4, 1/125 sec., f11.
PROCESSING: Ilford Microphen.
PRINTING: Grade 2½ (Multigrade); 12 secs., f8; model's left eye shaded 2 secs.

Keeping the composition simple

This double portrait of a brother and sister is an exercise in simplicity in both content and composition. Their denims give a unity of appearance without the diversion of detail. The art of dressing the model for portraiture is to take away rather than to add. The couple posed so naturally that I had only to move their hands and feet a little to strengthen what was already a simple but strong triangular shape.

The light from two studio flash heads was bounced into umbrellas covered with diffusing material which provided an almost shadowless illumination.
Hasselblad, 80 mm, Ilford FP4, 1/125 sec., f11.
PROCESSING: Ilford Microphen.
PRINTING: Grade 4; 12 secs., f8; boy's back shaded 3 secs., girl's foot burned-in 4 secs. Print re-exposed during development to give light-gray tone.

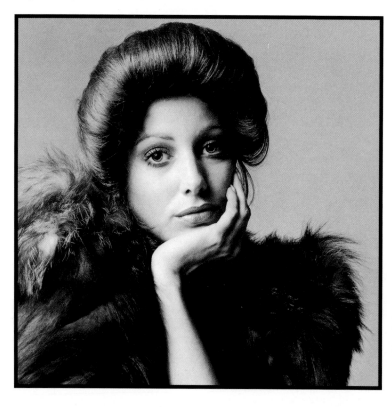

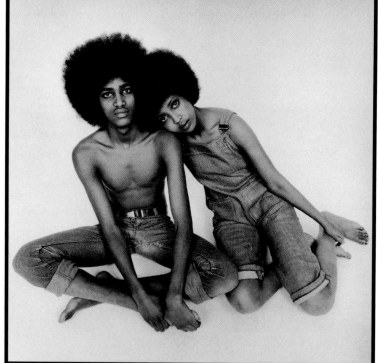

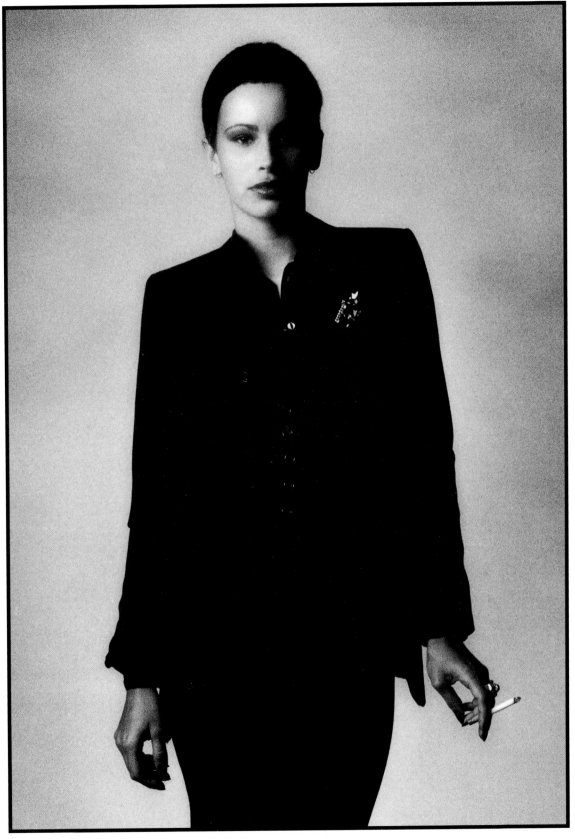

Portraying shape

The hint of masculinity conveyed by the dark trouser suit with waistcoat and the cropped hair only serve to underline the femininity of this model. This impression of female elegance also owes much to the fact that the picture is in black and white. Without the distraction of colour, the female stance and the shape and structure of the face are emphasized.

I lit the model with a single flash light reflected from an umbrella and used a filter on the lens to soften her outline.

Hasselblad, 150 mm, Ilford HP5, 1/125 sec., f16. No. 1 Softar filter.

PROCESSING: Ilford Microphen.

PRINTING: Grade 3 (Multigrade); 10 secs., f8; waistcoat shaded 4 secs., left-hand side of background burned-in 5 secs.

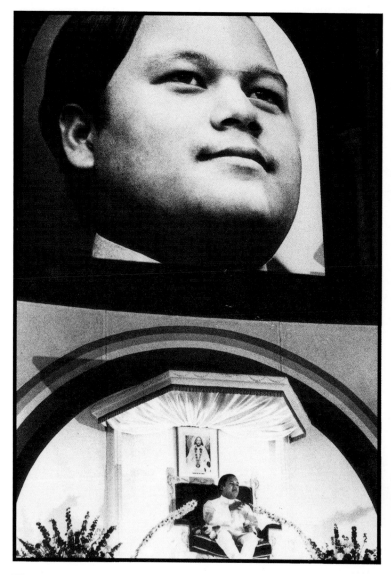

The inner meaning

Guru Maharaji Jai at one of his huge audiences in London in the 1970s. The "boy god" was dwarfed by his own portrait, and the resulting composition suggested to me that he was an insignificant little man blown up out of all proportion by his image-makers and followers alike. Whenever you shoot a portrait, whether the subject is famous or not, you make a statement about him or her. As your ability to visualize tones and to compose a picture increases, you enjoy greater freedom to concentrate on your subject and to portray that person according to your own response.

Nikon F2, 80-200 mm zoom at 150 mm, Ilford HP5, 1/60 sec., f5.6.
PROCESSING: Ilford Microphen.
PRINTING: Grade 3; 8 secs., f8; guru shaded 2 secs., light semicircular area surrounding him burned-in 15 secs.

A wider view

As in the picture on the left, it is the subject's public image that is the real theme. For this shot of the outspoken British politician Enoch Powell, I used a 24 mm lens so that I could work at close range and yet include and emphasize the posters. As you grow accustomed to the compositional possibilities of different lenses, or of a wide-ranging zoom lens, it becomes second nature to select the right focal length for your interpretation.

Nikon F2, 24 mm, Ilford FP4, 1/125 sec., f8.
PROCESSING: Ilford Microphen.
PRINTING: Grade 3; 8 secs., f8; posters burned-in 5 secs.

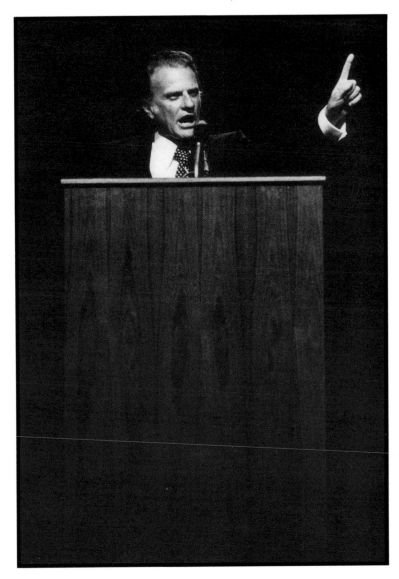

Spot metering

Billy Graham saving souls. I composed the shot with the evangelist in the top third of the frame. This both suggested his relationship to the audience below and gave more impact to his heavenward-pointing finger. A spotlight already emphasized his face. All I had to do was expose for it properly and make sure that the dark tones surrounding the speaker provided a striking contrast. I used a spot meter to take a reading from the face, as I always do when photographing such an event from a fixed position. The low light made it necessary to rate the film at twice the recommended speed and to compensate during processing.
Nikon F2, 180 mm, Ilford HP5 (rated at ISO 800), 1/250 sec., f2.8.
PROCESSING: Ilford Microphen, pushed 1 stop.
PRINTING: Grade 3½ (Multigrade); 10 secs., f11; hand burned-in 4 secs., bottom third of print burned-in 5 secs.

Making a photo opportunity

There was a photo opportunity the day before Duke Ellington was due to perform at Westminster Abbey, London. About 30 agency and newspaper photographers were jostling to get a shot. Before the picture session, as Ellington was talking with one of his musicians, he presented himself to the camera. I moved forward and started shooting from a kneeling position about 15 yards (14 m) from him. I had fitted a 24 mm lens, to include the vaulting above. I got four shots before being ushered away. I was aware that the powerful light from a spot at the top left-hand side would call for extensive burning-in during printing.

In the end everyone shot more or less the same picture. I just felt lucky to have got there first!
Nikon FE, 24 mm, Ilford HP5, 1/60 sec., f4.
PROCESSING: Ilford ID-11.
PRINTING: Grade 3; 8 secs., f11; top left area burned-in 50 secs.

69

Recording special events

My friends Linda and Michael Burgess with their new-born baby Jasmin. This was an easy picture to take, but it is what photography is about – the recording of special moments for posterity. The couple glow with happiness and pride, surrounded by flowers and messages of congratulation from friends and relatives. This is the kind of scene that makes you kick yourself later on if you have not got a shot of it. Nikon FE, 35 mm, Ilford HP5, 1/60 sec., f4.
PROCESSING: Ilford Microphen.
PRINTING: Grade 2½ (Multigrade); 10 secs., f8; baby burned-in 4 secs.

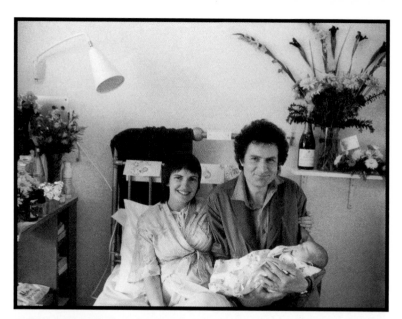

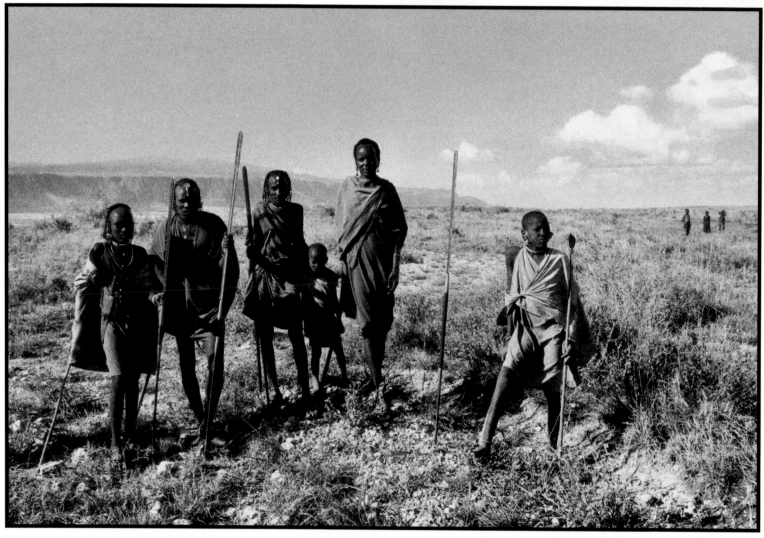

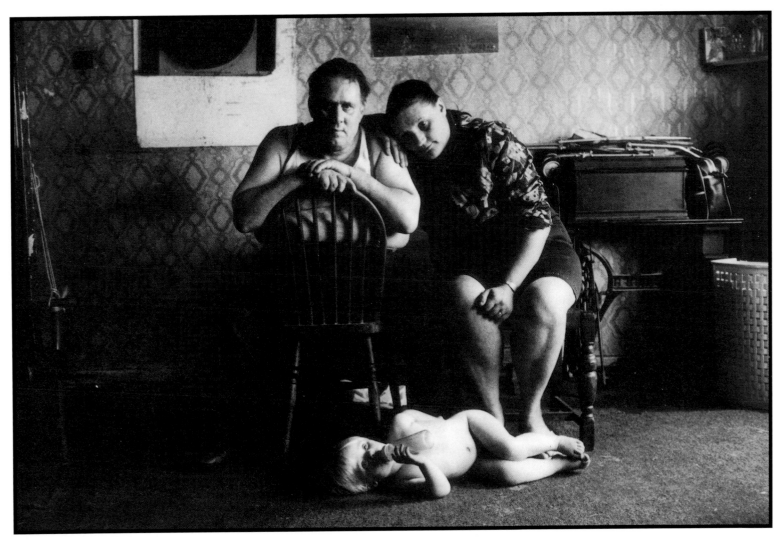

Including the environment

OPPOSITE BOTTOM: *I made colour and black and white pictures of these Masai warriors on the plains of Tanzania. The colour shots looked almost pretty and certainly lacked the dignity conveyed by the black and white studies.*

I used a 35 mm lens in order to include the setting. In this way I could show a tough people in a tough, lean land. Using a tripod for location portraits gains the attention of the subjects and, more importantly, concentrates the photographer's mind on the business of composition. An orange filter maintained the contrast between the tones of the sky and the clouds. When using a filter, you normally need to increase exposure slightly to compensate for its light-reducing effect. Here I added 1/3 stop to the meter's reading.
Nikon FE, 35 mm, Ilford HP5, 1/250 sec., f8. Orange filter.
PROCESSING: Ilford Microphen.
PRINTING: Grade 3; 14 secs., f8; right-hand third of sky burned-in 8 secs.

Exposing for the shadows

One of a series of portraits I made for a TV documentary of British families living in poverty. I composed the picture formally to include the shabby room and capture its melancholy air. The baby would only lie still on the floor. This detail in itself reinforced the mood of defeat expressed by the couple.

Do not automatically rely on flash when the light looks insufficient. Use a tripod instead, but ask your subject to remain still. The shutter speed was 1/4 sec., and the air of formality induced by the long exposure has worked well. Cross-lighting from a window produced a somber, low-key range of tones. I would have lost some of this atmosphere had I lit the scene artificially. For low-light portraits you must assess carefully the amount of light available. It is best to be generous with the exposure, and I exposed for the shadows.
Nikon F2, 35 mm, Ilford HP5, 1/4 sec., f4.
PROCESSING: Ilford Microphen.
PRINTING: Grade 3; 10 secs., f5.6; baby burned-in 6 secs., shadow area shaded 3 secs.

Landscape

While photographing one of his justly famous Yosemite landscapes, Ansel Adams is reported to have said "Forget what it looks like. How does it feel?" That question prompted him to replace his yellow filter with a red one. The result was a much more dramatic image. He had reproduced his "mind's eye" view – not just how the scene looked.

Inexperienced landscape photographers are often disappointed with their efforts in black and white. In most cases this is because they have not yet understood how the lens and the film "see" the landscape and have not learned how to visualize colours in terms of light and shade. Don't be defeated by such disappointments. Instead, try to assess where you went wrong. One of the main problems in landscape photography is how to take a photograph that gives the scene as much significance as the eye saw in it, for most landscapes turn out far less exciting in the final print. The answer is to simplify the picture. Most people start off by taking broad views. But by isolating the section of a scene that has most meaning for you, you will start to produce stronger landscapes.

The beginner in landscape photography soon discovers the limitations of the standard lens, which reproduces the scene roughly as the unaided eye sees it but may not convey what the photographer feels about it. For a much more dynamic result choose either a wide-angle lens, which allows the inclusion of foreground detail as an important element in the composition and conveys scale and distance, or a telephoto lens to exclude the foreground and compress the subject planes.

Black and white film, by sacrificing colour, creates a mood that is at a remove from reality. You can take this effect further by concentrating on details within a landscape such as swirling water, the texture of bark or rock, or the shapes formed by driven sand or snow. By placing the emphasis on tonal variation, form and texture you can produce an almost abstract result.

Composition is not the only factor of particular importance to landscape photography. Assessing lighting conditions and choosing the right time of day to shoot is also critical to a good result. If possible, study the subject in different kinds of weather and at different times of day. As a general rule, the oblique light of early morning or evening is best, particularly for photographs of mountains and hills. Avoid bright midday light since it is harsh and flat, and destroys form and texture. Menacing weather, though, can lend atmosphere to the most ordinary of scenes.

Capturing the magic of light
I was driving through the New South Wales outback on a very hot day when, unexpectedly and very fast, huge black clouds built up and I found myself in the middle of a violent electrical storm. I took one shot based on the camera's light reading but, on reflection, decided to shoot for the highlights in what had suddenly become a very dramatic scene. The lighting was like a spotlight shining through a single hole in the dense black cloud. I took a light reading from my hand, which I assessed to be about equal in value to the highlights. The resulting exposure was $1\frac{1}{2}$ stops less than the camera's reading. This light lasted only about ten minutes before the rain poured down in torrents and the spotlight was turned off.

Light is the magic ingredient in landscape photography, and you must be prepared to work very fast at times to capture that magic on film. Working in black and white, we lack the luxury of pretty colours, relying instead on exciting light to breathe vitality into the landscape. Nikon FE2, 28 mm, Ilford HP5, 1/250 sec., f11.
PROCESSING: Kodak D-76.
PRINTING: Grade $3\frac{1}{2}$ (Multigrade); 8 secs., f8; top quarter burned-in 3 secs.

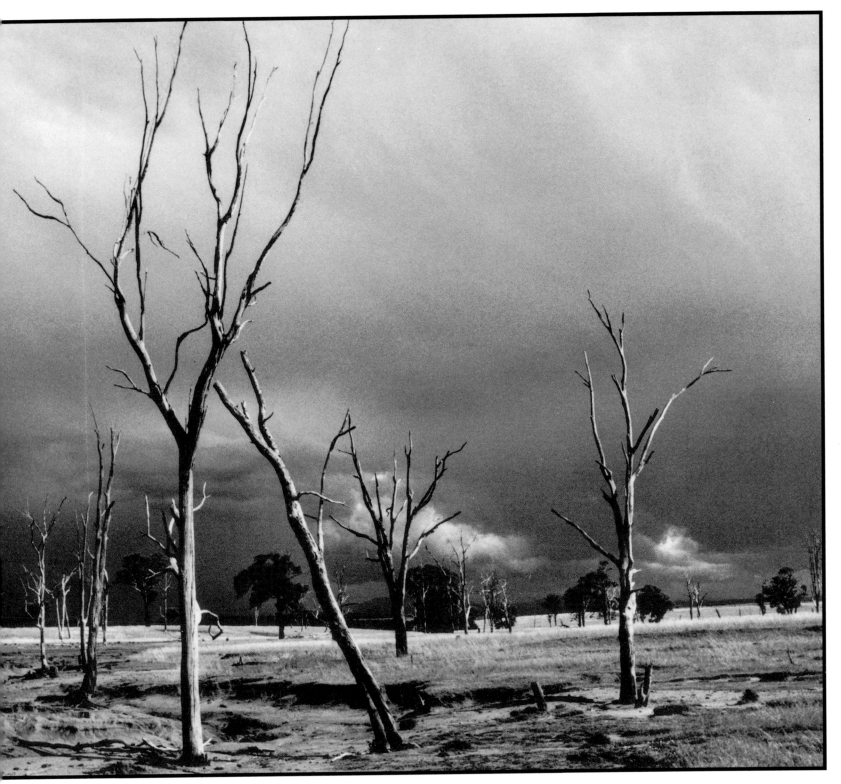

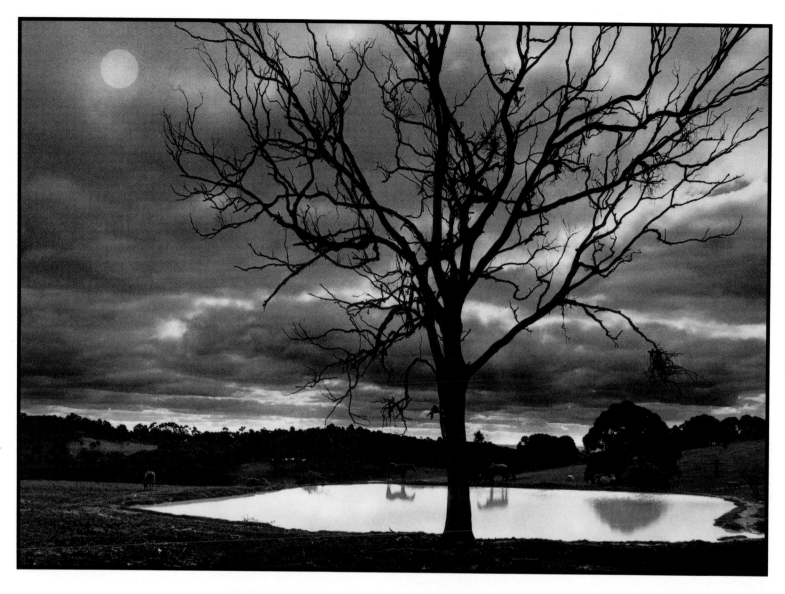

A fabricated landscape

I shot this scene early one morning in Victoria, Australia. The cloud formation was striking, the light value of the pond was strong, and the reflections of the horses and the tree added subtle interest. I was aware that I would have difficulty in holding detail in the horses as well as their reflections because of the difference in light value between the two elements – too great for the film I had in the camera.

However, when I tried a red filter on the lens I could see the possibility of shooting "day for night." I made several exposures, some for the poorly lit areas and some for the highlights. (There was a difference of 3 stops between these areas.) The negative I chose was in the middle of the exposure range. I printed dark in order to hold only the reflections and the sky. I added the "moon" (cut from white card) at the printing stage as an afterthought.

Landscape photography is well suited to such darkroom tricks, and the picture need be no less convincing for being invented. Nikon F2, 28 mm, Agfa APX100, 1/30 sec., f8. Red filter. PROCESSING: Agfa Rodinal. PRINTING: Grade 3 (Multigrade); 25 secs., f16; sky at top right burned-in 15 secs., moon superimposed 5 secs.

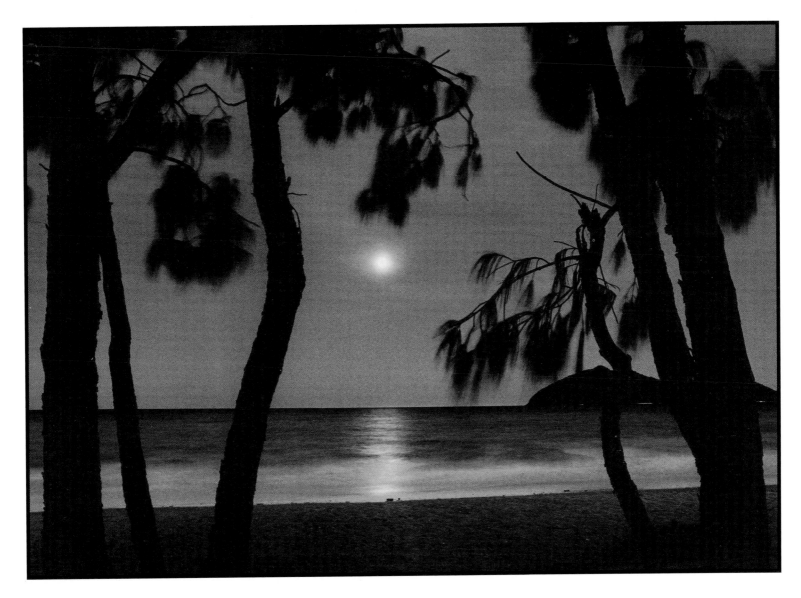

Automatic light metering

Most black and white photography relies heavily on the interpretation of tones. Often, the effect that the photographer visualizes may be more subtle than the camera's built-in light meter can "read." Sometimes, though, there is no need to override the automatic metering system. For this shot I let the camera determine the exposure because I knew that its center-weighted metering system would base its reading on both the brightest and the darkest light values in the scene, which is what I wanted.

The metering systems on modern cameras are generally excellent, but unless the tonal distribution is as uncomplicated as it was for this picture, you must first decide what result you want and then tell the camera what to do. The light meter itself has no taste, and is in most cases designed to produce what is known as an "averaged" reading.

A slow shutter was required here, so that the gentle movement of the trees in the wind has recorded as an agreeable blur.
Nikon F2, 35-70 mm zoom at 35 mm, Agfa APX100, ½ sec., f8.
PROCESSING: Agfa Rodinal.
PRINTING: Grade 2 (Multigrade); 7 secs., f8; moon burned-in 30 secs.

Textural landscape

I took this shot of cliffs in Hawaii from a high position and used a long lens to pick out the volcanic detail. Before long lenses came along, this fascinating texture could have been appreciated only with the aid of a telescope. A prime effect of telephoto lenses is to compress subject planes. A landscape like this takes on an almost abstract quality in which texture is everything. The original was in colour, but this print conveys the composition of the rocks more graphically if less scientifically.

Nikon FE2, 300 mm, Ilford FP4 interneg from Fuji 100, 1/250 sec., f8.
PROCESSING: Kodak D-76.
PRINTING: Grade 3½ (Multigrade); 12 secs., f8; top right-hand corner burned-in 5 secs.

Complementing a landscape

The cloud formation and this long, straight dirt road in Tanzania were not enough to make a picture. But when the black spot of the truck appeared there was suddenly a focal point. I hastily fitted a red filter in order to increase the contrast, at the same time lightening the road, darkening the grass, and strengthening the tone of the sky so that the clouds stood out. A wide-angle lens made the most of the perspective provided by the disappearing road.

Nikon F2, 28 mm, Ilford HP5, 1/125 sec, f11. Red filter.

PROCESSING: Ilford Microphen.

PRINTING: Grade 3; 16 secs., f11; road shaded 4 secs.

Retaining subject detail

When I set out at daybreak to photograph Balinese landscapes the light made everything look flat and dull. But when I discovered these rice paddies the scene came instantly to life. The bright light value of the water created an interesting tonal contrast with the rest of the landscape. I enhanced this still more by using an orange filter.

Characteristically, the overcast light revealed detail in both the highlights and the shadow areas. An averaged exposure was appropriate here and produced a negative that retained this wide range of detail. Remarkable

manmade patterns surrounded me. All I had to do was frame a section of the scene that conveyed the character of the whole landscape.

Traditionally, large-format cameras are thought to be best for landscapes. But in my view the 35 mm camera is perfectly suited to the subject, because of the very wide choice of high-quality lenses and the high resolution of many of the films now available for the format. Nikon F2, 35 mm, Agfa APX100, 1/60 sec., f11. Orange filter. PROCESSING: Agfa Rodinal. PRINTING: Grade 2½ (Multigrade); 30 secs., f11; all but the highlight areas shaded 6-12 secs.

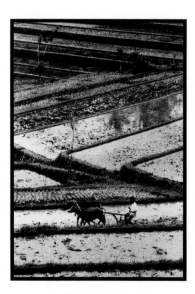

Landscape as pattern

By sacrificing a degree of realism, long lenses can turn an ordinary landscape into a powerful picture. In the picture above a 300 mm telephoto has shortened the perspective, emphasizing the patterns of the rice fields and making them into a very immediate, almost theatrical, backdrop to the farmer. In landscapes in which a focus of interest is deliberately included, the picture is usually most effective if the focus of interest is in the lower part of the frame.

The highly graphic, almost abstract, rice fields were an ideal subject for a black and white picture. Although I could have captured the scene in colour I decided not to, since for me both the compelling nature of the patterns and the overall mood of the scene were better conveyed tonally. Nikon FE2, 300 mm, Kodak TMX 3200, 1/500 sec., f11. PROCESSING: Kodak T-Max. PRINTING: Grade 2½ (Multigrade); 15 secs., f8; highlights in fields burned-in 3-8 secs.

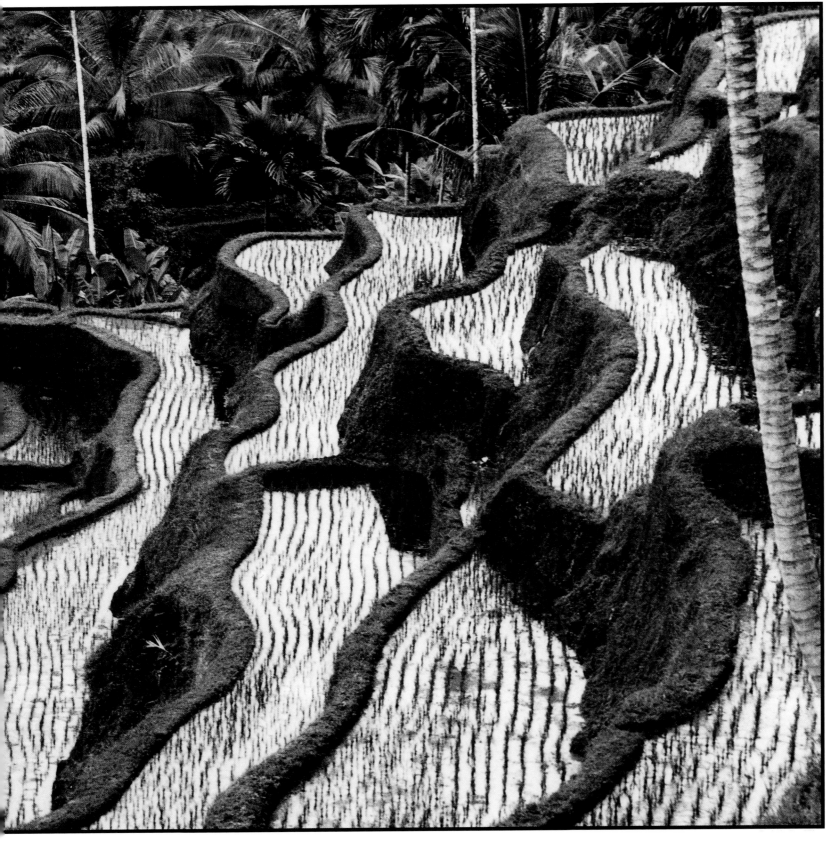

Impressions of the city

These shots of the Chicago skyline illustrate two ways to treat a scene from the same viewpoint. Both pictures were based on the compositional guide known as the Rule of Thirds (see p. 41).

(see p. 41).

The top picture was intended to tell a story – winter in Chicago. I decided that I needed no detail in the buildings, just an impression of the city in winter, so I exposed for detail in the ice and allowed the skyline to become a silhouette. Because I was shooting a mood picture rather than a hard-edged, detailed study, I chose a fast film. The exposure was based on the sky, the light value of which was between that of the ice and that of the buildings, although nearer to the first. The tonal range was in fact too great for the film to handle as a straight shot. However, had I not wanted a silhouette, I could have used a neutral density (ND) filter graduated so as to affect part of the scene only (in this instance, the ice) to reduce the contrast between the ice and the buildings by 2 stops.

The bottom picture was shot at the same exposure, but I added an orange filter to darken the sky for a dramatic effect.

Nikon FE2, 80-200 mm zoom at 150 mm, Kodak TMX 400, 1/250 sec., f8. Orange filter (bottom picture).
PROCESSING: Kodak T-Max.
PRINTING: Grade 2 (Multigrade); 10 secs., f11; skyline shaded 3 secs. (top picture); sky burned-in 10 secs. (bottom picture).

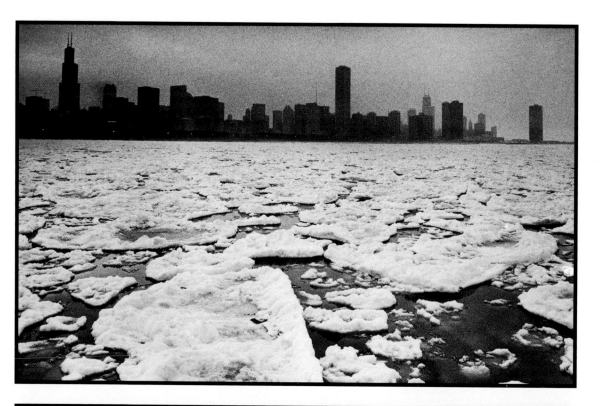

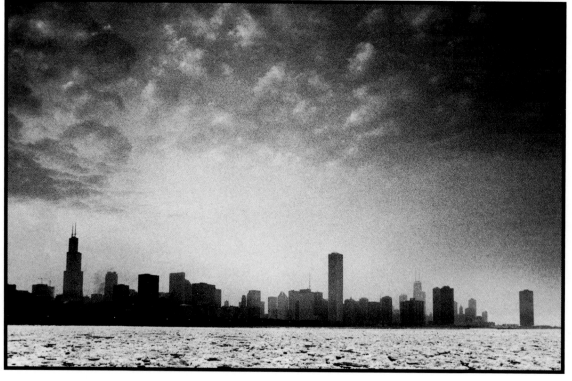

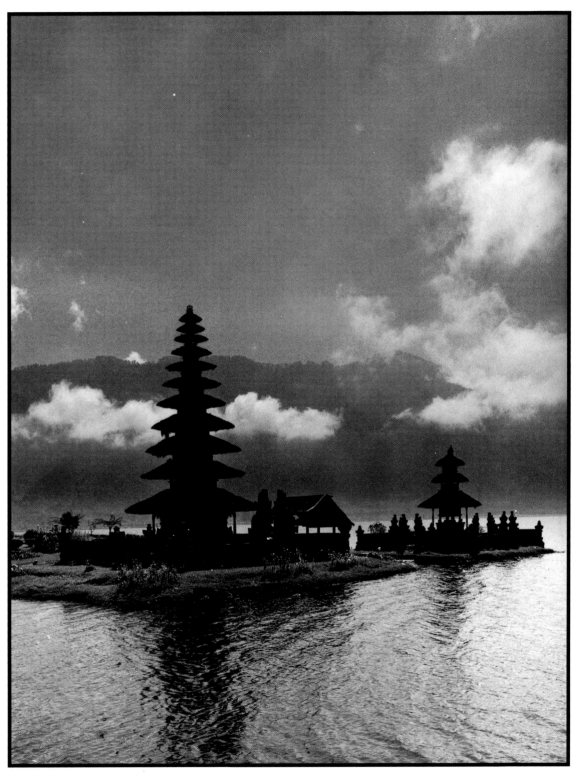

Keeping the composition simple
The sun was almost directly above this shrine in Bali, and the scene as pictured here was ideal for the $2\frac{1}{4} \times 2\frac{1}{4}$ in (6×6 cm) format. It was a straightforward task – all I had to do was to keep the composition simple and to exploit the relationship of the tones. I decided to expose for the mountains because I wanted no detail in the shrine, just a solid silhouette. A red filter increased the tonal contrast and in particular darkened the sky in relation to the clouds.
Hasselblad, 80 mm, Kodak TMX 100, 1/125 sec., f8. Red filter.
PROCESSING: Kodak T-Max.
PRINTING: Grade $3\frac{1}{2}$ (Multigrade); 15 secs., f8.

Reportage

It is not easy to separate reportage from other areas of photography, for all pictures "report" on their subject, either by revealing its physical character, or its mood, or both. Until recently, newspapers and magazines have accustomed us to see black and white as the medium of reportage, especially of the harsh truth, and, despite the spread of high-quality colour printing, the black and white image still retains great expressive power. Our memories of world events are usually conditioned by the great black and white news reportage pictures. But the best reportage photography, such as that of Henri Cartier-Bresson, is just as often an acute vision of ordinary, everyday situations. What unites the greatest pictures in both spheres is that they were taken with respect for the subject and with a proper humility in the face of the feelings of others. You need not be in the front line of a war to take powerful reportage pictures. The subject matter is all around you.

When covering conflict or other dangerous situations, the reportage photographer often has to put his or her safety at risk in order to gain a realistic appraisal of events. The good reportage photographer is never completely detached, for he or she cannot avoid offering an interpretation of the subject by making a choice of camera angle, lens, exposure or darkroom treatment.

The essence of successful reportage is to concentrate information and meaning in a single image. Black and white photography assists this concentration, for its artifice confronts the eye in a way that colour pictures often fail to do. Be sure to gain adequate coverage of the subject, for many pictures taken on the spur of the moment will not be good enough to keep. Shooting with a medium-format camera as well as a 35 mm SLR allows you to vary your interpretation of a story. The reportage photographer is on a treasure hunt. Sometimes the picture that says it all is found at once, while at other times the search takes days. But the experienced photographer, even if he or she has captured the definitive shot immediately, continues to shoot, just in case events take another turn.

Recording the event

I wasn't sure if the hospital staff would allow pictures of the birth of my first son, Nick – or if I would be calm enough to take them. I slipped my half-frame Canon Dial camera into my pocket anyway. In fact, they did and I was (just). I took this picture about two minutes after the birth, and it remains a precious item in our family album. Black and white photography is all about capturing the moment, so just go ahead and shoot. You can in any case make adjustments if necessary at the printing stage.
Canon, Ilford HP5, automatic exposure.
PROCESSING: Ilford Microphen.
PRINTING: Grade 3; 12 secs., f8; mother's face shaded 3 secs.; pillow burned-in 20 secs.

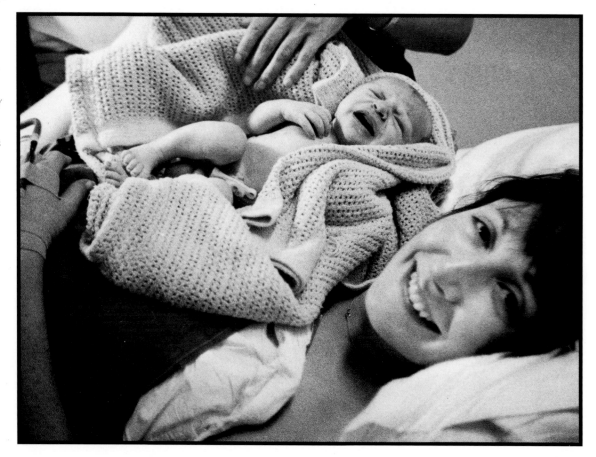

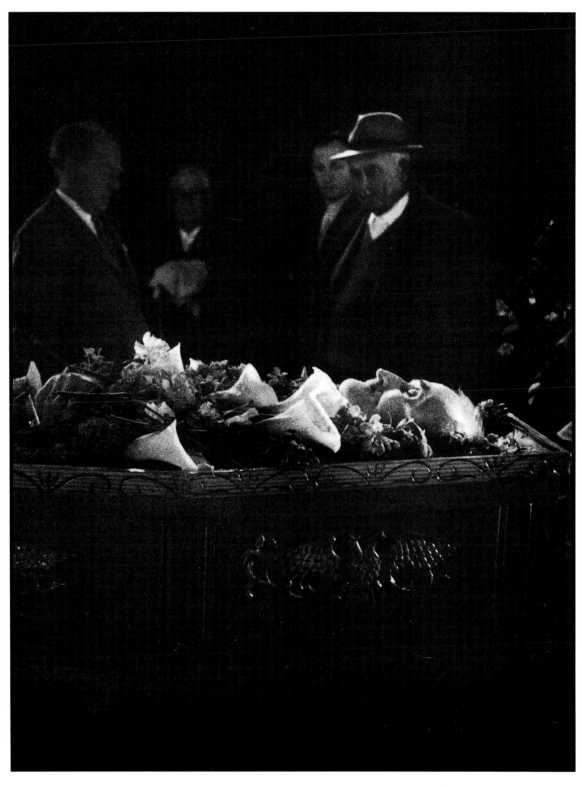

Using low light

For three days I had witnessed the corpse being paraded around the little Corfu town, and finally it was laid to rest in a chapel. I agonized over whether I should intrude on private grief and ask to take a picture. When I did ask, though, I was at once given permission by the mourners. I made two exposures and left quietly.

Often, you will need to use available light of a low intensity, as was the case here. Yet it was sufficient to highlight the dead man's face. It takes a lot of practice to read low light effectively. Don't let early failures put you off and make you reach for flash equipment. Fast film and large maximum apertures make almost any shot possible nowadays. In sensitive situations, if you are sincere and people don't feel exploited, you will often be allowed to take pictures that at first seemed impossible. But always obtain permission before shooting.

Nikon F2, 50 mm, Ilford HP5, 1/30 sec., f1.2.
PROCESSING: Ilford Microphen.
PRINTING: Grade 4; 10 secs., f8; flowers burned-in 20 secs., left third of print burned-in 30 secs.; coffin shaded 4 secs.

Anticipating a response

A picture from a photo story on the election campaign of the controversial British politician Enoch Powell when he was at the height of his popularity, in the 1970s. I singled out the woman because she seemed to be typical of his followers. When your task is to portray an audience's reactions, listen closely to the speaker and familiarize yourself with his or her style of delivery so that you can anticipate a response. It is almost a certainty that the face you are focused on will reflect the general mood you want to convey.

There was not much light in the auditorium, so I used a monopod to steady the long lens that I needed to isolate the woman from the crowd. Nikkormat, 180 mm, Ilford HP4, 1/60 sec., f2.8.
PROCESSING: Ilford Microphen.
PRINTING: Grade 3; 8 secs., f8; shadow side of face shaded 3 secs.

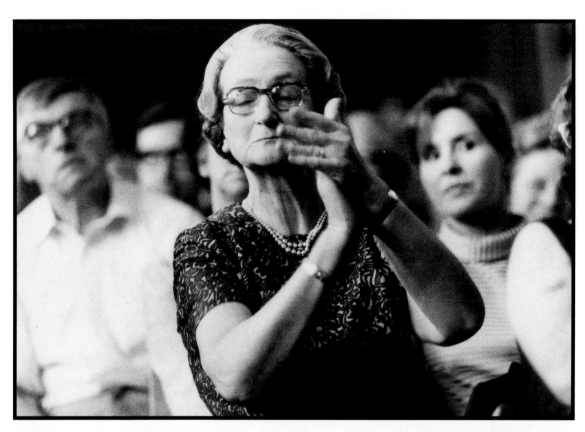

Capturing the spirit of the crowd

I used a long, large-aperture lens (180 mm, f2.8) to pick out this rapt figure in a crowd listening to Guru Maharaji Jai. The shallow depth of field at maximum aperture has thrown foreground and background out of focus, so that the eye is drawn to the young man. When photographing crowds, find a single person whose expression or actions epitomize the mood of the gathering. This gives the picture an emotional and visual focal point. Nikon F2, 180 mm, Ilford HP5, 1/60 sec., f2.8.
PROCESSING: Ilford Microphen, pushed ½ stop.
PRINTING: Grade 3 (Multigrade); 10 secs.,f8.

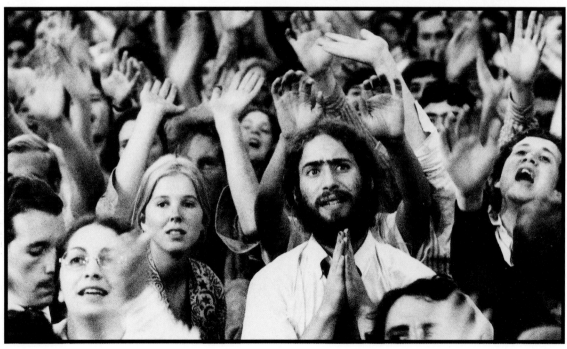

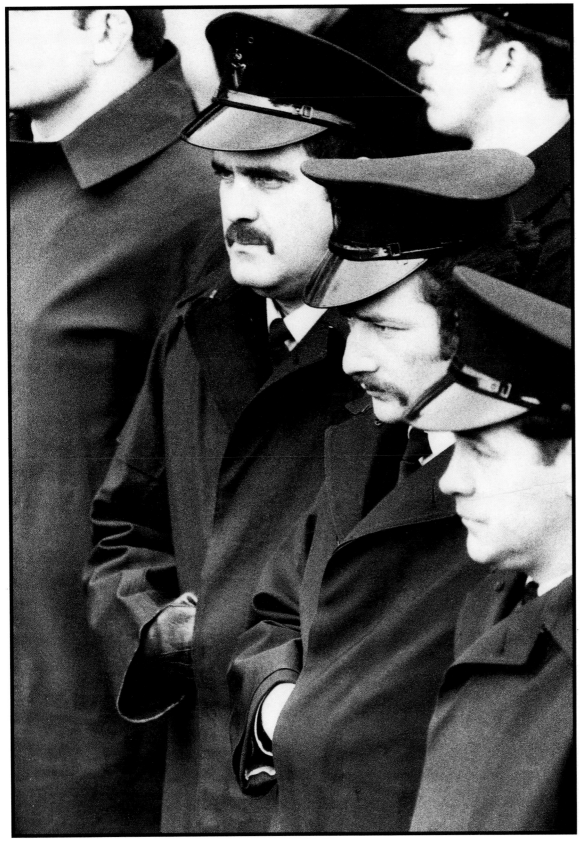

Framing to emphasize tension
Members of the Royal Ulster Constabulary on security duty at an IRA funeral in Londonderry, Northern Ireland. The dramatic relationship between dark and light tones and the tight framing (from a fixed position with an 80-200 mm zoom lens) combine to convey the tension in the faces and the readiness of the hands to pull the trigger if necessary.

I framed the image so as to concentrate on the essential facts and to exclude all distracting detail. In reportage work it is best to tell the story in the simplest and most powerful way possible. With practise you can learn to identify the crucial subject matter and to see the tonal separation as the film will see and record it.

Nikon FE, 80-200 mm zoom at approximately 180 mm, Ilford HP5, 1/250 sec., f8.
PROCESSING: Kodak D-76.
PRINTING: Grade $2\frac{1}{2}$ (Multigrade); 8 secs., f8; faces burned-in 5 secs.

A straightforward solution
This anxious young mother and her starving baby were civilian casualties of the Indo-Pakistan war of 1971, which resulted in the creation of Bangladesh as a new nation.

I shot with both black and white and colour. The stark tones of black and white conveyed more effectively the worst horror of war – the fate of the innocent victims. The light was low but of good quality.

Making intimate pictures of the suffering of others is a disturbing experience. In such cases shooting in black and white is emotionally and technically the best solution. You don't need to worry about mixed light sources (here, daylight plus naked tungsten) disturbing the colour balance, and if the negative is less than perfect you can experiment in the darkroom until you produce a print that has the feeling you experienced at the time. But you won't recreate that feeling unless the picture is strong in the first place, for in reportage content is all-important.

Nikon F, 35 mm, Ilford HP5, 1/30 sec., f2.
PROCESSING: Ilford ID-11, pushed 1 stop.
PRINTING: Grade 4; 15 secs., f8; left side of mother's face shaded 5 secs.; baby's face shaded 4 secs.; top left of background burned-in 20 secs.

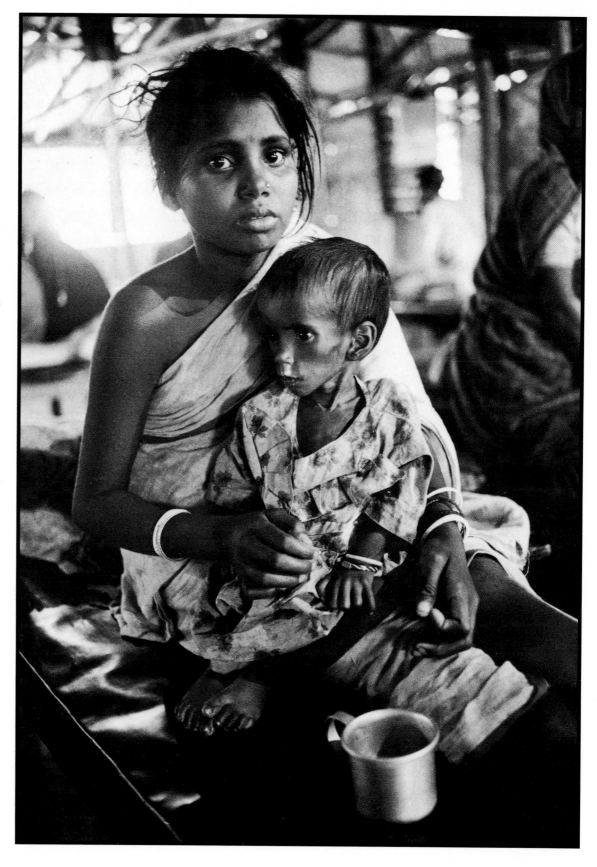

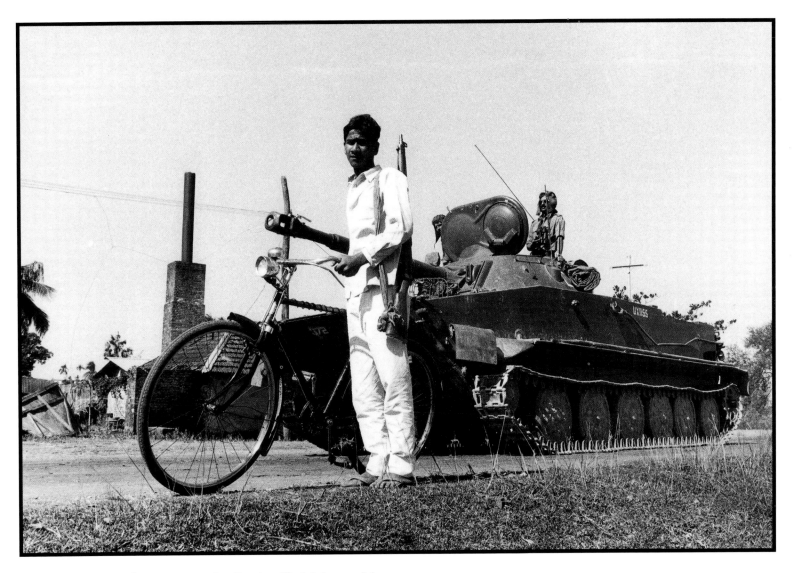

The emotive power of black and white

The Indian tank lumbering toward the front line during the Indo-Pakistan war formed a striking contrast with the frailty of the teenaged Mukti Bahini guerilla with his antiquated rifle and bicycle. Many East Pakistani youths engaged in the struggle for their country's independence were victims of the conflict.

I have always read the young man's expression as both sad and resigned to whatever fate threw in his direction. The brightness of the sky and the grass, had they been depicted in colour, would have been at odds with the mood of the subject. Shooting in black and white has provided a visual record that is much truer to the melancholy and foreboding nature of the scene.
Nikon F, 28 mm, Ilford HP4, 1/250 sec., f11.
PROCESSING: in hotel bath with unknown developing agent.
PRINTING: Grade 2; 10 secs., f8; side of tank shaded 3 secs., sky burned-in 6 secs.

Highlighting the subject

Consulting the menu is a serious business all over France. I captured this elderly couple, who had been comparing restaurants, at their fourth (and final) stop. The lady was barely tall enough to read the details of the menu, so her partner relayed its delights to her.

The chairs and awnings were brightly coloured and would have conflicted with the telling of the story if I had used colour film. The tonal relationship is simple and strong. In fact, there was such a difference in value between the light on the couple and that beneath the awnings that the shadows could be printed black, bringing the figures and the menu into prominence.
Nikon FE, 35-105 mm zoom at 70 mm, Ilford HP5, 1/125 sec., f5.6.
PROCESSING: Ilford Microphen.
PRINTING: Grade 2½ (Multigrade); 10 secs., f5.6.

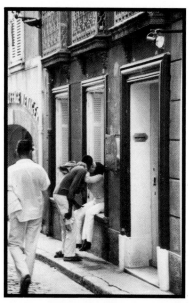

Matching film to light conditions

Reportage involves shooting in a wide variety of light conditions. A medium-speed film such as Ilford HP5 or XP1, or Kodak Tri-X, has a greater latitude than slower films. With a softer developer such as Ilford Microphen, the result should be printable whether you shot in soft shade, as here, or bright sunlight.
Nikon F2, 35-105 mm zoom at approximately 100 mm, Ilford HP5, 1/500 sec., f5.6.
PROCESSING: Ilford Microphen.
PRINTING: Grade 2; 10 secs., f11; all highlight areas burned-in 10-40 secs.

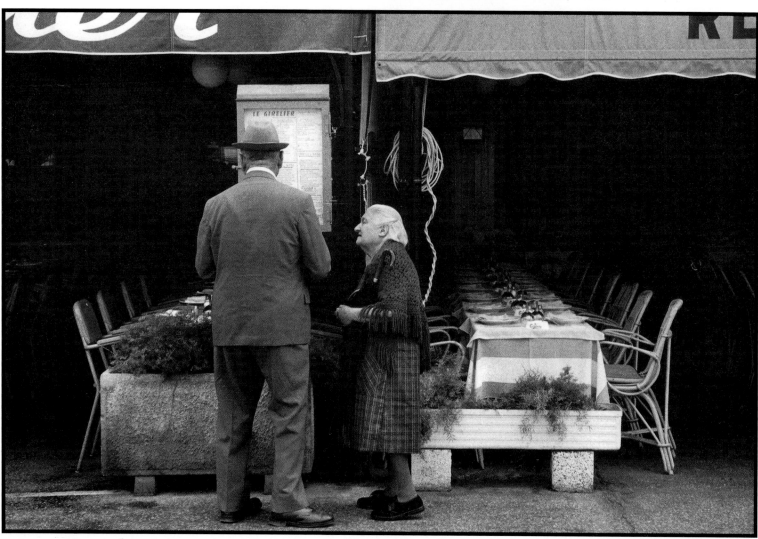

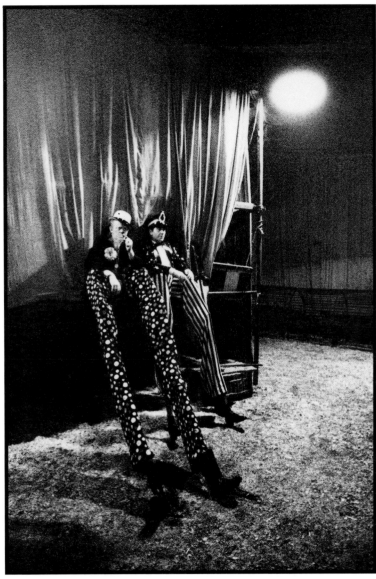

Visualizing tones

Backstage at Billy Smart's Circus, these clowns had their stilts on, ready to perform. The light was low but had a beautifully atmospheric quality. At the same time I realized that its rawness would produce negatives that would be difficult to print, with burned-out highlights and thin shadows. I overexposed by a stop more than the camera indicated, to ensure that there would be enough detail in the faces.

The skill in visualizing tones is to be able to see the scene in terms of its potential as a negative. Forget the final print at this stage. Instead, concentrate on what you must do to produce a strong negative, particularly in difficult lighting situations such as this one.
Nikon F3, 28 mm, Kodak Recording Film 2475, 1/30 sec., f5.6.
PROCESSING: Kodak HC-110.
PRINTING: Grade 4; 8 secs., f11; highlight areas burned-in 10-40 secs.

Sympathy with the subject

A picture from a feature on unemployment. The two men were arguing outside the social security office. It was obvious from the look on the taller man's face that he had heard the other's argument many times before.

Often, self-consciousness leads reportage photographers to fear that they are more noticeable than they really are. If you cultivate the feeling of being invisible, it is amazing how free you are to take pictures. I also believe that people can sense whether you are sympathetic or not, and they react accordingly. You must become so at one with your equipment that you can shoot fast and smoothly, almost like blinking.
Nikkormat, 35-105 mm zoom at 35 mm, Ilford HP5, 1/125 sec., f8.
PROCESSING: Ilford ID-11.
PRINTING: Grade 3; 10 secs., f8.

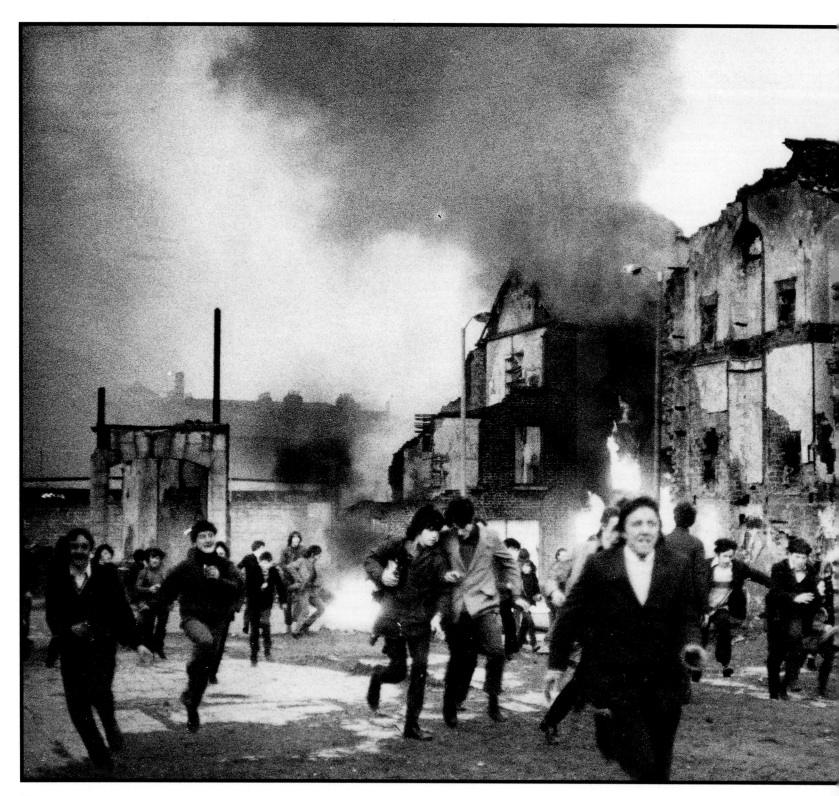

The telling detail

The impassioned scrawl of graffiti, particularly in black and white, can be far more expressive and illuminating than thousands of words from a journalist's pen. The brief message seen here sums up the feelings of many in the area of Londonderry that was known, when it was controlled by the IRA, as "Free Derry."

The photojournalist must constantly be on the lookout for any detail that will help tell the story. Nikon F3, 80-200 mm zoom at 120 mm, Ilford HP5, 1/125 sec., f8. PROCESSING: Ilford ID-11. PRINTING: Grade 3; 12 secs., f8.

Inventing a story

My curiosity was aroused by this terse statement on a building in what appeared to be a deserted area. I never found out the truth of the situation but chose to record the scene as one that was open to various interpretations.

The photograph tells a story about people, without people. But it is also about architecture. I used a perspective-control (PC) lens and a tripod because the scene seemed to demand that the verticals be kept vertical and the composition be classically formal. A red filter heightened contrast, both in the buildings and by darkening the sky. Nikon FE2, 28 mm (PC), Kodak TMX 100, 1/125 sec., f8. Red filter. PROCESSING: Kodak T-Max. PRINTING: Grade 2½ (Multigrade); 12 secs., f8; shadow area of building shaded 5 secs., wall on left and foreground burned-in 4 secs.

Black and white for intensity

OPPOSITE: *As I returned to my hotel after a long day of shooting pictures of trouble-torn Belfast for* Paris Match *magazine, I heard a commotion and turned to see a gang of youths running from a building they had just torched.*

There was not enough light left to shoot with an aperture that would give depth of field extending from the fleeing figures to the burning building, so I focused on the latter. Even so, the figures are sharp enough to tell the story. The negative was thin in tone but printed as a somber image that caught very well my feelings at that moment. I printed to leave little shadow detail and make the faces livid. A colour picture would have softened the scene, the pretty flames and dusk sky detracting from the starkness of the mood. Nikon F3, 105 mm, Ilford HP5 (rated at ISO 800), 1/125 sec., f4. PROCESSING: Ilford Microphen, pushed 1 stop. PRINTING: Grade 4½ (Multigrade); 6 secs., f11; area above figures burned-in 6 secs., sky and smoke burned-in 16 secs.

Nudes

The nude offers the most challenging exercise in the interpretation of shape and form. The photographer's aim should be to produce a result that is sensual and artistic rather than merely titillating. While colour film has a distracting realism that makes this difficult, black and white film, with its graphic quality and artifice, is the ideal medium.

Your main tool for recording the lines, tones and textures of the nude is lighting. The human body directly lit comprises tubular shapes, and to reveal their form you must provide top, side or back light (see pp. 30–31). Frontal lighting flattens curves, creating a two-dimensional effect. Your goal should be to arrange the lighting so as to accentuate the subject's most telling features; you can use it to flatter the model just as a painter may narrow a waist or reduce

a thigh with a brushstroke. Consider too the relationship between light and shade and the subject's pose – for example, what happens to the breast when the arm is raised? Don't concentrate on the technical aspects to the exclusion of the picture's most important ingredient: a successful nude study requires a confident, relaxed and comfortable model. Appreciate that bodies need to be kept warm, and ensure that your studio or room meets these requirements. Give your subjects time to relax and make sure that they are happy with any pose you want them to adopt before you start shooting.

Experimenting with composition

An intimate situation like this can make a very attractive picture, but is potentially embarrassing for the models. I kept the mood light in order to help them relax.

I found by experimentation a composition that worked well–the two triangles formed by the arms frame the woman's face and breast. The curve of the man's back balances the line of the woman's hip. I rotated the models in position until the light (from a heavily diffused box light of 2 m × 1 m/ 6½ ft × 3 ft) provided the highlights and shadows I wanted to see. I was able to highlight the breast and darken the shadow areas on the print because I exposed for more detail than I later used. If you are in doubt about the final tonal balance, expose for the shadows and print for the highlights.

Nikon F3, 80-200 mm zoom at 105 mm, Ilford HP5, 1/125 sec., f11. PROCESSING: Ilford Microphen. PRINTING: Grade 2 (Multigrade); 12 secs., f8; shadow between figures burned-in 10 secs.; background at right burned-in 14 secs.

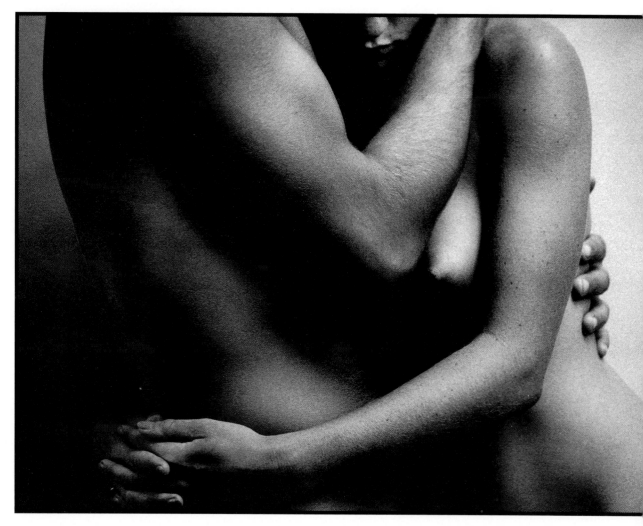

Seeing in black and white

We hadn't seen Dorrine, an old friend, for some time when she arrived unexpectedly – glowingly pregnant. We dashed into the studio to celebrate and capture the event with a picture. I went straight ahead and shot the original with an awful dark green background in place. But since I liked Dorrine's expression, the lighting and the composition, I made a black and white interneg, and I've never regretted sacrificing the colour.

Visualizing from colour to black and white is a skill you can develop by looking carefully at your own transparencies. Those in which the colour is unsuccessful but the shapes and the play of light and shade work well are candidates for conversion.

In fact, the picture is a natural for black and white treatment because the high overhead light, bounced from an umbrella above the model and at 45 degrees to her, has highlighted the round shapes and created powerful black areas to complement them. But, as with all successful nude studies, it was the relaxed and spontaneous atmosphere that made fruitful experimentation possible.

Nikon F, 105 mm, Ilford HP5 interneg from Ektachrome 400, 1/125 sec., f16.

PRINTING: Grade 2; 15 secs., f8; all highlights printed 10-20 secs.

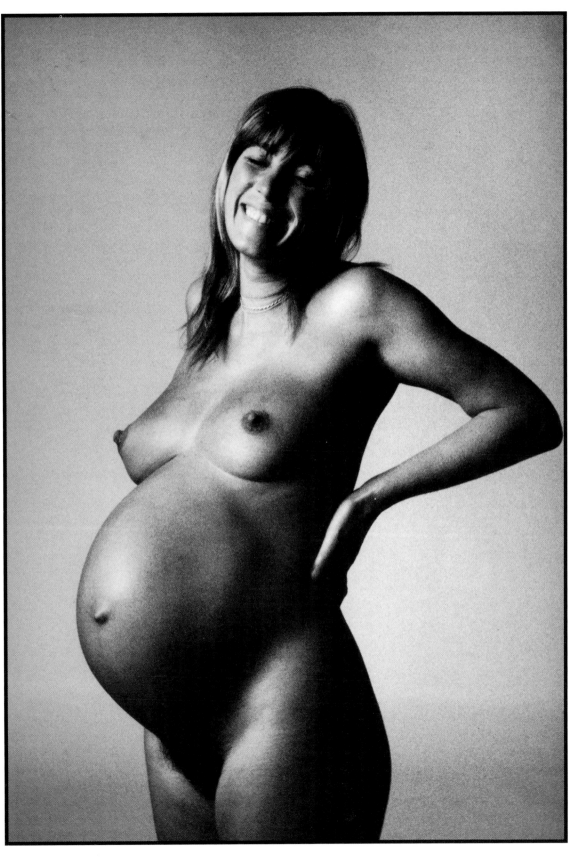

Revealing modelling
The strong side light from a window gave good modelling and a reflector controlled the depth of the shadows. Nikon FE2, 35-105 mm zoom at 105 mm, Ilford HP5, 1/60 sec., f5.6. PROCESSING: *Ilford Microphen.* PRINTING: *Grade 3; 10 secs., f11; highlights burned-in 5-10 secs.*

Exercise in light and shade
The nude on the right was originally shot in colour, but the black and white version makes a stronger graphic image. Lit by daylight, the shape and form of the model remain dark and mysterious against the painted background. A No.1 Softar filter softened the detail, emphasizing the body's contours.

The erect pose creates a strong L-shape that contrasts with the roundness of the breasts. With nude studies it nearly always pays to keep the pose very simple and to ensure that the model's arms do not interfere with the overall design of the picture. Nikon FE2, 80-200 mm zoom at 120 mm, Ilford FP4 (duped from 3M 1000 original), 1/30 sec., f8. No. 1 Softar filter. PRINTING: *Grade 1½ (Multigrade); 10 secs., f11-16.*

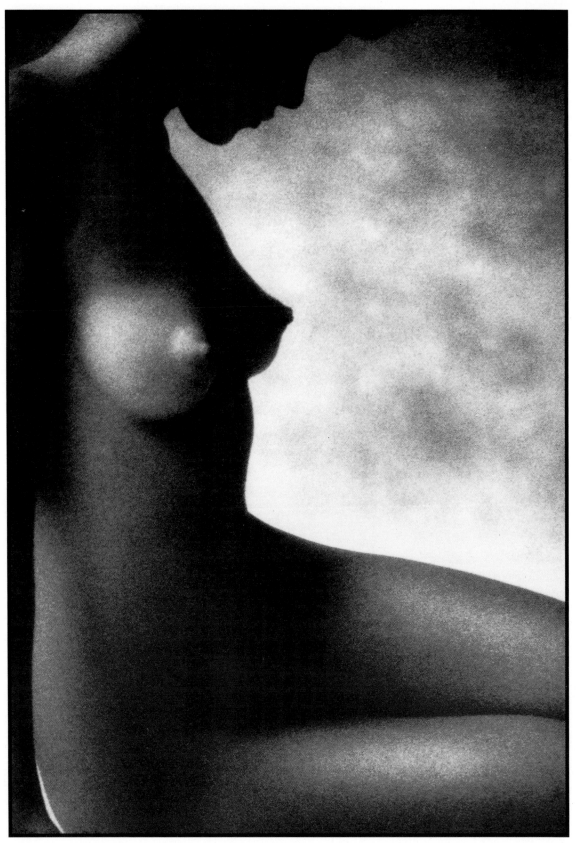

A study in naturalness

This picture is of a girl who happens to be naked, and contrivance is kept to a minimum. Above all, she is perfectly at ease as she confronts the camera, as if she is simply having her portrait taken. The fine, flowing shape of her pose is given strength by the unusually low (almost ground-level) camera angle.

A large window provided natural light, and the exposure was critical – I took a highlight reading with a spot meter, leaving the shadow areas to fall off to dark grays. A No. 1 Softar filter softened the tones and the skin texture. I used an old camera-tent fly as a background.

Nikon F3, 80-200 mm zoom at 90 mm, Ilford HP5, 1/30 sec., f8-11. No. 1 Softar filter.
PROCESSING: Ilford Microphen, pushed 1 stop.
PRINTING: Grade 2 (Multigrade); 10 secs., f5.6; highlights burned-in 6-12 secs.

Natural spotlighting

This picture was taken in the late afternoon in Kenya. The setting sun was bursting through the trees along the shore like a myriad of spotlights. When the boy entered the brightest spot, I shot. Later, I printed for the highlights and let the rest of the print go into dark grays.

I was able to visualize the interplay of highlight and shadow before the action took place and so was fully aware of what the camera would see if the boy walked through the sun's spotlight. Where I captured him was the warmest, brightest place on the beach, so I knew that before long he would be drawn to it.

The picture was not intended to be a classic nude study, but to provide a lasting record of childish innocence. Incidentally, I have withheld the identity of the little boy in the face of threats from a now rather large young man.
Nikon FE, 180 mm, Ilford HP5, 1/125 sec., f4.
PROCESSING: Kodak D-76.
PRINTING: Grade 4; 18 secs., f8; highlight areas burned-in 10 secs.

Depicting volume

*Choosing the right pose for the
model is one of the most important
skills for a photographer of nudes.
Here, my aim was to capture the
volume and roundness of the model's
form. The generous curve of the hip
was produced by crossing the right
leg over the left and placing the
knee on the floor. I exposed for the
highlights so that the shadows could
be printed as black. This lighting
contrast further helped to define the
form of the body. A No. 1 Softar
filter lent a smoothness to the skin
tones.*

Nikon FE, 80-200 mm zoom at 120
mm, Ilford HP5, 1/125 sec., f11. No.
1 Softar filter.

PROCESSING: Ilford Microphen.
PRINTING: Grade 1½ (Multigrade); 15
secs., f8.

Constructing a shot

*The first ingredients were a
beautiful back and bottom. Then
careful positioning created the
rhythm from the top of the shoulder
down to the waist, round the hip
and down the leg. Finally, the right
lighting and background were
selected. I put a flash on a boom to
get top light right over the model
and chose a dark background to
emphasize the body's highlighted
outline.*

*Nude photographs in black and
white need to be constructed step by
step, since the result is determined to
a great extent by the distribution of
tones. Here they go from dark to
light to dark, giving volume and
substance to the body.*

Nikon F3, 80-200 mm at 125 mm,
Ilford HP5, 1/125 sec., f11.

PROCESSING: Ilford Microphen.
PRINTING: Grade 3; 10 secs., f8; hair
shaded 3 secs.

Children

At times children's natural inclination to perform, and their disarming lack of self-consciousness, can make them the most natural subject in the world for photography. On other occasions they can drive you to distraction. They have a great talent for producing their most photogenic pose or expression immediately after you have packed away your camera. The solution is simple – always have it on hand and loaded with film. Children soon forget the camera and become engrossed in whatever their current interest is.

Content is everything when you are photographing children. Don't be put off by poor light, cold, rain or anything else – just shoot. Black and white film gives you the precious freedom to concentrate on content and make any necessary adjustments in the darkroom later. In this way you can have the satisfaction of completing in a very short time the process that began with seeing the chance of a picture.

As with all photography of people, your relationship to the subject is of prime importance. When you are photographing children, in particular, never push them too hard or show your displeasure if a session doesn't go to plan. Children alternate between loving being photographed and hating it. During the hate stage, it is wisest to back off and try again later.

Most photographers' fascination with the theme of children dates back to the arrival of their first child. What they are constantly searching for is not just another shot of their own son or daughter, but a picture that strikes a chord of recognition in us all – a picture we can instantly recognize as marking a definitive moment in growing up.

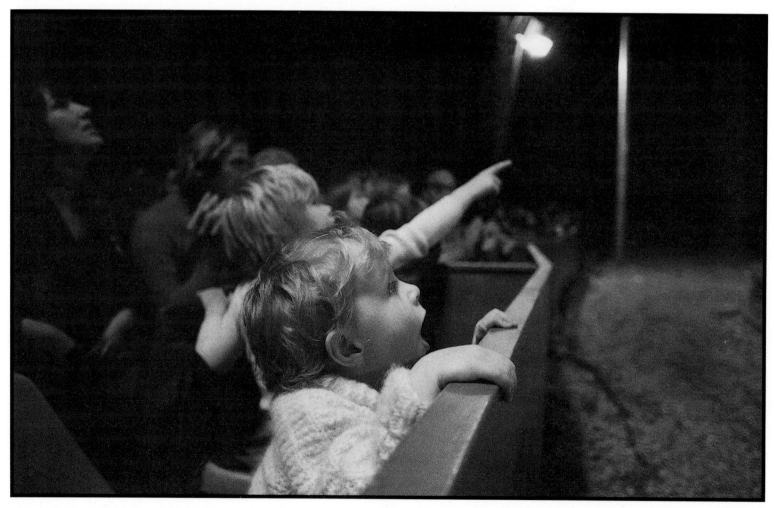

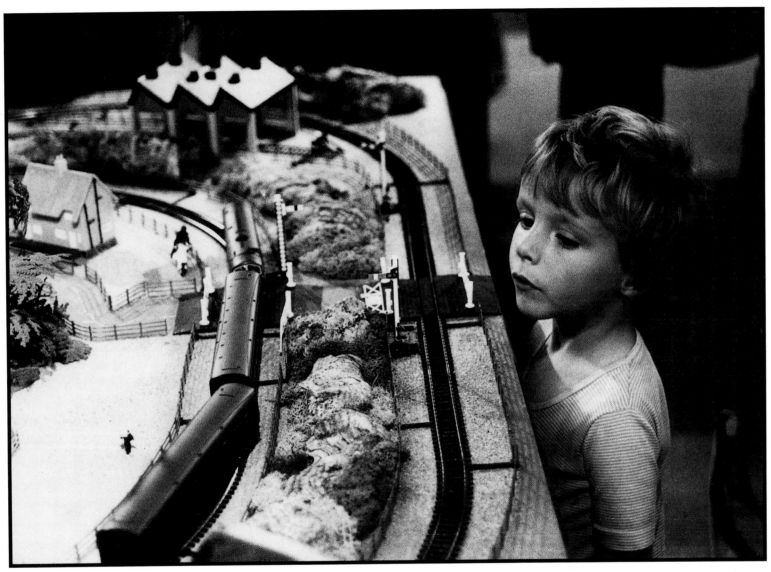

Existing light for atmosphere

OPPOSITE: *When our two sons were young I carried a camera everywhere, although I took very few posed shots of them. This picture was shot during the trapeze act on Nick's first visit to the circus. I had prefocused on him, and the composition was helped when his friend pointed to the artists. The highlit handrail divides the picture in two, just as it separates the spectators from the dark unknown where something dramatic is clearly* taking place. *In such situations many photographers automatically turn to flash. But with today's fast lenses and film, pictures can be made in almost any sort of light without killing the atmosphere created by the existing light.*
Nikon FE, 50 mm, Ilford HP5, 1/30 sec., f1.2.
PROCESSING: Ilford Microphen, pushed to ISO 1000.
PRINTING: Grade 2½ (Multigrade); 12 secs., f8; black area at right burned-in 4 secs.

Capturing a moment of absorption

My son Nick at Hamley's famous toy store in London. Like most four-year-old boys, he was fascinated by toy trains. Since we were all young once, it should not be difficult to recognize a situation that will absorb the child to such an extent that he or she is completely unaware of the camera.

This picture would not have been as successful in colour. The colours of the striped T-shirt and of the trains *would have distracted the eye from what is the real subject – a child's intense fascination.*
Nikon FE, 35 mm, Ilford HP5, 1/30 sec., f2.
PROCESSING: Ilford Microphen, pushed to ISO 800.
PRINTING: Grade 2½ (Multigrade); 12 secs., f8; face shaded 2 secs.; highlight areas of train set burned-in 4 secs.

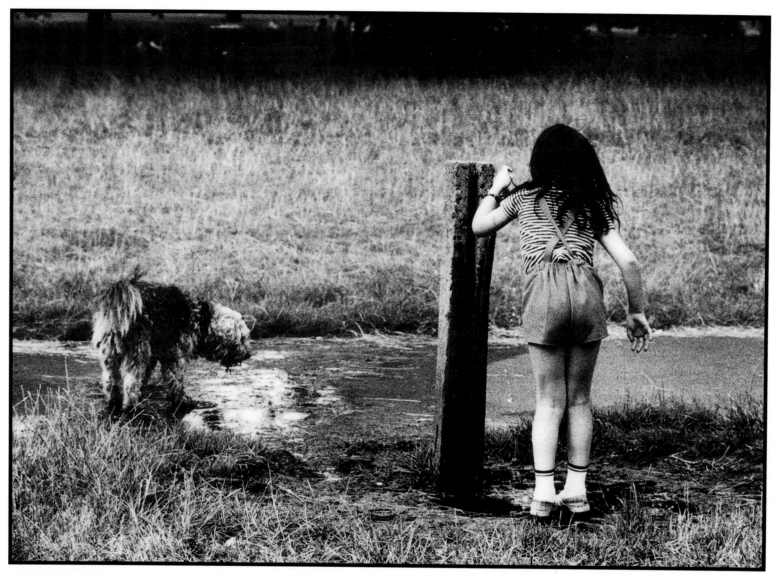

Reduced contrast

I was walking in Hyde Park, London, with a 35-105 mm zoom lens on the camera and two spare films. It was a hot day, and the little girl and her dog went to their respective watering holes. Instinctively, I took this unposed photograph.

Once you start photographing the world of children, you are faced with the challenge of an inexhaustible subject. I use ISO 400 film, which can cope with almost

any photographic situation.

However, when you reproduce several different lighting conditions on a single film, there is the risk that, during processing, some of the shots will be far more contrasty than others that were taken in softer light. It is easier to print soft negatives than hard negatives. Therefore, to make sure that none of my negatives is too contrasty, I always rate my ISO 400 film at ISO 250 and then underdevelop accordingly.

Nikkormat, 35-105 mm zoom, Ilford HP4, 1/500 sec., f5.6.
PROCESSING: Ilford ID-11, development reduced by one minute to compensate for rating ISO 400 film at ISO 250.
PRINTING: Grade 2½ (Multigrade); 10 secs., f8; dog shaded 2 secs.

A simple composition

I set up this shot, taken at a school sports day, but I did not have to ask the boy to look triumphant. Originally shot in colour, the picture is stronger as a composition in black and white. I chose a dark background and cropped tightly to remove anything that might distract the attention from the simple shape made by the champ and his prize.

When directing children for photographs, be positive, firm, and direct, since they nearly always prefer to be told what to do. But, most of all, keep the composition simple.

Nikon FE, 80-200 mm zoom at 150 mm, Ilford FP4 interneg from Ektachrome X, 1/125 sec., f5.6.
PRINTING: Grade 2 (Multigrade); 8 secs., f8.

Using horizontals and verticals

My sons Nick and Matt, aged 5 and 3, relaxing on Brighton beach. I was drawn first by my emotional response to the two little figures in their big, grown-up deckchairs, then by the graphic quality of the two powerful vertical rectangles inside the horizontal rectangle of the frame. Nick's left foot joins the two vertical elements into a further satisfying horizontal shape.

The shot was given strength by the low camera angle. The midday light is directly overhead, and hard, giving a sharp edge to the composition. There is no such thing as bad natural light for black and white photography. You just have to learn how best to use it.

Nikon FE, 80-200 mm at 100 mm, Ilford HP5, 1/500 sec., f11.
PROCESSING: Ilford Microphen.
PRINTING: Grade 2; 8 secs., f8; face on left burned-in 3 secs.; figure on right shaded 3 secs.

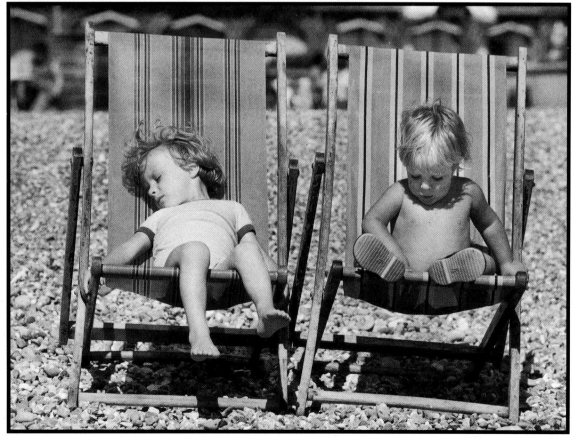

The shot that counts

I asked my six-year-old son Matt, who had just come home from school and was changing his clothes, to sit down for a "quickie" portrait. The result is one of my favourite pictures of him as a small boy. The spontaneity of the situation allowed me to capture that rascally expression so often found in boys of that age. Be prepared to make the first shot the only shot when photographing children because they will soon start to pose or become tense and conceal their real personality.

Here I had the added benefit of a benign north light and a darkish background that offered no distraction.

Nikon F3, 85 mm, Ilford HP5, 1/125 sec., f5.6.
PROCESSING: Ilford Microphen.
PRINTING: Grade 3; 12 secs., f8; shadow side of face shaded 2 secs.

Using a low camera angle

OPPOSITE RIGHT: *A formal portrait of Matthew. He chose to be photographed in his football outfit. I could have insisted that he clean his boots and the ball, or at least tie his laces, but then it would not have been him. Instead, his vitality and strength shine through. To capture a child's personality, it is best to let the subject convey his or her own self image. Sticking to your idea of that personality can kill the picture's authenticity.*

For posed portraits of children it is best to adopt a low camera angle – not only because it is less intimidating to them, but also because it usually produces a result that is more dignified and more dynamic as a composition. Like the informal study of Matt, far left, this picture was taken in daylight from a north-facing studio window. In the absence of this sort of light you can achieve a similar result by bouncing flash off a white umbrella or board, or even a white sheet, onto the subject. The lighting need be no more complex than this.

When shooting with black and white film in a studio in daylight I always rate my film slower than the manufacturer's recommended speed, to avoid thin negatives that lack shadow detail.

Hasselblad, 80 mm, Ilford HP5 (rated at ISO 250), 1/60 sec., f5.6.
PROCESSING: Ilford Microphen.
PRINTING: Grade 3; 8 secs., f8.

Photographing a group

Group pictures of children, in or out of the studio, are never easy. In this shot I aimed to create a particular mood without imposing my interpretation on the group. I used an old camera-tent fly and borrowed some tea chests and planks. Some moody music helped create the serious, streetwise feel that I wanted. I made a sketch of the kids' positions before they arrived, partly for the composition but also to give them confidence in how I handled the shoot. When we got started (the whole session lasted only fifteen minutes) I needed to make just two positional changes.

I always use a tripod for pictures of children. This centers their attention and frees my hands to entertain them and "conduct" the shoot. When working with children it is essential to stay relaxed yet not lose, or even appear to lose, control of the situation. You need to hold the attention of all of the children all of the time. To do this, it helps to have an idea before the session of what you want and to prepare accordingly.

Hasselblad, 50 mm, Ilford HP5 (rated at ISO 300), 1/30 sec., f8.
PROCESSING: Ilford Microphen.
PRINTING: Grade 2½ (Multigrade); 16 secs., f8; gradual shading from left to right: figures on left received 12 secs., on right, 16 secs.

Maintaining depth of field

For this set-up shot I lay on my stomach and had Matt's friends aim a volley of balls at him. Film of ISO 3200 allowed me to use a fast shutter speed with a smallish aperture. This would still give me good depth of field even if I were to focus clumsily because of the speed of the action.

I framed the shot with a generous space to the left of the goalkeeper so that he would appear small in relation to the net. Its expanse reinforces the notion that Matt is still only a boy, although even a full-grown goalkeeper can feel small as he stands guard.

In situations such as this, where there is a lot of light to fool the camera's meter and cause underexposure of the figure, first take a light reading from the subject's face or your hand.

Nikon F301, 80-200 mm zoom at 150 mm, Kodak TMX 3200, 1/2000 sec., f11.
PROCESSING: Kodak T-Max.
PRINTING: Grade 4 (Multigrade); 8 secs., f8; ball and net burned-in 10 secs.

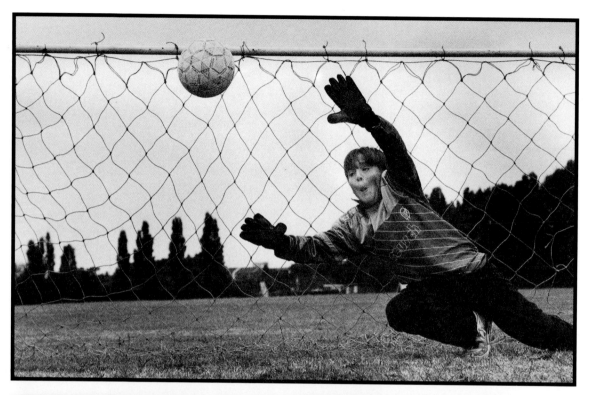

Exposure compensation

Nick was filled with joy at the fresh fall of snow. While snow has exciting graphic potential for black and white pictures, exposing for it requires great care. Having taken a reflected-light reading with the camera or a hand-held meter, I overexpose by 1½ stops. This ensures that the negative retains the tonal detail that I may require at the printing stage.

Nikon FE, 80-200 mm zoom at 80 mm, Ilford HP5, 1/125 sec., f8.
PROCESSING: Ilford Microphen.
PRINTING: Grade 2½ (Multigrade); 12 secs., f8; face burned-in 8 secs.

104

Graphic tonal contrast

The boys were firing their water pistols at the targets when I arrived, but it did not take a genius to predict that they would turn them on each other at any moment. I used fast film for a grainy, gutsy feel and a zoom lens at a moderate telephoto setting to take me right into the action. Never hesitate to confront the action when an opportunity like this presents itself to you. At least I managed to grab three shots before getting sprayed with a jet of water myself!

Apart from capturing the spirit of horseplay, what makes the picture work for me is the frozen white spray against the dark background. Achieving a satisfying separation of tones becomes almost automatic with practise.

Nikon F301, 80-200 mm at 200 mm, Kodak TMX 3200, 1/1500 sec., f11.
PROCESSING: Kodak T-Max.
PRINTING: Grade 2½ (Multigrade); 12 secs., f8; background and spray burned-in 10 secs., highlight area on left burned-in 20 secs.

Instant decisions

*I peeped around the door unnoticed
to capture my son Matthew listening
to his grandmother, who was
reading him a story. The best way to
achieve a reasonable success rate
with "spontaneous" shots like this is
to practise at every opportunity,
since you must focus, compose and
choose the ideal moment (in this
case, the yawn) in a split second.*

Nikon FE, 105 mm, Ilford HP5, 1/60
sec., f4.
PROCESSING: Ilford ID-11.
PRINTING: Grade 4; 15 secs., f8;
Matthew's face burned-in 4 secs.,
Nanna's face shaded 5 secs.

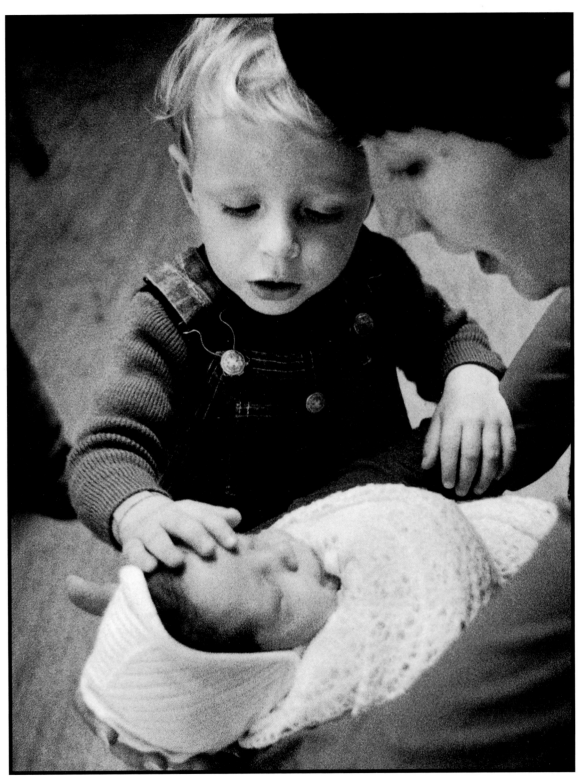

Using a fast film for atmosphere

I wanted a permanent record of the moment when my elder son Nicholas saw his new-born brother Matthew for the first time. I thought about using flash because the light in the hospital was very low. But since flash is often intrusive and harsh, killing the tender atmosphere of an occasion like this, I decided to shoot with a fast film instead and uprate it to ISO 1600. Later, I pushed the development to compensate for uprating the film, but it was a difficult picture to print. It was well worth the effort, though, because photographs of important family events are treasured for years, if not generations.

Nikon FE, 35 mm, Ilford HP5, 1/30 sec., f1.4.
PROCESSING: Ilford Microphen (pushed 2 stops).
PRINTING: Grade 3; 10 secs., f8; baby's face burned-in 7 secs., shawl burned-in 20 secs.

Nature

Colour photography allows us to reproduce the world of living things with great accuracy. Yet nowadays many photographers are turning to black and white as a means of exploring the more subtle aspects of natural subjects. Black and white nature photography highlights those characteristics that are best explored without colour: shape, form and texture. The emphasis is on the photographer's own interpretation of the subject. In this respect the wide exposure latitude of black and white film is very useful because the subject can be made lighter or darker than reality (darkening rocks or bark, for example, creates a greater sense of drama).

Follow the example of the early masters of nature photography in black and white, such as Edward Weston, who were excited by the rhythms, textures and patterns of natural objects, and went to great lengths to discover the best lighting to convey these qualities. Wynn Bullock expressed this approach to the natural world thus:

"I didn't want to tell the tree or weed what it was. I wanted it to tell me something and, through me, express its meaning in nature."

Static subjects are full of possibilities, but creatures in motion add another dimension to nature photography. In a black and white picture it is the graphic shape of the moving subject that provides the main interest. The best way to develop your skill in this area is to photograph pets or animals in zoos (always seek permission before you photograph caged animals). As with other moving subjects, you should try to anticipate the peak of the action. Although the technical demands are similar to those of sports photography, when you are photographing animals the element of unpredictability is greater, so you must be prepared to use a lot of film to get a reasonable number of successful shots. As with other types of action photography, it is best to carry a versatile selection of lenses, but not to burden yourself with equipment. Zoom lenses will save weight by replacing several prime lenses.

Texture as subject

It is possible to take close-up shots of trees for years and not tire of the subject. I shot this characterful ancient oak in Richmond Park, near London. I added the leaf in a strategic position to provide a focal point amid the swirling pattern.

The air was perfectly still, so I was able to use a slow film (ISO 50) to enhance sharpness and grain. The correspondingly slow shutter speed made a tripod and a cable release necessary. I used a green filter to lighten the tone of the leaf and to increase overall contrast. A soft, overcast light enabled me to gain detail in both the shadows and the highlights without needing to soften the development.

This subject, perfectly suited to black and white, would also have responded well to a large-format camera. The minimal enlargement required would have made possible a superb print that showed off the texture to the full.

Nikon F2, 105 mm (macro), Ilford Pan F, 1/4 sec., f16. Green filter.
PROCESSING: Ilford Microphen.
PRINTING: Grade 3 (Multigrade); 12 secs., f8; leaf shaded 2 secs.

Exploring light and shade

I was attracted to this palm frond because of the relationship in terms of light values that existed between the leaf and the background. Since I did not have a spot meter, I used the camera, with an 80-200 mm zoom lens set at 200 mm, to take a close-up light reading. For the shot itself I used the lens at 120 mm.

Nature photography in black and white is an exploration of light and shade and of pattern. The permutations are infinite.

Nikon F2, 80-200 mm zoom at 120 mm, Kodak TMX 100, 1/500 sec., f8.
PROCESSING: Kodak T-Max.
PRINTING: Grade $2\frac{1}{2}$ (Multigrade); 15 secs., f8; light edges of leaf burned-in 5 secs.

Modifying tones

The background to this short-range study of a Koala in captivity was a mess of wire and other distracting elements, so I used a hand-held flash to alter the balance of tones so as to emphasize the animal. The koala became lighter and the background 3 stops darker than the reading the daylight had given. The sharp light provided by the flash also revealed crisp detail in the fur.

Nikon F301, 80-200 mm zoom at 150 mm, Ilford HP5, 1/250 sec., f11.
PROCESSING: Kodak D-76.
PRINTING: Grade 3 (Multigrade); 15 secs., f8.

Using fill-in light

Bessy, one of the family pets. The garden was strongly lit by a low-angled winter sun. I used a white reflector to bounce light onto Bessy. The light tones of the dog and the tulips work well against the dark background, but I needed the fill-in light provided by the reflector to record detail in the main subject. Fill-in flash would have achieved a similar result, but I prefer to use a reflector if possible because I can see exactly how the light is falling and assess it with a meter before shooting.

Nikon F301, 135 mm, Ilford HP5, 1/250 sec., f5.6.
PROCESSING: Kodak D-76.
PRINTING: Grade 3 (Multigrade); 15 secs., f8; background above dog burned-in 10 secs.

Using a box frame

This close-up shot was made on location with the help of a collapsible box frame. The frame has three sides, and the camera is placed where the fourth would be. Each side panel can be interchanged with other panels to provide a range of functions. The panels can be diffusers that soften light passing through them, or can be used to reflect or absorb light. The background panel can be black, white or gray, or it can be removed to provide a natural background for the subject. A diffusing panel can also be used on the top of the box. Apart from giving subtle lighting control, the box frame is an effective wind-break in the field.

This shot was taken with a black background, with the top and one side open, and with a white reflector panel opposite the open side. I used a 105 mm macro lens and a tripod. A reliable tripod that allows the camera to be used close to the ground is very useful for most nature photography.

Nikon F2, 105 mm (macro), Ilford HP4, 1/4 sec., f16.
PROCESSING: Ilford Microphen.
PRINTING: Grade 3 (Multigrade); 15 secs., f8.

WILDLIFE PHOTOGRAPHY

☐ Use an experienced guide to help you locate animals.

☐ Avoid travelling with large groups since they tend to disturb animals and shake the vehicle when shooting.

☐ Use only a four-wheel drive vehicle.

☐ Use a bean bag or a special window support for the camera when shooting through the window or out of the roof of the vehicle.

☐ Carry fast film since many animals are most active early in the morning and in the evening, when light is low.

☐ Use a lens of at least 300 mm since many shots will only be possible from a distance.

Matching medium and subject
The zebra must have been conceived with the black and white photographer in mind. I photographed the striking creatures in these two pictures in Kenya and cropped the shots tight in the darkroom. They do not pretend to be natural history studies, just a visual game with what their creator so generously provided.
Nikon F3, 300 mm, Ilford HP5, 1/500 sec., f5.6.
PROCESSING: Agfa Rodinal.
PRINTING: Grade 4 (Multigrade); 15 secs., f8 (top picture); 11 secs., f8 (bottom picture).

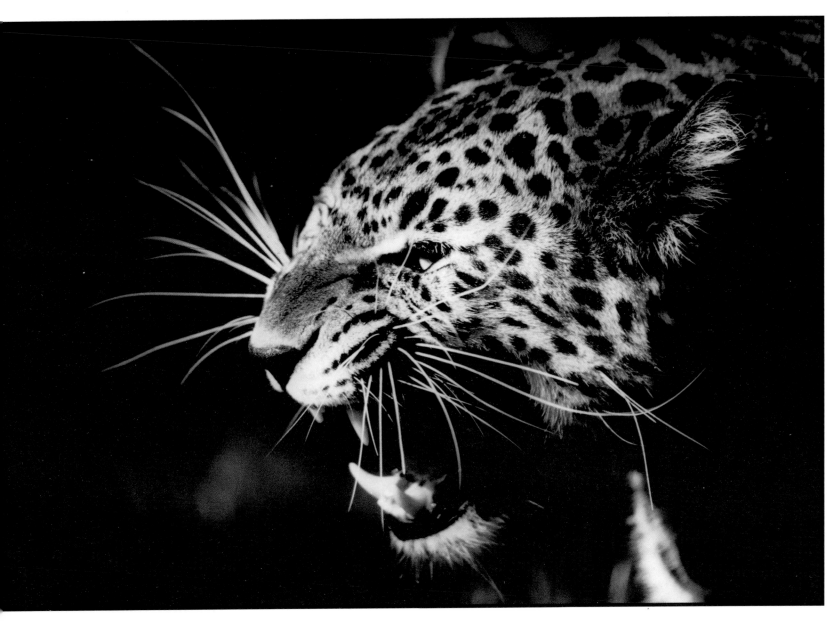

Photographing caged animals

I originally shot this picture in colour but later decided that it would have at least as much impact in black and white. The shot works well in black and white because of the marked tonal separation. By burning-in the head I made a high-contrast print that emphasized the spots, the whiskers and the fearsome teeth. I was at a zoo with a keeper and was allowed to place my camera right on the bars of the cage. Because of their closeness, the bars did not register on film. However, you should never do this without the guidance of a keeper, since big cats are extremely fast. Often, if you are genuinely interested in the animals, a keeper will give you useful tips on their behaviour so that you can get good pictures in complete safety.

Nikon F3, 80-200 mm zoom at 180 mm, Ilford FP4 interneg from Fuji 100, 1/250 sec., f4.
PROCESSING: Ilford Microphen.
PRINTING: Grade 4 (Multigrade), 15 secs., f8; head burned-in 4-7 secs.

Sport and Action

Black and white film is particularly appropriate for photographing floodlit sports events because in artificial light of any kind there are none of the colour-balance problems that make colour film difficult to work with in such situations. And the new ultra-fast, high-grain films (see pp. 34-5) allow you to shoot without using flash equipment and to set the fast shutter speeds needed to "freeze" action, even with a relatively slow long lens. (Fast telephotos, some of which have apertures as wide as f2, are available, but their high cost is prohibitive to all but the professional sports photographer.)

Whatever film you have in the camera, the key to photographing sport and action is anticipation. Your finger must be squeezing the shutter release, with focus and exposure already taken care of, before the action peaks. The only way to be in this state of readiness is to know as much as possible about the sport or other activity you are shooting. You can then predict the action and perhaps capture it at its peak. Prefocusing on a spot that will be crossed by your subject is clearly a useful ploy. Knowing what is likely to happen when, say, an athlete realizes that he is being overtaken or a football player is tackled, allows you to foresee and frame a telling shot. Creating an effective composition requires more than being able to predict the peak of the action. A zoom lens is invaluable, for it is seldom possible to change lenses on the spur of the moment. When photographing a building, you can move farther away and reframe, but at the ringside or athletics track there is no such choice.

Exploiting fast film
I took along colour and black and white film, but the strong shapes formed by the contortions of the rollercoaster, right, were made for black and white. I planned the composition in terms of both its visual impact and its narrative strength. The 80-200 mm zoom allowed accurate framing from a fixed position. I wanted good depth of field, with the curved structure sharp from foreground to background. I also needed a shutter speed fast enough to freeze the all-revealing expressions on the riders' faces. Therefore I chose Kodak TMX 3200 and exposed it at ISO 2400, which allowed (with an infinitely variable shutter) a speed of about 1/1500 sec.
Nikon F301, 80-200 mm zoom at 180 mm, Kodak TMX 3200, approximately 1/1500 sec., f16.
PROCESSING: Kodak T-Max.
PRINTING: Grade $3\frac{1}{2}$ (Multigrade); 12 secs., f8; faces burned-in 3 secs.; trees shaded 4 secs.

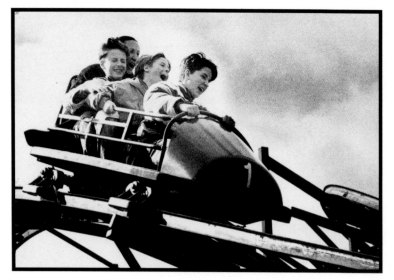

Symbolic detail
A 300 mm lens produced a tight composition that, by concentrating on the facial expressions, conveyed the exhilaration of speed. It took several attempts, though. For action photographs you will need to shoot many frames for every one that successfully captures movement. Black and white film allowed control of detail in the faces during printing.
Nikon F301, 300 mm, Kodak TMX 3200, 1/2000 sec., f11.
PROCESSING: Kodak T-Max.
PRINTING: Grade $2\frac{1}{2}$ (Multigrade); 10 secs., f16; faces shaded 3 secs.; sky burned-in 25 secs.

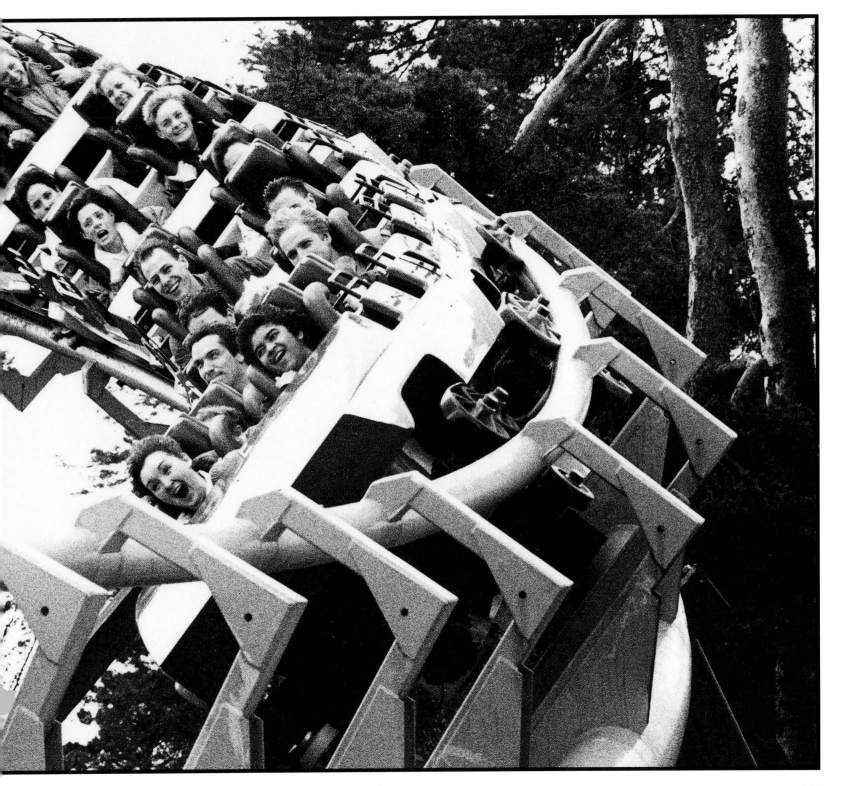

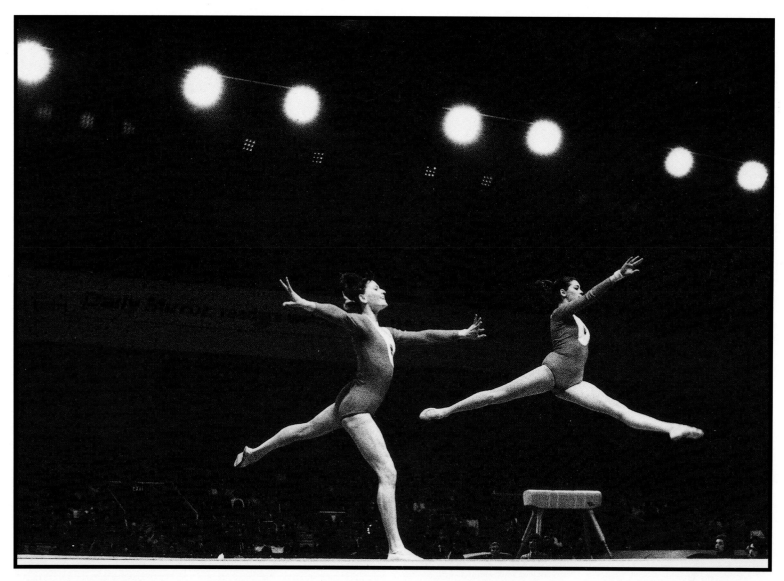

Composing moving elements

When you are shooting a sport or a stage performance indoors in artificial light (flash is usually prohibited because it distracts the performers) it is essential to think carefully about the exposure. The dark background of this picture would have misled the camera's meter, causing overexposure. Before the display began I took light readings from my hand and the background. The difference between them was four stops, so I knew that

there would be a contrasty separation of tones.

My first impression of the action was the amazing height achieved by the gymnasts. To best illustrate this I shot from the level of the floor. It was lucky that there was a vaulting horse in the background, for by including this as a small element of the shot I could make the leaping gymnast appear to soar even higher. I took many combinations of the two figures and chose this one because of the composition. The line of the

leaping gymnast's backward-stretched leg is gracefully followed through by the outstretched leg of the other gymnast. Black and white was the ideal medium for capturing the graphic unity of their shapes. When photographing fast-moving team sports you need to be familiar with the sport in order to anticipate exciting action. However, in situations like the one shown above, you can simply consider the subject as moving shapes and shoot when the configuration excites you.

Nikon F2, 105 mm, Ilford HP5 (rated at ISO 1000), 1/250 sec., f5.6.
PROCESSING: Ilford Microphen, pushed to compensate for rating ISO 400 film at ISO 1000).
PRINTING: Grade 3½ (Multigrade); 12 secs., f8; area around lights burned-in 15 secs.

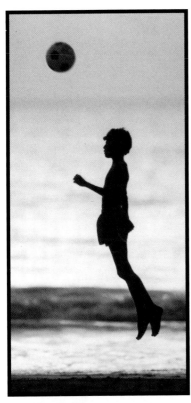

Peak of the action

The moment when movement seems to reach a limit and ceases for a split second is described as the peak of the action. Here, you need to know as much about the sport or kind of action you are photographing as about handling the camera.

For the picture on the left, I framed the subject with a long lens and exposed to create a silhouette. This technique is particularly well suited to black and white photography, with its emphasis on shape and tonal contrast.

Nikon FE, 300 mm, Ilford HP5, 1/250 sec., f5.6.
PROCESSING: Ilford ID-11.
PRINTING: Grade 3 (Multigrade); 10 secs., f8.

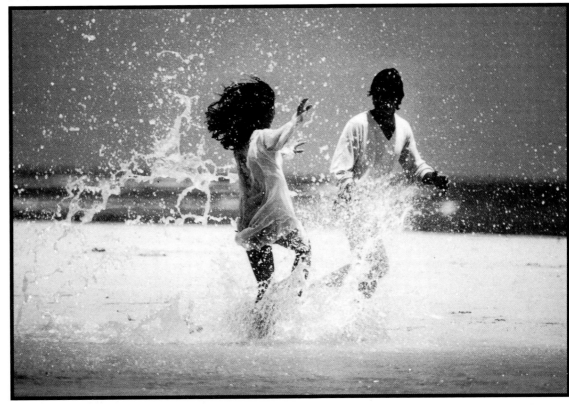

"Freezing" movement coming toward the camera

In the shot on the left the man's movement was "frozen" by a shutter speed of 1/125 sec. If he had been running across the frame 1/250 or 1/500 sec. would have been needed. I prefocused in front of him and shot immediately as he came into focus.

Nikon F2, 500 mm (mirror lens), Ilford FP4, 1/125 sec., f8.
PROCESSING: Ilford ID-11.
PRINTING: Grade 3; 8 secs., f8; bottom third burned-in 4 secs.

Seeing what the eye misses

The electronic shutters on the latest 35 mm SLR cameras operate at speeds as fast as 1/2000 sec. (in some cases up to 1/8000 sec.), so that you can freeze action too fast for the eye to visualize.

The photograph above, taken at 1/2000 sec., "froze" the spray in a way that I could not have planned with any precision. However, I did know that the use of a red filter with black and white film would both darken the sky and make the momentarily static water more pronounced in the print.

Nikon FE2, 400 mm, Ilford HP5, 1/2000 sec., f11. Red filter.
PROCESSING: Kodak D-76, pushed 1 stop.
PRINTING: Grade 3; 12 secs., f8; sand burned-in 10 secs.

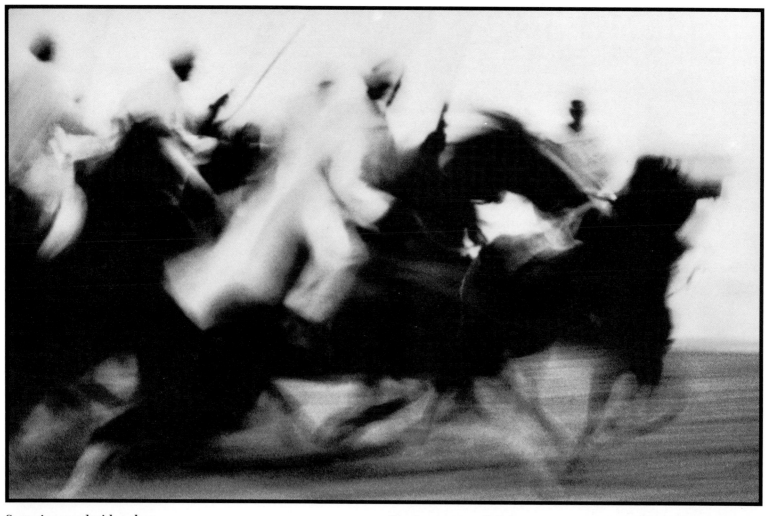

Capturing speed with a slow shutter

With fast-moving subjects it is not possible to predict the exact tonal distribution, but you can visualize roughly where the dark and the light swirls of tone will occur. The more abstraction you require, the slower the shutter speed needed. I photographed these Moroccan horsemen at 1/15 sec.
Nikon FE, 90-200 mm zoom at 200 mm, Ilford HP5, 1/15 sec., f16.
PROCESSING: Ilford Microphen.
PRINTING: Grade 2 (Multigrade); 12 secs., f8; horses and beach shaded 5 secs.

The importance of timing

OPPOSITE: *Calcio storico is a form of football played in Florence that dates back to the fifteenth century. The Medici used it as military training – a minute into the game and you can see why. It is among the most vigorous of ball games and is made all the more striking to watch by the period dress worn by the players.*

The picture shows one of the most admired tactics, a violent kick at the leg of the man with the ball. Having witnessed this tackle several times, I was able to anticipate the next time. As has been wisely said of sports photography, if you see it happen in the viewfinder it is already too late. A motordrive or an autowinder on single-shot setting will allow you to keep your eye at the viewfinder and concentrate on focusing and capturing the moment. Use a fast film, so that you can use a fast shutter speed and a small aperture for extensive depth of field. Nikon FE, 300 mm, Ilford HP5 (rated at ISO 1000), 1/500 sec., f8.
PROCESSING: Ilford Microphen, pushed to compensate for rating ISO 400 film at ISO 1000.
PRINTING: Grade 2 (Multigrade); 10 secs., f5.6; all highlight areas burned-in 4-15 secs. Print cropped tight.

Architecture

Black and white film is a classic choice for any architectural photograph where you want to pay attention to the effects of light on a building's basic shape, structure, line or form, rather than to aspects of its colour or texture.

Elliott Erwitt, a fine reportage photographer, took on a massive project – to photograph the one hundred and fifty most important buildings in the USA. On completing the assignment, the photographer commented, "You can't just walk up to a building and take a picture of it. You have to get up early to see it in the early light. You have to navigate around it, figuring out its best angles, its worst. There are even times when you have to figure out a way to flatter it a little."

Ask yourself the questions Erwitt must have asked himself on seeing each building. What sort of light suits it best? Early morning? Late afternoon? Dusk, with the lights on? Hard light? Overcast conditions? Buildings are still-lifes, but you can't move them about. To get the best from the prevailing light and to achieve the composition you want, you must move the camera, often farther, or higher, than you imagined.

Architectural detail
To give full coverage to architectural subjects you need to include shots of detail such as this one from the amphitheater shown on the right. There was abundant cross-lighting to capture the relief, so I was able to shoot without a tripod. If the light had been flat and unsympathetic, I would have used a small hand-held flash at 45 degrees to the camera to provide sharp, contrasty light.
Nikon FE2, 55 mm (macro), Ilford FP4, 1/500 sec., f8.
PROCESSING: Ilford Microphen.
PRINTING: Grade 2 (Multigrade); 7 secs., f8.

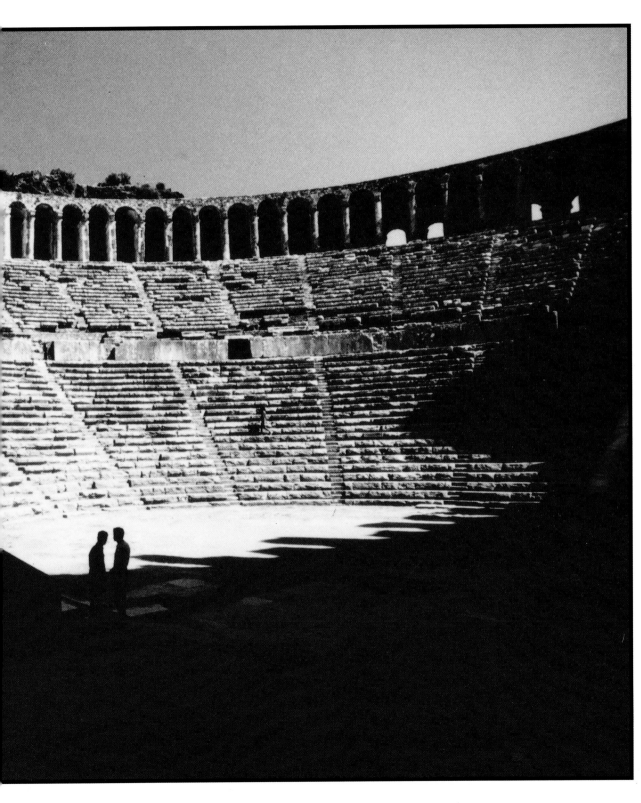

Exposing for the highlights

The photographer who travels will encounter unfamiliar styles of building that are worth recording both as a souvenir and as straight architectural studies. However, since we may never get another opportunity to photograph a particular location, we must make the best of the light available at the time. When I arrived at this Roman amphitheater in southern Turkey it was mid afternoon, very hot, and with very hard light and deep shadows. I decided to expose for the highlights and to let the shadows go black (they would then hide the unsightly rubble and the garbage left by tourists). I used an orange filter to increase the tonal contrast still more and to render the dark-blue sky a dark gray. A relatively small aperture (f16) provided the extensive depth of field that was appropriate for the subject.

I took several pictures with an 18 mm lens, and kept the camera level since tilting it up would have destroyed the symmetry that was an essential part of the scene. But the shots lacked a sense of scale, so I asked two tourists to stand in position for a picture, and their presence solved the problem.
Nikon FE2, 18 mm, Ilford FP4, 1/250 sec., f16. Orange filter.
PROCESSING: Ilford Microphen.
PRINTING: Grade 3 (Multigrade); 10 secs., f8.

Geometrical exercise

I cropped in tight on this house, a typical French colonial mansion in the Seychelles, to emphasize the geometrical symmetry of the design – the rectangular shutters, the triangular roofs and the horizontal lines of the weatherboard. Here there was clearly no need for colour, since the point of the picture is the interplay of shapes. I prevented the verticals converging by shooting from a distance with a long lens.

The palms provided a contrast in shape with the strict geometry of the house and served to identify its location as tropical. The little girl came out while I was shooting. I preferred the frames that included her since she humanized the subject, which is, after all, domestic architecture.

Nikon FE, 80-200 mm zoom at 150 mm, Ilford FP4 interneg from Kodak Ektachrome 64 original, 1/125 sec., f8.

PRINTING: Grade 2½ (Multigrade); 10 secs., f8.

Controlling perspective

Melbourne's inner suburbs comprise street after street of these elaborate Victorian colonial terraces with their "wedding-cake" decoration and ornamental wrought-iron balconies. A notorious problem with architectural shots is that vertical lines appear to converge unattractively so that the building looks as if it is toppling backward. For this photograph I adopted the usual solution: I used a perspective-control (PC) lens. This allows you to vary the position of the image in the viewfinder and at the same time keep the camera parallel with the ground, avoiding optical convergence. An alternative approach would have been to use a large-format camera with a rising front to correct the verticals.

If you have neither a PC lens or a camera with a rising front, there are two ways to render verticals straight. Either use a high camera angle so that the camera is halfway between the top and the bottom of the building (though this is seldom possible) or move farther away from the building and use the longest lens you have. For architectural pictures a tall tripod and a stepladder increase flexibility by allowing, respectively, long exposures and variable camera angles. To obtain ultra-fine grain and high resolution I shot with a very slow (ISO 25) film.

I made several exposures, but the dull light was a problem. I decided to wait in case the sun's last rays should burst through the low gap in the cloud that I had noticed. A little later the sun lit up the house like a spotlight. I used no filters – the contrast in this shot is purely that of the spotlit white house against mid-gray clouds.

Nikon F3, 28 mm (PC), Agfa APX25, 1/125 sec., f8.
PROCESSING: Agfa Rodinal.
PRINTING: Grade 3 (Multigrade); 14 secs., f8.

Experimenting with shape and tone

In the photograph below I experimented with three compositional elements – the skyscraper, the buildings facing it, and the incongruous slightness of the streetlight. I chose a very wide-angle (18 mm) lens to exaggerate the perspective.

In colour the juxtaposition of shapes might have been as dramatic, but the use of black and white adds another dimension, for the shot is also an exercise in arranging blocks of tone – dark to light to dark. The streetlight bridges the tonal gulf that separates the buildings.
Nikon FE, 18 mm, Ilford Pan F, 1/125 sec., f5.6.
PROCESSING: Ilford ID-11.
PRINTING: Grade 2 (Multigrade); 8 secs., f8; buildings on left shaded 4 secs.

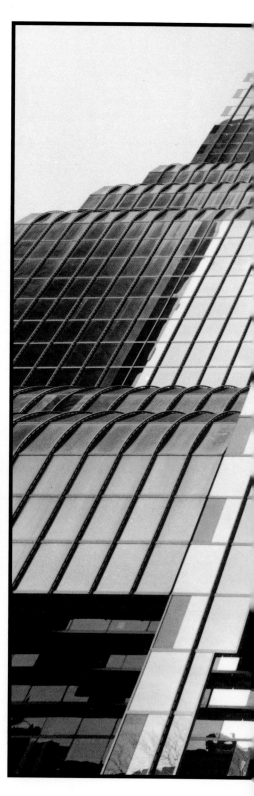

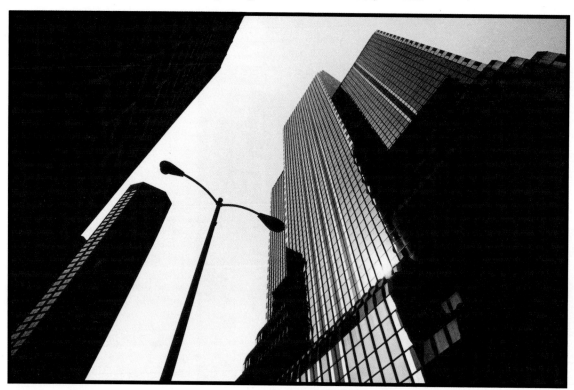

The personality of a building

With the shot right, taken in Chicago, I tried to convey the ordinary person's view of a skyscraper, as against the perspective-corrected picture a professional photographer would take for an architect. As with any theme, a good architectural photograph captures how the photographer feels about the subject. Modern buildings are not all anonymous structures with a cold, clinical beauty. They relate to their surroundings by reflecting details of other buildings and by mirroring the ever-changing appearance of the sky. The tonal variety in this building was provided largely by the reflections of those opposite. Parts of it stood out white against the dark reflections and black against the pale reflections of the sky.

I mounted my camera on a tripod and square-on to the semicircular entrance. Since the tonal range of the subject was extreme, I decided to make an exposure that averaged the highlights and the shadows. A slow, high-resolution film provided maximum sharpness and hard edges in keeping with the clean lines of the building.
Nikon FE2, 24 mm, Ilford Pan F, 1/60 sec., f8.
PROCESSING: Ilford ID-11.
PRINTING: Grade 2 (Multigrade); 8 secs., f8; all highlight areas burned-in 10-20 secs., entrance shaded 2 secs.

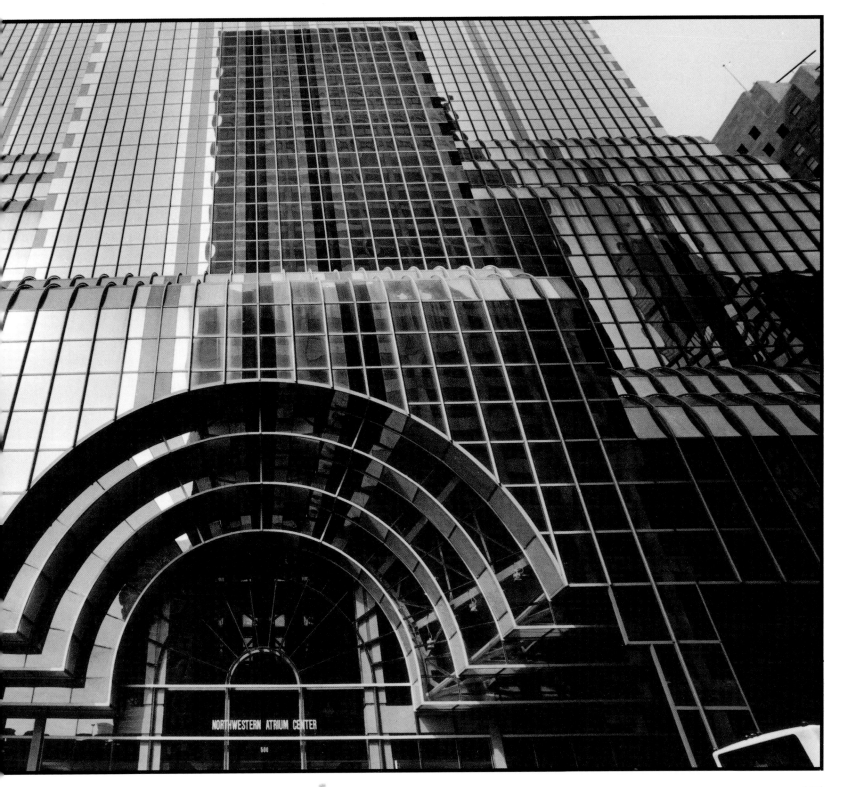

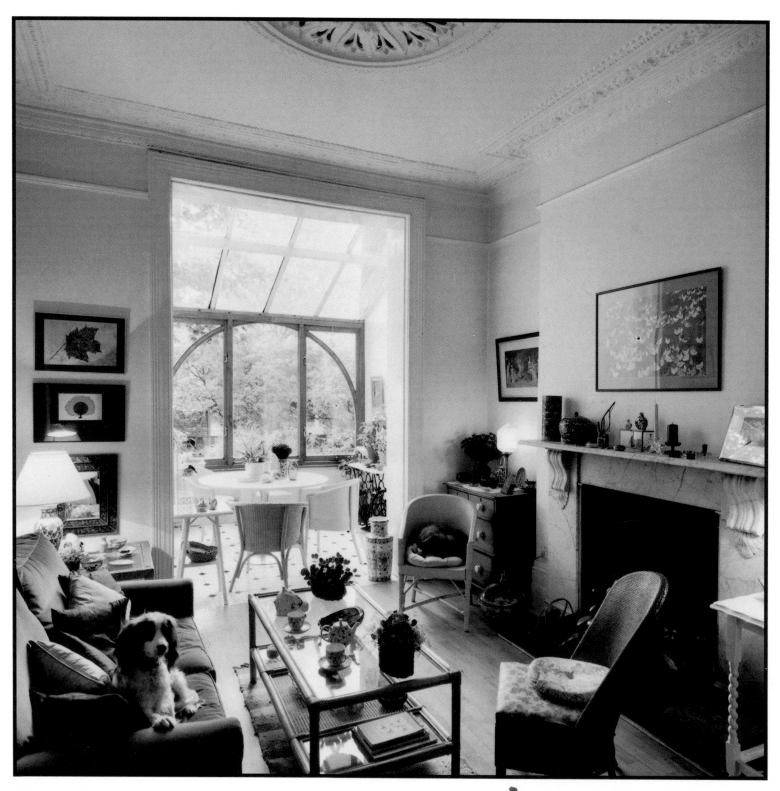

Avoiding distortion of verticals

OPPOSITE: *This interior shot was taken in my home. If I had tilted the camera to capture the full height of the room (13 ft/4 m) the verticals would have been distorted by the wide-angle lens required for such a picture. Even a slight amount of distortion of this kind can spoil an interior. Therefore I set the medium-format camera on a tripod at half the room height and used a level to make sure that it was absolutely square.*

Next, I arranged the room carefully to achieve a composition that was satisfying in terms of the juxtaposition of shapes and tones. The table is parallel to the sofa, the chair in the foreground is framed by the black rectangle of the fireplace, the bowl of flowers is dark against the tiles.
Hasselblad, 40 mm, Ilford FP4, 2 secs., f16.
PROCESSING: See page 143.
PRINTING: Grade 2 (Multigrade); 14 secs., f8; conservatory burned-in 6 secs.

Exploiting wide-angle distortion

For this shot of a Parisian stairwell, I used to advantage the slightly exaggerated perspective produced by a wide-angle lens. Shooting another person's creative work always involves the risk of imposing your own view on it. Here, however, I felt that the framing and the camera angle produced a result that was sympathetic to the architect's intentions. The main light was from a skylight, but I used electric light to fill the shadows.
Nikon F2, 24 mm, Ilford FP4, 1 sec., f11.
PROCESSING: Ilford Microphen.
PRINTING: Grade 2½ (Multigrade); 8 secs., f8; highlight areas burned-in 6-15 secs.

Still-life

After exhaustive experimentation with lighting, exposure, films and developers, Edward Steichen said of one of his still-life pictures "There, for the first time in a photograph, I am able to sense volume as well as form." That was at the turn of the twentieth century, but still-life photographers continue to be obsessed by the challenge of conveying the immediacy and beauty of static subjects. Total control over the subject makes a wide range of interpretative choices possible. The still-life photographer must make crucial decisions regarding composition, lighting and viewpoint. Nothing is left to chance, and so each picture is a reflection of the photographer's technical skill and imagination.

Still-life is a foundation stone of black and white photography because it allows you to make a studied exploration of shape, form, texture and tone – the essential components of composition in this medium. The ability to visualize how colours will translate into tones is at the heart of black and white photography. Still-life photography helps you to develop a particularly strong grasp of this skill.

To create a successful still-life you must pay great attention to both composition and lighting. Begin by choosing a background because this can have a great influence on the final picture. You must decide whether you want it to be complementary, contrasting or simply neutral. Next, start with one object and add others to build up a pleasing design, paying attention with each additional element to the changing lighting requirements, as well as the composition.

For your first experiments with still-life photography use only natural light. Explore the different effects that are made possible by moving the subject, by diffusing the light with a translucent medium, or by using a reflective surface to cast a soft light onto the subject. Then progress to a single artificial light source (see p. 30), arranged so that all the shadows fall in the same direction (this gives a natural look to the composition).

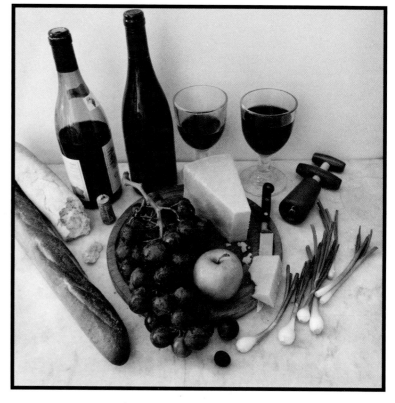

Composing a still-life in tones
The components of a still-life should be distinguishable but linked by the overall design. The platter above gave me a circular shape around which to arrange the other items. Since I was shooting in black and white, I arranged the objects to emphasize their tonal differences. A good compositional guide in shots like this is to surround a dark tone with light tones, and vice versa. The distorted perspective (produced by using a wide-angle lens from a high viewpoint) draws the eye into the shot and seems to complement the circular arrangement, so I decided not to correct the verticals by using a perspective-control (PC) lens. Hasselblad, 50 mm, Ilford FP4, 1 sec., f11.
PROCESSING: Kodak D-76.
PRINTING: Grade 3 (Multigrade); 16 secs., f8; highlight areas burned-in 3-7 secs., grapes shaded 5 secs.

Using repeating shapes
OPPOSITE: *For this shot I first positioned the platter. To create depth and a contrast in shape I introduced the vessels, emphasizing their circular theme by adopting a viewpoint which showed the mouths as generous ellipses. I chose a long lens to minimize the distortion caused by this high viewpoint (compare picture above) and to compact the group by compressing the perspective. For an explanation of the lighting set-up, see p.32. Hasselblad, 150 mm, Ilford FP4, ½ sec., f22.*
PROCESSING: Kodak D-76.
PRINTING: Grade 3 (Multigrade); 15 secs., f8; platter shaded 5 secs., print flashed to render wall gray.

A study in shape and form

This shell from Kenya was shot on dark-gray paper and lit by a high window behind and above it. So perfect was its shape that all I aimed to do was to reproduce it as well as possible. Had I wanted a natural-history-style shot, I would have used colour film, but it was the shape and form I was interested in, so black and white film was ideal.

I rotated the shell by minute degrees toward and away from the camera until I found a position in which the light picked up the rim. I placed a white card bent into a semicircle between the camera and the shell to reflect light on to the underside of the shell. The long exposure required made it necessary to use a tripod and a cable release.

Setting up the shot is a major part of still-life photography. Unless you combine attention to detail with a willingness to experiment, you will be lucky to achieve success.
Nikon F3, 55 mm (macro), Ilford HP5, 2 secs., f22.
PROCESSING: Ilford Microphen.
PRINTING: Grade $2\frac{1}{2}$; 14 secs., f8; interior of shell shaded 3 secs., background burned-in 2-5 secs. to even the tones.

Photographing multiple subjects

To display the shells, right, I arranged them diagonally across a 2 × 2 in (6 × 6 cm) frame. I positioned the large shell first, and arranged the others so that they seem to tumble from it, as from a cornucopia. The placing of the individual shells was based on their shapes and the negative shapes (the spaces) between them. The negative shapes are particularly important in still-life studies because they can make or break the design. The pointed shell was used to provide a sense of movement across the shot.

The light from a strobe was diffused by a 6 ft (2 m) umbrella behind the set-up and bounced off reflectors in front of the camera. Daylight would have been just as effective at other times, but not in midwinter London.
Hasselblad, 50 mm, Ilford FP4, 1/250 sec., f16.
PROCESSING: Kodak D-76.
PRINTING: Grade $2\frac{1}{2}$ (Multigrade); 8 secs., f8; all highlight areas burned-in 2-10 secs., edges of frame burned-in 3 secs.

Sympathetic shapes

This shot came out of my experiments with juxtaposing shells of different shapes with the large shell. I had already placed this shell on a black background to define its outline and to set off the highlights produced by window light. It was relatively easy to find a shell of a dramatically different size that nevertheless echoed its semicircular, downward shape. But the arrangement needed something else, so I added the shell below it on the left which has, by contrast with the other two, an upward emphasis, yet is still sympathetic in shape to them both.

Nikon F3, 105 mm (macro), Ilford Pan F, 2 secs., f16.

PROCESSING: Ilford Microphen.

PRINTING: Grade 2 (Multigrade); 15 secs., f8; right side of large shell shaded 5 secs., small shells burned-in 5-8 secs.

Focusing the attention

Even the most mundane subject matter can make an interesting still-life. I picked the Coke can (opposite) and cigarette packet (above right) from the gutter. The Coke can presented the same problems of lighting and composition that an elegant piece of china would have done.

On looking closely at the cigarette packet (this sort of photography focuses the concentration wonderfully) I discovered that in the UK more than 30,000 people die each year from lung cancer. Do smokers notice this grim message? Or must you take still-life pictures for it to sink in?

The battered trainer is as much a portrait of the wearer as of the shoe itself. It has obviously been worn by someone (my son Matthew) who "gets a kick out of life."

All pictures: Nikon F3, 105 mm (macro), Ilford Pan F, 1/2 sec., f16.
PROCESSING: Ilford Microphen.
PRINTING: Can: Grade $2\frac{1}{2}$ (Multigrade); 7 secs., f8; highlights burned-in 4 secs.
Packet: Grade $2\frac{1}{2}$ (Multigrade); 14 secs., f8; shadow areas shaded 3-7 secs.
Trainer: Grade 3 (Multigrade); 10 secs., f8.

Using an auxiliary close-up lens
This ear belongs to one of my sons, who was a baby at the time. I was attracted to the idea of a close-up shot by the delicate form that light and shade described. I used an auxiliary close-up lens on a 105 mm lens and took the picture hand-held while my son slept.

An auxiliary lens of this kind does not reduce the light that reaches the film, so there is no need for exposure compensation. But it does diminish definition very slightly, which may be important if the shot must be ultra-sharp.
Nikon FE, 105 mm (with auxiliary close-up lens), Ilford HP5, 1/125 sec., f5.6.
PROCESSING: Ilford Microphen, pushed 1 stop.
PRINTING: Grade 3; 10 secs., f8.

Lighting with a ring flash

Because the lens must be very near to the subject for close-up work, it can be difficult to position a light source so that it gives shadowless and fully descriptive illumination. This eye was lit by a ring flash attached to the lens. The device produces enough light to enable you to stop down to f16 or f22. Because there is little subject depth in close-up shots, this sort of aperture will provide front-to-back sharpness.
Nikon FE2, 105 mm (macro), Ilford HP5, 1/250 sec., f22.
PROCESSING: Ilford Microphen.
PRINTING: Grade 3; 10 secs., f8.

Capturing detail in close-up

To light the shot on the left, I held a dedicated flash 1 ft (30 cm) above and to the side of the coin and bounced its light across the subject off a white card positioned on the other side of the coin. The low-angled flash provided cross-lighting which emphasized the relief of the coin.
Nikon FE2, 105 mm macro with extension ring, Ilford FP4, 1/250 sec., f22.
PROCESSING: Ilford Microphen.
PRINTING: Grade 3; 14 secs., f8.

Using extension tubes

To photograph tiny detergent bubbles that had formed on a glass bowl, I fitted extension tubes between the camera and a 55 mm macro lens. By extending the lens-to-film distance, the tubes enable the subject to be photographed at a magnification greater than × 1.
Nikon FE2, 55 mm (macro, with extension tubes), Ilford HP5, 1/250 sec., f8.
PROCESSING: Kodak D-76.
PRINTING: Grade 5 (Multigrade); 8 secs., f8.

The Art of the Print

For me, the great joy of black and white photography is still, after 25 years, to see the image magically come to life in the developer and to know that I can then print that picture just the way I want it. And yet the darkroom intimidates many because they assume that to get results at all you have to be half chemist and half electrician. This is certainly not true nowadays, when even the term "darkroom" itself is misleading. Loading film into the developing tank (in the 35 mm and 120 formats) is the only procedure that requires total darkness. Development takes place in a light-tight tank in room light and prints are made under a safelight. Darkroom chemicals are much simpler and more reliable than they were and versatile printing papers save time, effort and money.

Perhaps the most demanding – and rewarding – part of darkroom work is that which inspired the title of this chapter, "The Art of the Print." If you send your negatives to a laboratory to be printed by a machine programmed to meet average requirements you relinquish your creative control over a major area of black and white photography. You should develop and print your own pictures as much as possible. For without the insight into the medium that the darkroom gives, and without the chance to add your personal touch, your progress as a photographer will be slow – and you will miss half the fun of working in black and white.

The darkroom

The black and white photographer who has a spare room or can hire space will benefit from having a permanent darkroom similar to the one shown below. The ideal room is one that can be made light-tight, kept clean easily, ventilated adequately and devoted exclusively to darkroom work. It should be divided into a dry side (below) and a wet side (below, opposite) in which, ideally, running water is available. Separating the two sides minimizes the risk of contaminating unused materials. Position safelights in a convenient place at least 3 ft (1 m) from where paper is used. They should not be near the enlarger either, otherwise it may be difficult to focus the negative image. Use a wall-mounted heat source (not a free-standing appliance) to maintain the temperature at about 68° F (20° C), which will ensure the stability of most working solutions. Provide adequate storage space for chemicals, paper, negatives, prints and other equipment.

Dry side (below)
1 Negative files
2 Print trimmer
3 Adhesive tape
4 Lightbox
5 Retouching tools
6 Straight edges
7 Safelight
8 Cutting mat
9 Focus magnifier
10 Enlarger
11 Dodgers
12 Masks
13 Enlarger timer
14 Paper store
15 Waste bin

Wet side (opposite bottom)
1 Funnels
2 Mixing beakers
3 Developing tanks
4 Film spirals
5 Lightbox
6 Thermometer
7 Developing dishes
8 Tongs
9 Paper towels
10 Squeegees
11 Sink
12 Film clips
13 Timer
14 Safelight
15 Film dryer
16 Chemical store

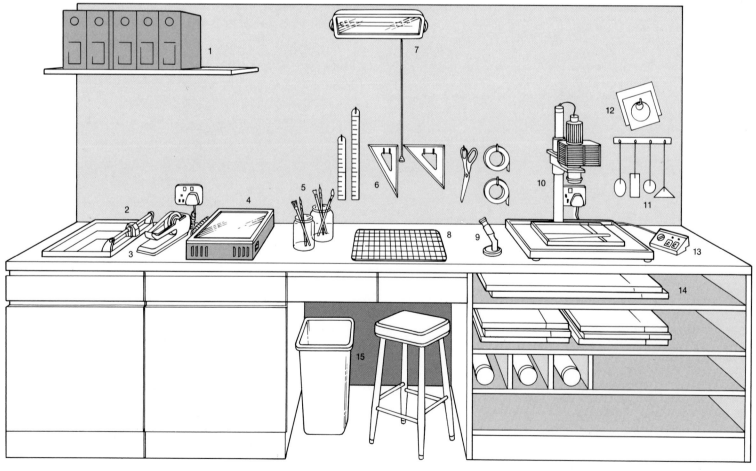

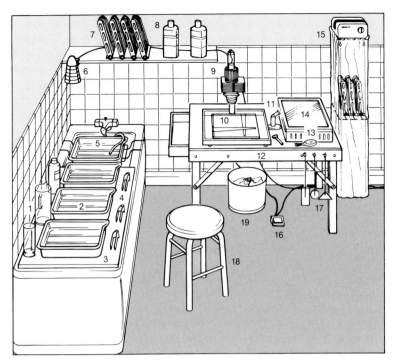

Temporary darkroom

If you do not have a spare room or even an understairs cupboard that can be set aside as a permanent darkroom, a bathroom or other suitable room can double up as a temporary darkroom. It can be set up along the lines of the bathroom darkroom shown on the left. However, as long as the need for safety is observed, particularly where electricity and water are near one another, there is much scope for improvization. The equipment should be arranged so that it can be stored away easily after each session and the room restored to its main use. In this example, power for the enlarger is provided by means of a cable from outside the bathroom.

Key

1 Mixing beakers
2 Developing dishes
3 Bench with non-spill lip
4 Tongs
5 Washer
6 Safelight
7 Print drying rack
8 Chemicals
9 Enlarger
10 Masking board
11 Focus magnifier
12 Folding bench
13 Blower brush
14 Lightbox with worktop
15 Film dryer
16 Foot switch for enlarger
17 Dodgers
18 Stool
19 Waste bin

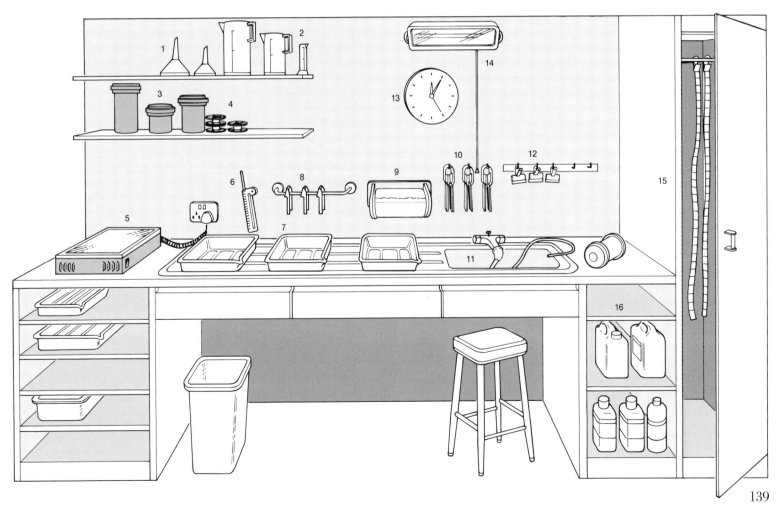

Developing

An exposed frame of film carries a latent image that must be made visible in negative form by being developed before a positive image, the print, can be made. Developing (also referred to as processing) a film is explained on the opposite page.

Efficient black and white development produces a negative of average density (darkness) and contrast (the density range and the separation of tones). Reasonable density and contrast allow the image to be easily printed on normal Grade 2 paper. Contrast and grain (the amount of metallic silver particles visible in the image; the less grain the clearer the image detail) and, to a lesser extent, density are determined by the duration of the development, the temperature of the developer and the amount of agitation given to the developing tank. The exposure received by the film in the camera largely determines the density of the negative, dictating how it will be developed, but here we are concerned only with the effects of development.

The longer the development time, the greater the contrast, grain and density in the negative. Contrast, grain and highlight (but not shadow) density are also enhanced by raising the temperature of the developer above the normal temperature for black and white development, 68° F/20° C. Use of the developer at a temperature lower than the manufacturer's recommended figure has the reverse effect. However, it is not advisable because the results are unpredictable.

Following standard procedures

For the beginner, the only way to produce printable negatives is to adhere to the exact development times, temperatures and agitation procedures specified by the manufacturer. You should also follow the standard procedures for fixing the image and washing the developed film. Only by adopting the correct darkroom practices from the start and then sticking to them will you achieve consistently worthwhile results.

Contamination, either chemical or physical (particles of dust), must be avoided at all times. Scrub your work surfaces clean of chemicals spilled during mixing and keep them dry. Never sweep the darkroom; always use a vacuum cleaner and a damp cloth to avoid raising dust. It is also very important to keep your film spirals clean and dry.

Organize your equipment on the bench in such a way that each item is comfortably to hand in the required sequence, for you will

THE CHEMISTRY OF DEVELOPING

To develop black and white film three basic chemical solutions are needed: developer, stop bath and fixer. Developer turns the latent image formed when light strikes the film into a silver-halide image. It is an alkaline solution and its effect is halted by the use of a mild acid solution – the stop bath. To remove the unexposed halides and to "fix" the image, preventing it from being further affected by exposure to light and so becoming discoloured, a bath of fixer is used.

Various types of developer are available and the choice of which to use is to some extent a matter of personal preference. Universal developers are used in different dilutions for developing both films and papers. However, their wide application derives from a compromise over the requirements of the different materials for which they are used and they do not bring the best out in every type of film or paper.

Developers with specific functions are also available. Fine-grain developers are sufficiently widely used nowadays to be regarded as general-purpose developers. Their use makes it possible to enlarge the negative considerably without grain becoming very evident. High-energy developers "push" (increase) the effective speed of the film by 1-3 stops without increasing contrast. They increase grain and are often used with fast films to maximize it. High-definition, or high-acutance, developers increase contrast and therefore sharpness.

Additional solutions are often used in development. These include hypo eliminator, which removes the spent fixer and assists the washing of the print, and wetting agent, which is introduced during the final rinse to minimize the marks that can occur when the negative dries. Intensifiers and reducers are used to alter the density, or degree of darkness, in the negative following normal development.

be working in the dark part of the time. Once you have decided on the layout of the equipment, stick to it each time you use the darkroom and always return each item to its place after use. I wear a long industrial coat with large pockets and keep the undeveloped films in the left-hand pocket. After removing the film from the cassette and loading it, I place the cassette in the right-hand pocket, since it is best to avoid having any unwanted items on the work surface.

Developing a film

Loading film for developing

Before developing your first film you must be able to load a film onto a spiral in complete darkness. Using an old film, practise in daylight first and then in the dark or with your eyes closed. Your hands must be completely clean and dry and you should always hold the film by the edges. First, remove the cassette end with a bottle opener and take out the film. Cut off the leader with scissors and feed the film carefully onto the spiral – from the outside in with a plastic spiral, from the inside out with the metal type.

1 *Mix chemicals to exact proportions specified by manufacturer and to 68° F/20° C. To maintain this temperature while loading film onto the spiral, stand chemicals in a vessel containing heated water.*

2 *In complete darkness load film onto a clean, dry spiral. Place spiral in developing tank and close lid, making sure that it is secure. Check that the developer is still at the right temperature.*

3 *Switch the room light on and pour developer into tank. Set and start timer. Agitate tank immediately for 10 seconds with an agitation rod or by inverting it. Repeat agitation after every minute of development.*

4 *Ten seconds before development ends, begin to pour out developer. Pour in stop bath and use agitation rod, or invert tank, to remove air bubbles from film. After one minute pour out stop bath.*

5 *Pour in fixer and set clock to manufacturer's fixing time. Agitate tank at once for 20 seconds and repeat as recommended. Pour out fixer, remove lid of tank and briefly examine end of film.*

6 *Stand tank in sink, remove lid and insert hose. Wash the film on the spiral with a gentle flow of water. After recommended washing time (usually 20 minutes), pour in a few drops of wetting agent.*

7 *Remove spiral, fix a hanging clip to the end of the film and pull it slowly through rubber squeegee tongs or chamois leather (these must be clean and grit-free). Hang film up to dry.*

NEGATIVE VARIATIONS

Underexposure or overexposure at the picture-taking stage produces a negative that will be difficult to print. If the highlight (dark) areas in the negative are too "thick" or the shadow (light) areas too "thin," the print will lack detail in those areas and will show poor contrast.

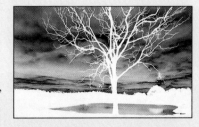

Underexposed negative
Since underexposure has produced no shadow detail, this negative could only print as a silhouette of the tree against the clouds.

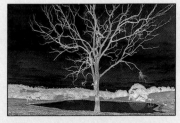

Correctly exposed negative
There is detail in both the highlight and shadow areas, so the print will display a good tonal range from white through gray to black.

Overexposed negative
The highlights are "blocked up" (excessively dark), making it difficult to retain detail and sharpness in those areas when printed.

Compensation development

Increasing the development time, a technique referred to as "pushing" development or push-processing, can rescue a flat, underexposed negative by increasing the contrast, although it should be noted that it is normally the highlights rather than the shadows that are enhanced. However, an exception to this general rule is Kodak TMX 3200 film developed in Kodak T-Max. With this combination the shadow detail remains excellent when development is "pushed" to ISO 6400.

Decreasing the development time ("pulling" development) reduces contrast in an overexposed negative, but as a means of exposure compensation is far less predictable in its effect than overdevelopment brought about by increasing the time. For this reason it is generally not advisable to reduce development time by more than 1 stop.

The following chart shows the effect on Ilford HP5 (ISO 400) film of varying the development time (and, in one case, the developer). All the combinations are ones that I often use. As you gain experience in developing you will come to recognize negatives that will benefit from a variation in development time.

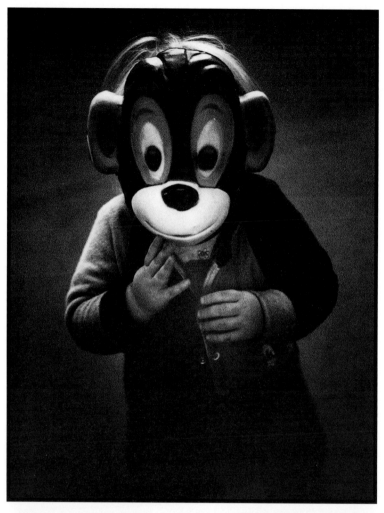

Development time	Developer	Effect
+30%	Ilford ID-11	+1 stop (ISO 800)
+75%	Ilford ID-11	+2 stops (ISO 1600)
+150%	Ilford Microphen	+3 stops (ISO 3200)
−30%	Ilford ID-11	−1 stop (ISO 200)

"Pushing" development

The negative of the photograph top right turned out to be very "flat" because the picture had been taken in low light. I "pushed" development by as much as possible (3 stops) to increase the contrast and make it printable. Note, however, that although the highlights are acceptable there is still little shadow detail.
Nikon FE, 105 mm, Ilford HP5, 1/60 sec., f2.5.
PROCESSING: Microphen, pushed 3 stops.
PRINTING: Grade 4; 8 secs., f8; face burned-in 3 secs.

Enhancing grain

The picture right was shot on high-speed (ISO 4000) film and developed for 10 minutes (60 percent longer than the standard time for the film-developer combination) to achieve pronounced grain. For maximum grain, I could have made an interpositive of the original on lith film, then made an internegative of the positive on lith film, and printed the new negative.
Nikon FE, 80-200 mm zoom at 150 mm, Kodak Recording Film 2475, 1/30 sec., f4.5.
PROCESSING: Kodak HC-110.
PRINTING: Grade 4 (Multigrade); 10 secs., f11.

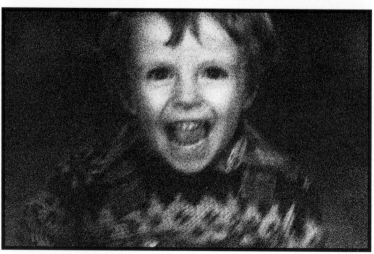

Developing a film

Loading film for developing

Before developing your first film you must be able to load a film onto a spiral in complete darkness. Using an old film, practise in daylight first and then in the dark or with your eyes closed. Your hands must be completely clean and dry and you should always hold the film by the edges. First, remove the cassette end with a bottle opener and take out the film. Cut off the leader with scissors and feed the film carefully onto the spiral – from the outside in with a plastic spiral, from the inside out with the metal type.

1 *Mix chemicals to exact proportions specified by manufacturer and to 68° F/20° C. To maintain this temperature while loading film onto the spiral, stand chemicals in a vessel containing heated water.*

2 *In complete darkness load film onto a clean, dry spiral. Place spiral in developing tank and close lid, making sure that it is secure. Check that the developer is still at the right temperature.*

3 *Switch the room light on and pour developer into tank. Set and start timer. Agitate tank immediately for 10 seconds with an agitation rod or by inverting it. Repeat agitation after every minute of development.*

4 *Ten seconds before development ends, begin to pour out developer. Pour in stop bath and use agitation rod, or invert tank, to remove air bubbles from film. After one minute pour out stop bath.*

5 *Pour in fixer and set clock to manufacturer's fixing time. Agitate tank at once for 20 seconds and repeat as recommended. Pour out fixer, remove lid of tank and briefly examine end of film.*

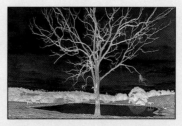

6 *Stand tank in sink, remove lid and insert hose. Wash the film on the spiral with a gentle flow of water. After recommended washing time (usually 20 minutes), pour in a few drops of wetting agent.*

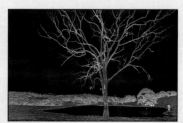

7 *Remove spiral, fix a hanging clip to the end of the film and pull it slowly through rubber squeegee tongs or chamois leather (these must be clean and grit-free). Hang film up to dry.*

NEGATIVE VARIATIONS

Underexposure or overexposure at the picture-taking stage produces a negative that will be difficult to print. If the highlight (dark) areas in the negative are too "thick" or the shadow (light) areas too "thin," the print will lack detail in those areas and will show poor contrast.

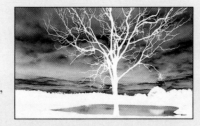

Underexposed negative
Since underexposure has produced no shadow detail, this negative could only print as a silhouette of the tree against the clouds.

Correctly exposed negative
There is detail in both the highlight and shadow areas, so the print will display a good tonal range from white through gray to black.

Overexposed negative
The highlights are "blocked up" (excessively dark), making it difficult to retain detail and sharpness in those areas when printed.

Compensation development

Increasing the development time, a technique referred to as "pushing" development or push-processing, can rescue a flat, underexposed negative by increasing the contrast, although it should be noted that it is normally the highlights rather than the shadows that are enhanced. However, an exception to this general rule is Kodak TMX 3200 film developed in Kodak T-Max. With this combination the shadow detail remains excellent when development is "pushed" to ISO 6400.

Decreasing the development time ("pulling" development) reduces contrast in an overexposed negative, but as a means of exposure compensation is far less predictable in its effect than overdevelopment brought about by increasing the time. For this reason it is generally not advisable to reduce development time by more than 1 stop.

The following chart shows the effect on Ilford HP5 (ISO 400) film of varying the development time (and, in one case, the developer). All the combinations are ones that I often use. As you gain experience in developing you will come to recognize negatives that will benefit from a variation in development time.

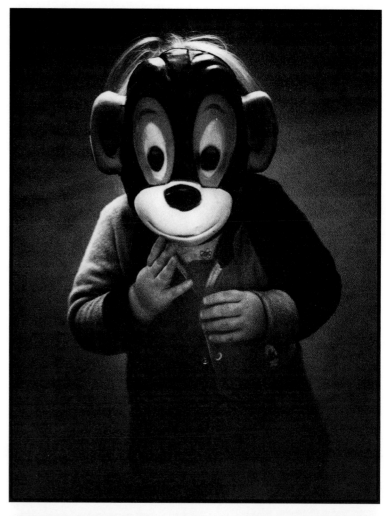

Development time	Developer	Effect
+30%	Ilford ID-11	+1 stop (ISO 800)
+75%	Ilford ID-11	+2 stops (ISO 1600)
+150%	Ilford Microphen	+3 stops (ISO 3200)
−30%	Ilford ID-11	−1 stop (ISO 200)

"Pushing" development
The negative of the photograph top right turned out to be very "flat" because the picture had been taken in low light. I "pushed" development by as much as possible (3 stops) to increase the contrast and make it printable. Note, however, that although the highlights are acceptable there is still little shadow detail.
Nikon FE, 105 mm, Ilford HP5, 1/60 sec., f2.5.
PROCESSING: Microphen, pushed 3 stops.
PRINTING: Grade 4; 8 secs., f8; face burned-in 3 secs.

Enhancing grain
The picture right was shot on high-speed (ISO 4000) film and developed for 10 minutes (60 percent longer than the standard time for the film-developer combination) to achieve pronounced grain. For maximum grain, I could have made an interpositive of the original on lith film, then made an internegative of the positive on lith film, and printed the new negative.
Nikon FE, 80-200 mm zoom at 150 mm, Kodak Recording Film 2475, 1/30 sec., f4.5.
PROCESSING: Kodak HC-110.
PRINTING: Grade 4 (Multigrade); 10 secs., f11.

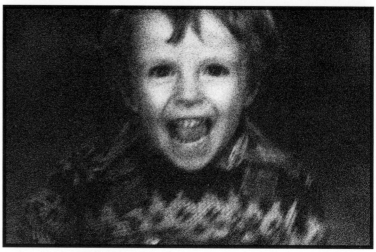

Controlling contrast

There will be times when you want to interpret the subject in a particular way by increasing or reducing the contrast in the negative. Lengthening development time increases contrast, while shortening it reduces contrast (see opposite page). For a more pronounced effect you can vary both the camera exposure and the development time. To decrease contrast, overexpose and then underdevelop the film. To increase contrast, underexpose and then overdevelop the film. The effect on contrast of combining underexposure with overdevelopment can be enhanced by raising the temperature of the developer.

However, I find that I need to reduce or soften contrast more often than increase it, notably with inherently high-contrast subjects or when shooting in very contrasty light. There are various ways to achieve this, the most gentle in effect being to reduce agitation from, for example, 10 seconds in every minute to 3 seconds in every 2 minutes. When I overexpose and under-develop, which has a greater effect than reducing agitation, I either increase exposure by half a stop and cut development time by 15-20 percent, or increase exposure by a stop and cut development time by 30-35 percent. More pronounced still is the effect of diluting the developer, but to do this you should follow the manufacturer's specifications.

USING A WATER BATH

The contrast range of the subject in the photograph below left was too great to allow a normally developed negative to be printed satisfactorily. I had shot it on Kodak TMX-100, which I developed in Kodak T-Max. The result was that the area of the conservatory was completely "burned out" in the print. To achieve a picture with far less contrast I photographed the subject again, this time on Ilford HP5, a lower-contrast film than TMX-100, and used a water bath during development. This technique contracts the tonal range more than any of the methods described above. In the result, below right, there is far more detail in both the highlight and shadow areas than in the earlier print.

To use a water bath, develop the film for 1 minute in developer (with agitation) and then for 3 minutes (without agitation) in water. Return the film for 1 minute to the developer and then for 3 minutes to water bath. You may need to repeat the cycle a third time. You can vary the effect by experimenting with different combinations of film and developer.

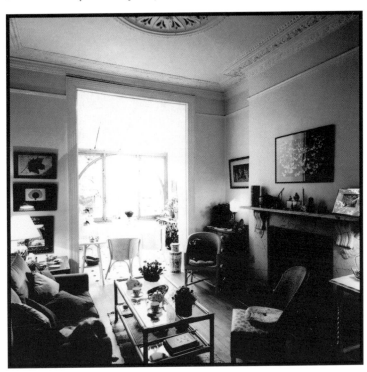
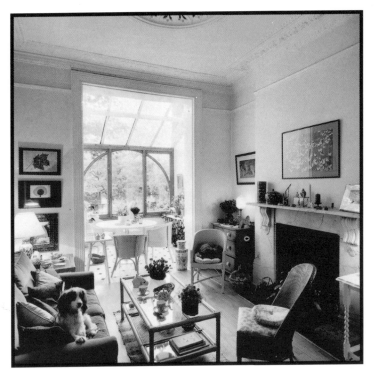

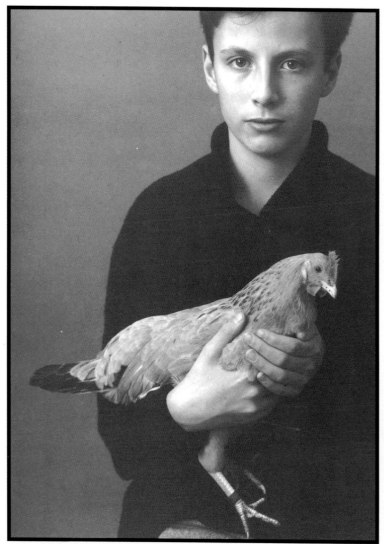

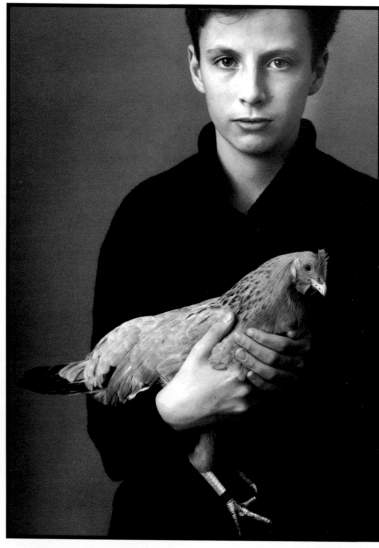

Intensifying a negative

An underexposed negative was printed on Grade 4 paper to produce the picture above. My fears were confirmed when I saw the flat print lacking in detail. I decided to try intensification and used JRD Chromium intensifier, following the manufacturer's instructions precisely. I then reprinted the negative on a slightly softer (Grade 3) paper. The resulting print, above right, displays a much broader and more satisfying tonal range.

INTENSIFICATION AND REDUCTION

When, as a direct result of either underexposure or underdevelopment, a negative is "thin," an intensifier can be used to increase density, contrast and grain. Intensifiers strengthen highlight areas more than they do shadows. The maximum effective increase in density is about 1 stop. Kodak IN-5 intensifier is excellent and I recommend JRD Chromium intensifier, which is easy to use. Run a test on a dispensable frame of the same density on the same film before treating the negative.

When overexposure or overdevelopment is the problem, a reducer will compensate for the resulting "thick" negative. The process is particularly useful with a fogged negative.

Choosing a developer

If you are a newcomer to the darkroom, until you gain experience it is best to use only the developers made by the major film manufacturers for use with their films. The chart below lists the main characteristics of a wide range of developers, and will provide you with alternatives if you are unable to match developer and film according to the manufacturer's recommendations. This chart will be particularly useful to those who are ready to experiment with different combinations of film and developer.

Most professional photographers use only the one, or perhaps two, combinations they find most effective. I have been happy for many years with Ilford HP5 film and the same company's Microphen developer, particularly for my reportage work. More recently, I have also found very good the combination of Kodak's high-speed TMX 3200 film and its T-Max developer.

Developer	Characteristics	Suitable film speed	Suitable film	Remarks
Kodak D-76 Ilford ID-11	Fine grain and good definition	Normal	Any	Identical excellent general-purpose developers with long life (ideal for tank replenishment).
Agfa Rodinal	Fine grain and high definition	Normal	Any	Excellent all-round developer.
Ilford Ilfosol-S	Fine grain, one-shot	Normal	Any	Ideal occasional developer.
Ilford Ilfotec LC29	Reasonable grain for general-purpose use	Normal	Any	Good quality and very economical – ideal when a large number of films is to be developed.
Kodak HC-110	General purpose	Normal	Any	Ideal for dilution to reduce contrast.
Paterson High Definition FX-39	Fine grain and high definition	Normal	Any	Exploits properties of film using silver-halide-grain technology and also well suited to conventional-grain films with ratings up to ISO 200.
Ilford Microphen	Fine grain for general-purpose use	+40%	Any	Better for shadow detail than Ilford ID-11 or Kodak D-76. Film speed can be "pushed" by 40% without loss of quality. Ideal for tank replenishment.
Agfa Atomal	Very fine grain and good definition	+50%	Any	Good for "pushing" film speed. Long life – ideal for tank replenishment.
Paterson Acutol FX-14	High definition	+40%	Slow and medium-speed	Not suitable for use with fast film.
Paterson Acuspeed FX-20	Medium grain	+30–100%	Fast	Allows maximum speed with fast film.
Paterson Aculux FX-24	Fine grain and good definition	Normal	Any	Fine-grain developer giving excellent tonal gradation. Can be used for any film of any grain group.
Ilford Perceptol	Very fine grain and excellent definition	−50%	Slow	Sacrifices film speed for maximum fine grain and definition. Ideal for large prints.
Kodak T-Max	Fine grain and good definition	+300%	Kodak TMX series	Designed specifically for best results with Kodak TMX films.

Enlargers

Y ou can use a contact printing frame to produce prints the same size as the negative, but to make prints that are bigger than the negative you will need an enlarger. No item of darkroom equipment has more effect on the quality of the final print than the enlarger, of which there are two main types: condensers and diffusers. In the first, a condensing lens gathers light from the lamp in the enlarger head and directs it through the negative (or slide), the image of which passes through the enlarging lens onto light-sensitive paper on the baseboard below. The process is similar in a diffuser, except that the light passes through a screen that diffuses it, instead of through a condensing lens. Condenser enlargers give prints with greater contrast and sharpness than those produced by diffusers. Their main disadvantage is that they emphasize particles of dust or scratches on the film, which will be evident in the print. Despite this, condenser models are the best choice for those learning to print in black and white.

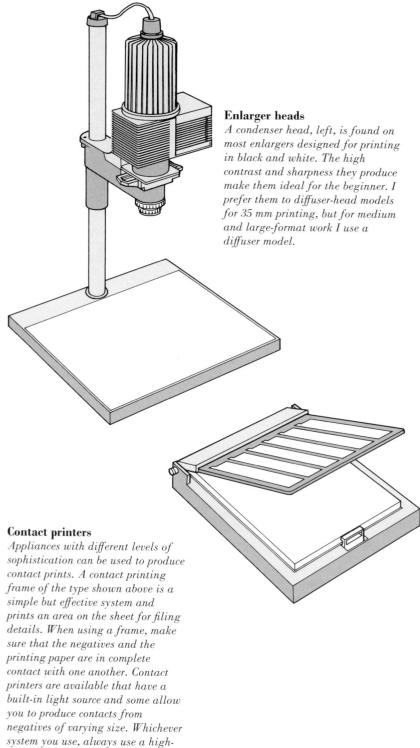

Enlarger heads
A condenser head, left, is found on most enlargers designed for printing in black and white. The high contrast and sharpness they produce make them ideal for the beginner. I prefer them to diffuser-head models for 35 mm printing, but for medium and large-format work I use a diffuser model.

Contact printers
Appliances with different levels of sophistication can be used to produce contact prints. A contact printing frame of the type shown above is a simple but effective system and prints an area on the sheet for filing details. When using a frame, make sure that the negatives and the printing paper are in complete contact with one another. Contact printers are available that have a built-in light source and some allow you to produce contacts from negatives of varying size. Whichever system you use, always use a high-quality magnifying glass to inspect the contacts.

Producing a contact sheet
In safelight and with the red filter across the enlarger lens, place a 10 × 8 in (25 × 20 cm) sheet of printing paper on the baseboard. Position the negative strips (in lengths of six frames) emulsion side down (shiny side up) on the paper and then place a sheet of clean glass over them. Turn off the enlarger,

slide back the red filter and expose the contact sheet. Develop and fix the contacts as for a normal print.

The more contacts you make the more you will appreciate the need for good organization. Whenever you produce negatives, file them, including adequate details. Use a grease pencil to mark contacts selected for printing, as above.

Printing papers

Papers for printing in black and white have either a fiber base or a plastic resin coating on each side of a fiber base. Resin-coated papers are more expensive but they need fewer chemicals and allow faster development. Washing, too, is much faster, taking only 2-4 minutes as compared with 20 minutes for fiber-based papers. Resin-coated papers dry rapidly without curling. If a high-gloss finish is required, it is necessary to glaze fiber-based paper whereas resin-coated paper is available with a gloss finish. Despite these differences, many photographers prefer fiber-based paper for its print quality.

A further important difference between papers is in the contrast they produce in the print. The "harder" the paper the greater the contrast it gives. Normally, papers are graded from 1 to 5: the higher the number the "harder" the paper. In recent years the use of Multigrade paper as an alternative to graded papers has increased greatly. The paper's grade, measured from 0 to 5 in half-grade increments, is altered by the use of interchangeable filters in the enlarger head. Importantly for enthusiast and professional photographer alike, Multigrade paper saves the expense of buying a range of grades.

Agfa, Ilford and Kodak all produce good-quality resin-coated and fiber-based Multigrade papers which I use for ordinary printing. However, for exhibition prints I prefer a high-quality, graded, fiber-based paper such as Ilford Galerie, to give a very wide range of tones. Other excellent fiber-based papers are Kodak Elite and Agfa Brovira. Smaller manufacturers such as Kentmere (UK) and Oriental Seagull (USA) produce ranges of superb-quality fiber-based papers. Kodak makes a panchromatic (sensitive to the whole spectrum) resin-coated paper, Panalure II, for making black and white prints from colour negatives. Try it for its fine quality, but also for valuable practice in visualizing colour as black and white tones.

MAKING A TEST STRIP

To make it possible to judge the correct exposure for the final print, the negative is printed at a range of exposures on adjacent sections of a sheet of printing paper, as in the example on the right. When this is developed, each section shows a different density. I prefer to print half a sheet rather than a strip. Although this seems wasteful, it saves money in the long run because the larger print area allows me to assess the tonal range more accurately and also because I use the remaining half for experimenting with localized exposure control. With the red filter across the lens, place the negative in the carrier and half a sheet of paper on the baseboard, positioning the paper so that it collects as much tonal information from the negative as possible. I make only three exposures, and try to plan it so that the middle section will be the correctly exposed one. Turn off the enlarger, slide back the red filter and make the first

exposure of, say, 5 seconds. Cover one-third of the paper with a black card and give 5 seconds of exposure to the other two thirds. Cover two-thirds of the paper and give a final 5 seconds of exposure to the last section. I aim to have a basic exposure of at least 10 seconds to allow time for shading. Develop the test strip and decide on the appropriate exposure.

Choosing the grade of paper

Although the choice of paper grade is a matter of personal preference, the newcomer to printing may find it helpful to see how this choice affects the range of results possible. Multigrade paper was used with filters F1 to F5 to produce the prints on the right from a negative with average tonal range and contrast. The example made with F1 is much too soft. F2 has a good range of tones, but is still a little soft for my taste. F3 is the right choice for me. The print has a full tonal range and is bright and "punchy." F4 is too contrasty and "hard," F5 even more so.

F1

F2

F3

F4

F5

ANALYZING A NEGATIVE

Always inspect the negative carefully to check for any potential printing problems. In this example the shadow (light) area holds very little detail in the corkscrew, the glasses of wine, the bottom of the bottles or the knife handle, and will print almost black. The tops of the bottles have enough detail to print, while the grapes hold good detail. The middle tones – the apple, the unbroken baguette, the cork and the shadow area of the cheese – were ideally exposed and the printing exposure can be based on them. The highlight (dark) areas – the broken loaf, well-lit part of the cheese, the scallions and the marble – hold good detail but will need to be burned-in (see p. 150). To show any tone the burned-out wall will need to be flashed (see p. 152).

Printing

The aim of printing

Since printing is largely a matter of personal interpretation and taste, it is difficult to define what makes a good black and white print. The traditional view is that it should display a full range of tones from a rich black through to a clean white. To pursue this aim blindly would limit your expressive powers, yet if you can consistently achieve such a result you should be able to produce any effect you want in your prints.

1 *Mix developer, stop bath and fixer as specified. (It is advisable, but not essential, to match developer and paper as recommended by manufacturer.) Avoid splashing stop bath or fixer into developer.*

2 *Clean negative and carrier. Insert negative. Turn off room light and turn on safelight. Set enlarger head for desired image size and focus. An aperture 2 stops down from maximum is usually best for overall sharpness.*

3 *Evaluate negative and select filter for making test strip (see p. 147) with Multigrade paper. Place test strip paper on easel emulsion side up and make exposures so as to be able to judge paper grade required.*

4 *Check that chemicals are at right temperature (68° F/20° C) and slide print emulsion side up into developer, without touching emulsion.*

5 *Agitate print and develop for time recommended by paper manufacturer.*

6 *Use stop bath and fixer as specified by manufacturer. Inspect test strip in room light and decide on basic exposure. Turn off room light and turn on safelight. Place paper on easel and make exposure.*

7 *Develop print. Place in stop bath. Fix. Wash print in running water (2-4 minutes for resin-coated, 20 minutes for fiber-based paper. Resin-coated papers can also be washed in three changes of still water).*

8 *Remove excess water thoroughly from print with squeegee or tongs and hang or lay on clean towel to dry. To accelerate drying, use a hairdrier or a fan heater at a minimum distance of 2 ft (0.6 m).*

Localized exposure control

Relatively few black and white negatives yield their maximum potential when you give them the overall basic exposure indicated by the test strip. Most have areas that respond best to localized over- or underexposure. Ninety percent of my prints benefit from one or other, or both, of the two main techniques: shading and burning-in. To shade an area of the print a black card (known as a dodger) or the hand is placed over the appropriate area of the printing paper to shield it from the basic exposure received by the rest of the print. Conversely, to burn-in an area of the print basic exposure is given to the whole print and then that area alone

is given extra exposure, the rest of the print being masked. Before shading or burning-in it is best to rehearse the procedure with the enlarger's red filter in place.

It is a good idea to keep a printing record so that when you want to make a repeat print you can check at a glance the precise details of the localized exposure you used. For each print that I make I paste the contact in a sturdy notebook. I annotate it with the printing date, the negative number and the basic exposure. I circle any areas that have been burned-in or shaded, adding precise details of the times.

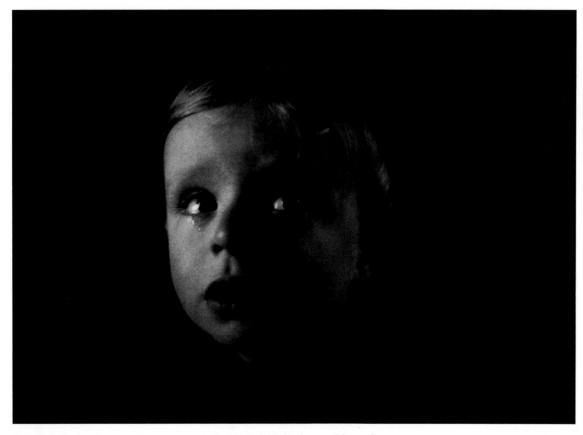

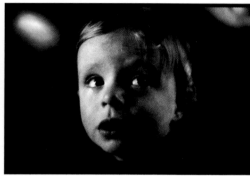

Using card to control exposure
For most shading I use black-card dodgers on wire handles (above, top). For shading straight-edged areas such as horizons I use sheets of card that are black on one side and white on the other, with the black side up. For burning-in I cut a hole of the required size in the same type of card. With the white side up, I can see the projected image clearly and can position the hole accurately. Move the card slightly during burning-in to avoid a hard edge.

Burning-in
In the print above right the eye is drawn away from the child's face by the figure creeping into the righthand corner and the large, out-of-focus highlight in the left of the background. The basic exposure, based on a test strip, was 13 seconds at f8 with a No. 4 filter on Multigrade paper. To improve the

print, I masked the face and burned-in the background for 25 seconds. The highlights on the nose also troubled me, so I burned them in for 15 seconds. The result was the print above, which has a more attractive tonal range than my first attempt, and contains no distracting elements.

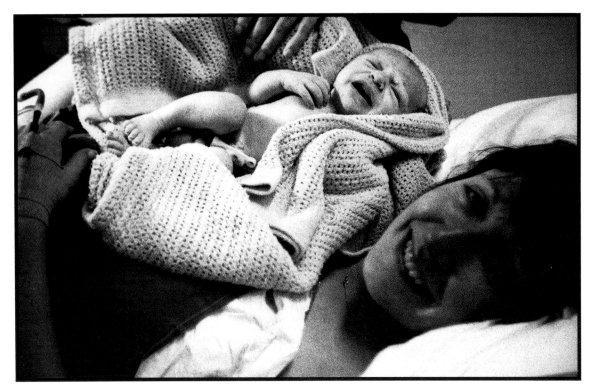

Shading

The picture on the left was printed with no localized exposure control. The shadows in the mother's face and arm proved too dense for the basic exposure (20 seconds at f8 on Grade 2 paper). I made another print, below, but this time to prevent those areas printing so dark I held back the exposure they received. I used a dodger to shade the face for 8 seconds, and with my hand shaded the arm for 6 seconds. During shading, move the card slightly to avoid a hard edge. It is generally easier to use dodgers to shade simple shapes, but I find that using my hands is much more effective for producing subtle masking effects. It also allows me to create an endless variety of apertures.

USING MULTIGRADE PAPER

To print a negative that has a contrast range too great for any one grade of paper to handle satisfactorily, use Multigrade (variable-contrast) paper. Print the high-contrast area using Filter 1, shading the rest of the print. Then print the low-contrast area using Filter 4 (or possibly 5), shading the previously exposed portion of the print. Like many darkroom techniques, this calls for experimentation. You could also try using Filter 3 for the main exposure, and then Filter 1 for the areas to be burned-in. If neither method of contrast control works, try flashing the print (see p. 152).

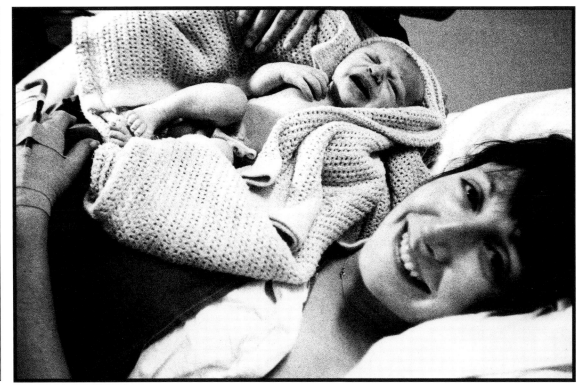

Flashing

Re-exposure of the print during development (following normal printing exposure) is known as flashing. The technique is used when the highlight range is too subtle to print satisfactorily, or when you want to print on paper of a higher contrast than the negative will allow in order to produce very rich blacks while maintaining highlight tones. A room light (preferably with a dimmer switch, so that you try different light levels) is most often used to flash the print, but a flashlight (torch) will also serve the purpose. Flashing is not easy to master and you must be prepared to experiment by varying the duration of the re-exposure. You can also flash before development. After normal exposure, leave the print in place and, with a diffuser over the enlarger lens, re-expose.

Reducing tonal range
To flash a print, give it about one second of exposure when it has been in the developer for between 30 and 40 seconds. Make sure that there are no bubbles or dirt in the developer. After flashing, watch carefully for the first sign of tone in the white areas and then rush the print into the stop bath.

The skin tones of the couple in the picture above were harsh in the first print. To maintain the skin's silkiness I required a normal-contrast (Grade 2) paper. But the hair lacked a rich black so I used a higher-contrast (Grade 4) paper and flashed the print, making the skin tones sleeker and turning the background a subtle gray.

Separating tones
Printed normally, the picture above would have lacked sufficient tonal separation. However, by flashing the print I was able to separate the high-value tones of the white hat from those of the white shutter, making the composition more subtle.

Combination and sandwich printing

In combination printing two or more negatives are printed sequentially, one on top of the other, to exploit simultaneously their different or complementary qualities. Nearly always, the technique involves masking parts of the print so that the final result comprises a combination of selected elements rather than two or more negatives printed together in their entirety.

Sandwich printing is a related technique in which two negatives are placed in the enlarger's negative carrier and printed together. The best results are achieved with images that have complementary highlight and shadow areas, but the composition should also be considered.

Sandwich printing

I experimented on the lightbox with many combinations of negatives taken on the same sessions as the shots below, before making my choice of images to print together, bottom. The shadow (light) areas in the negative of the sand dunes are well placed to receive the highlights (dark areas) in the negative of the nude girl. Most successful sandwich prints are based on more than a combination of complementary tones, and normally reveal either an harmonious juxtaposition of subjects or a striking, even surreal, contrast.

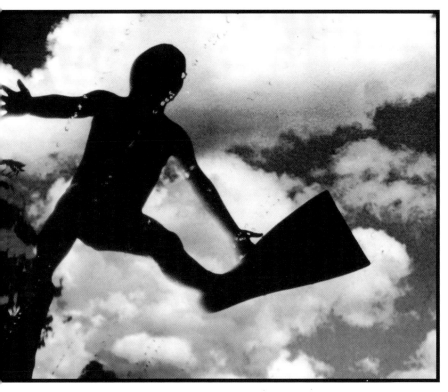

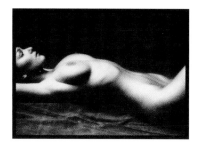

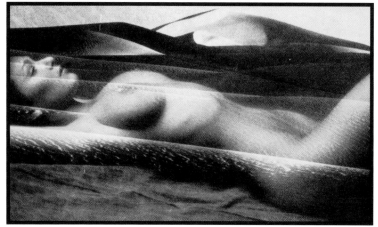

Combination printing

For the combination print above I used a boy jumping and the sky from another shot. I used the enlarger to project the negative of the boy onto white paper and drew his outline with a thick black felt-tip pen. I projected the negative of the sky onto the paper, adjusting the magnification of the clouds until they were in a position sympathetic to the boy. After making test exposures of both negatives, I exposed the negative of the boy onto Multigrade paper with a No. 4 filter for 6 seconds at f8, producing a silhouette. I removed the negative and the exposed paper. I inserted the negative of the clouds and lined it up with the tracing of the boy. I replaced the tracing with the exposed image of the boy and re-exposed the clouds onto the already exposed paper for 11 seconds at f5.6, softening the contrast in the clouds by using a No. 3 filter. Exposing for the clouds did not affect the boy because he was already a silhouette. I gave normal development to the composite print.

Tonal manipulation

Various techniques that can be described as tonal manipulation may be used in the darkroom to create highly individual images. Among the most commonly exploited are the Sabattier effect and line conversion. When a black and white print or film is re-exposed during development and development is allowed to continue the previously undeveloped areas darken and the positive print begins to reverse back to a negative. This process, known as the Sabattier effect, results in a print that is part positive and part negative. A partial tonal reversal of this kind can be striking and is therefore worth pursuing for its own sake. Unlike the technique known as solarization, which causes partial or complete tonal reversal through massive overexposure, the Sabattier effect fogs the print or film. It is therefore incorrect to describe it as pseudo-solarization, as is often done.

Line conversion involves transferring an image onto line film to produce a stark result comprising only black areas and white areas. The very high contrast that characterizes this type of film turns the light grays in the negative white, and the dark grays black, so that there are no intermediate gray tones between the two extremes. For a more pronounced line effect, the image can be transferred onto lith film, which gives an even stronger black. The normally developed black and white negative is contact-printed onto the lith film and the resulting positive transparency is itself contacted onto lith film. The resulting negative is then printed as normal. Most lith films can be handled in red safelight.

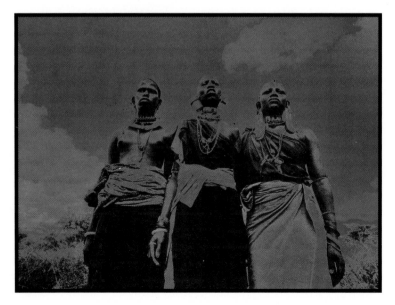

Sabattier effect
I achieved the partial reversal of tones in the photograph on the left by re-exposing the print (having earlier given it normal exposure) for 3 seconds in low light when it had been in the developer for 30 seconds. I continued development for another 30 seconds and then transferred the print to the stop bath.

Line conversion for tonal separation
A line conversion can be made from a colour transparency by making a copy negative of the original on lith film and then printing on Grade 5 paper (or on Multigrade paper using Filter 5). I used this technique to produce the picture above, the colour original of which was shot on an overcast day and lacked tonal interest as a colour picture. Conversion to line differentiated the tones strongly, giving the picture more impact.

Recomposition

Just as the tonal characteristics of a photograph can be altered in the darkroom, composition, too, can be modified. The most commonly used method of recomposing the image is cropping in the enlarger by masking those areas of the negative image that you do not want to appear in the print. In general, this should not be necessary if the composition was properly planned at the camera stage. However, cropping at the printing stage is useful for removing unwanted detail that was overlooked earlier, or simply to improve a shot that was necessarily composed in haste. A picture might also benefit from cropping if it was taken on a camera of the "wrong" format. For example, you may want to capture a subject that calls for a square format but have only a 35 mm camera. In such cases, you can visualize the picture as a square and later crop the print accordingly. Sometimes the value of such a format change does not strike you until you are printing, or even after. The complementary approach to cropping – adding to the print, as in the photograph on the right – can also prove effective, although it is less often an appropriate remedy.

Recomposing in the darkroom
The original extent of the picture right is indicated by the dotted line. I decided that the composition would be much more dramatic if I lengthened the black rotary blade leading down vertically to the compact circle of the helicopter. The print, made on Grade 5 paper, eliminated all tone from the sky. I defined the edges of the extended blade with steel rules, and masked off the print to each side of it. I then exposed normally, creating a black central area without detail as an extension of the real blade.

Retouching

The term "retouching" embraces a wide variety of techniques for improving the look of prints. They range from techniques to conceal marks to those used to enhance existing features or to add new ones. The best approach to the removal of blemishes is to make it unnecessary. It is especially important to ensure that when film is drying hair and specks of dust do not settle on it, since these are the main cause of unsightly marks on the print.

Spotting is the technique used to conceal such marks, which take the form of white lines or spots on the print. A good-quality fine sable brush is used to apply dye, available in a range of tones to suit any black and white print. The tone of the affected area is built up gradually, with great care, until it matches the tone of the area surrounding it.

Etching removes black spots, caused by the air bubbles and holes in the emulsion that can form during development, and the scratches that can occur in the camera or during printing. A scalpel is used very gently to scrape away the smallest amount of the print's surface. If the print is gouged, spotting will be needed to repair the damage.

Airbrushing is a sophisticated technique used to cover large areas of a print. The density of the spray can be adjusted to produce a subtle gradation of tone.

Retouching kit
The tray contains liquid dyes and solid tones, both of which are applied with a No.1 sable brush. Liquid dye is used in the airbrush, which is seen with a canister of compressed air. The tubes contain different tones of gray that can be diluted and applied with a brush. The scalpel is used to scratch over small areas of the print, the pencil to produce small areas of tone.

Spotting
The top picture on the right was marred by a hair and particles of dust. The lower picture shows what spotting can do to improve the image.

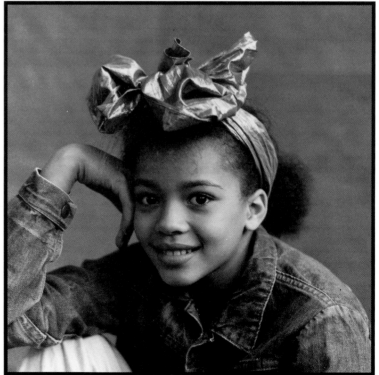

Glossary

Acutance Measure of image sharpness at boundaries between light and dark areas. High-acutance developers accentuate this boundary definition, apparently enhancing sharpness.

Agitation Movement set up between photographic material and developing solutions to ensure the uniform action of the latter.

Artificial light Illumination other than daylight. The main sources are electronic flashguns, cubes or bulbs and photofloods (floodlights).

Averaged metering Camera TTL metering method that measures light intensity over most of the viewfinder.

Backlighting Lighting from behind the subject, often producing a fringe or halo of light that separates the subject from the background.

Bellows A device inserted between the camera and the lens to increase the lens-to-film distance for close-up photography.

Bounced flash Flash illumination reflected from a wall, ceiling or purpose-made reflector to reach the subject as diffused light.

Burn-in To give extra enlarger exposure to dense, highlight areas of the print to produce greater darkness.

Center-weighted metering TTL metering method in which the reading is biased toward the light intensity at the center of the viewfinder.

Condenser A lens, usually of simple construction, used in an enlarger to focus light through the negative onto the enlarger lens.

Contrast Relationship between tones. A print with wide tonal differences is described as contrasty, one with a limited tonal range as flat.

Converter Auxiliary lens used with a camera lens to increase focal length, usually by two or three times.

Definition Sharpness of an image produced by a lens or recorded by a film.

Density Degree of darkness or opacity of a negative or print produced by exposure or development.

Depth of field The zone of acceptable sharpness in a photograph. It is determined by three variables: the size of the aperture, the lens-to-subject distance and the lens's focal length.

Development The treatment of a film or other photographic material by a developing agent to render visible the latent image produced by exposure. Also known as processing.

Diffusion Slight scattering of light to soften the image rendition of a lens, or the quality of a light source, usually by means of a diffusion filter in front of the camera or enlarger lens or a translucent material over the light source.

Dodging Giving less than the overall exposure to parts of a print that would otherwise appear too dark.

Emulsion The medium that carries the image on film or photographic paper. Usually takes the form of silver halides suspended in gelatin.

Enlargement A print larger than the negative, made by projecting the negative image to the desired size onto a light-sensitive paper. The term also refers to the technique itself.

Exposure latitude Ability of a film to record satisfactorily when exposure is not ideal. Black and white films generally have a greater exposure latitude than colour films, while fast black and white films have the greatest.

Fill-in light Supplementary light directed onto a subject to illuminate shadows created by the principal light.

Fixer Solution used to make permanent the developed image on film or paper, thus preventing further development or fading.

Flashing Exposure of the print to white light (following normal printing exposure) to reduce contrast.

Graininess Clumping together of the silver halide grains that form the image, producing a rough, granular appearance, especially noticeable in areas of even tone at high degrees of enlargement. Use of fast film, long development and overexposure are the main causes.

Gray card Card with an 18 percent gray tint, used to represent the mid-tone of an average scene. To determine exposure, a reading is taken from light reflected from the card.

High key Describes an image consisting mainly of light, delicate tones.

Highlights Bright parts of the subject, which reproduce as the darkest areas in the negative and as the lightest areas in the print.

Incident light reading Measurement of light falling on the subject by a meter which (usually) faces the camera position. Less common than the reflected light reading.

Intensification Chemical enhancement of the density of a weak negative image.

ISO system Numerical system for rating film speed. The name is based on the initials of the International Standards Organization and has largely replaced the ASA system, which uses identical figures. The higher the number, the faster the film.

Latent image Invisible image formed on the film by exposure, made visible by development.

Low key Describes an image consisting mainly of dark, rich tones.

Mirror lens Compact lens for 35 mm format with very long focal length (500 mm or longer) which forms the image by reflecting light through a series of mirrors rather than regular elements.

Monobath developer Developing solution combining developer and fixer.

Negative Image in which the tones of the original subject are reversed, so that light areas are recorded dark and vice versa.

Neutral density (ND) filter A gray filter that blocks a certain amount of light entering the lens. It is used when the light intensity is too great for the film, or to give limited exposure control with mirror lenses, which lack an aperture adjustment.

Opacity Ratio of the intensity of incident light to reflected light. An image transmitting half the light falling on it has an opacity of 2.

Overdevelopment Excessive development, producing dense negatives of high contrast that give featureless highlights when printed. Overdeveloped prints are fogged.

Overexposure Excessive exposure, producing dense, flat negatives with burned-out

highlights. Overexposure in printing negatives produces dark prints.

Positive Print in which the tones correspond to those in the original subject.

Pushing Prolonging development of film beyond the normal time to compensate for underexposure or to increase contrast. Also referred to as push-processing.

Reciprocity failure According to the principle of reciprocity, if the product of exposure (light X time) is constant, the exposure effect remains the same regardless of the intensity of the light. However, with exposures longer than about 1/8 sec. or shorter than 1/500 sec., the principle is unreliable and the result unpredictable.

Reduction Chemical reduction of the density of a negative.

Reflected light reading The measurement by a light meter of the amount of light reflected from a subject, as distinct from that falling on it (incident light).

Reflector Surface used to direct and concentrate light, usually from flash and other artificial light sources, into shadow areas. Metallic reflectors and white card or sheet are the most common types.

Replenishment The regeneration of developing solutions by the addition of those chemicals that have been altered or exhausted.

Resolution The ability of the lens and film to record adjacent fine detail.

Ring flash Electronic flash unit that fits around the front of the lens and produces virtually shadowless illumination, which is particularly useful for close-up photography.

Safelight Light that allows illumination in the darkroom without spoiling sensitized materials.

Shade To prevent light from the enlarger reaching an area of the printing paper during exposure in order to make that area lighter.

Sheet film Individual pieces of film are available in normal plate sizes. Also known as cut or flat film.

Silver halides Generic name for light-sensitive compounds of silver with a halogen (bromine, chlorine, fluorine, iodine). Silver bromide is the main constituent of photographic emulsions, but silver chloride and silver iodide are also used. The latent image produced on these compounds by exposure is converted to metallic silver by the developer.

Spotlight Studio light with reflector and lens that can focus light into a small, concentrated circle or give a wider beam.

Spot metering Camera TTL metering in which a reading is based on a very small area in the center of the viewfinder. Separate, hand-held spot meters are highly sensitive, taking a reading from an angle of measurement as small as 1 degree.

Spotting The removal or concealment of spots and blemishes on prints or negatives.

Stop bath Process in which a dilute solution of, for example, acetic acid is used to neutralize the effect of the developer.

Strobe light American term for an electronic flash unit. Also used as an abbreviation for stroboscopic light, a flash unit that fires repeatedly at predetermined intervals.

Test strip Strip of printing paper that receives several different exposures section by section so that when it is developed exposure and filtration can be assessed accurately without the need to produce trial prints.

Tonal range The range of tones between the lightest and darkest areas, usually of a positive.

Tonal separation Technique for increasing the visual contrast between some tones and eliminating others, either through development or printing.

Toning Altering the natural tone of a print by means of a chemical bath. The best-known effect is sepia toning, but almost any other colour, or combination of colours, can be used.

TTL metering "Through the lens" metering, a feature of all modern 35 mm SLR cameras. Light-sensitive cells in the camera register the intensity of image-forming light that passes through the lens. Most models meter the whole scene, but with a "center-weighted" bias, or take an "averaged" reading of the whole picture area. Cameras which use the "spot metering" system read only a small central area.

Tungsten-halogen lamp Incandescent studio lamp that gives a bright white light.

Underdevelopment The technique or result of giving less than the normal amount of development to a film or print.

Underexposure Condition in which too little light falls on the emulsion to form a sufficiently strong image. An underexposed negative is thin, a print too dark.

Uprating Using a film at a higher speed than that recommended by the manufacturer. The result is underexposure, which can be compensated for by increasing development time. Some films are designed for use over a range of speeds.

Wetting agent Solution in which a film is immersed after washing in order to reduce surface tension and so enable the film to dry more quickly.

Zoom lens Lens with a focal length that is infinitely variable between two fixed points (e.g. 28-50 mm, 70-210 mm). The focused image stays in focus at every focal length.

Index

Acknowledgments

Many thanks to my friend and fellow photographer Graeme Harris and his wife Margaret, whose busy studio I invaded for weeks while printing the photographs in this book.

To my editor and co-writer Richard Dawes for his patience, considerable professional expertise and sheer hard work.

To Simon Blacker for enthusiasm beyond the call of duty and for the elegant way in which he has laid out my photographs.

To Jack Tresidder for giving me the opportunity to produce this book, and for his support during that time.

To my family for their constant encouragement and understanding.

Illustrations by Irwin Technical Ltd, London.

Suppliers

Agfa UK
Great West Road
Brentford
Middlesex
TW8 9AX
0208-231-4903

Fuji Photo
Film UK Ltd
125 Finchley Road
London NW3 6JH
0207-586-5900

Jessop (UK)
98 Scudamore Road
Leicester LE3 1TZ
01162-326000

Kodak Ltd
Kodak House
Station Road
Hemel Hempstead
Hertfordshire
HP1 1JU
01442-261122